Get Creative!

The Digital Photo Idea Book

Kate Binder
Richard Binder

McGraw-Hill/Osborne

New York / Chicago / San Francisco
Lisbon / London / Madrid / Mexico City / Milan
New Delhi / San Juan / Seoul / Singapore / Sydney / Toronto

The **McGraw·Hill** Companies

McGraw-Hill/Osborne
2600 Tenth Street
Berkeley, California 94710
U.S.A.

To arrange bulk purchase discounts for sales promotions, premiums, or fund-raisers, please contact **McGraw-Hill**/Osborne at the above address. For information on translations or book distributors outside the U.S.A., please see the International Contact Information page immediately following the index of this book.

Get Creative! The Digital Photo Idea Book

1234567890 FGR FGR 019876543

ISBN 0-07-222721-4

Publisher	Brandon A. Nordin
Vice President & Associate Publisher	Scott Rogers
Acquisitions Editor	Marjorie McAneny
Project Editor	Patty Mon
Acquisitions Coordinator	Tana Allen
Technical Editor	Amy Hoy
Copy Editor	Sally Engelfried
Proofreader	Pam Vevea
Indexer	Karin Arrigoni
Computer Designers	Carie Abrew, Lucie Ericksen
Illustrators	Melinda L. Moore, Michael Mueller, Lyssa Wald
Series Design	Kate Binder, Prospect Hill Publishing Services; Carie Abrew
Cover Design	Pattie Lee

This book was composed with Corel VENTURA™ Publisher.

This book is dedicated to Tom St. Martin and Paul L. Anderson, whom we love, and whose superb photography inspired us and gave us a mark to shoot for.

About the Authors

Kate Binder is a graphics and publishing production expert who has worked in book, magazine, newspaper, and online publishing. She is a partner in Prospect Hill Publishing Services (www.prospecthillpub.com), located in Nashua, NH, with a diverse client list that includes Houghton Mifflin Company, Pearson Technology Group, Rockport Publishers, *Quilting Arts* magazine, Muska & Lipman Publishing, PennWell Corporation, and Internet Biz.Net. Kate has written about electronic publishing tools and techniques for *PEI* and *eDigital Photo* magazines among others, and is the author of several books, most recently *The Complete Idiot's Guide to Mac OS X*. When Kate's not working, she and her husband Don enjoy antiquing along the back roads of New England and training their five retired racing greyhounds in obedience, agility, and amateur racing. This is the first book she has written with her father, Richard.

Richard Binder is an artist, designer, and photographer who works in both traditional and electronic media. He has designed, written, and illustrated award-winning technical documentation, CD-ROMs, and personal and business Web sites. A photographer and darkroom technician for more than four decades, Richard follows in the footsteps of his grandfather, Paul L. Anderson, who pioneered darkroom techniques for manipulating and enhancing both negatives and printed images and was the author of several instructional photography books published early in the twentieth century. Richard uses both small- and large-format conventional cameras as well as digital cameras. Richard also enjoys collecting and restoring vintage fountain pens. Although his pen business (www.richardspens.com) is small, he is internationally recognized as an expert in restoration and in reshaping nibs for collectors who enjoy writing with their pens as well as admiring them. When they find time to relax, Richard and his wife Barbara enjoy the company of their two Abyssinian cats.

Contents

Introduction

If you're familiar with New Orleans cooking, you'll know the phrase "start with a roux." We love New Orleans for many reasons—you'll see some of our Louisiana photos in this book—but prominent among them is the wonderful food. New Orleans cuisine is among the world's most flavorful and varied, featuring elegant Creole dishes, earthy Cajun food, sophisticated Continental cuisine, and healthy dashes of Southern home cooking side by side with fabulous fresh seafood. Yum! But with all this variety, still nearly every exotic Cajun or Creole sauce recipe is built on the solid foundation provided by a roux, a classic flour-and-butter mixture.

Similarly, every recipe in this book starts with a photo and turns it into something more—we hope it's as enticing and attractive as those heaping plates of New Orleans food. We'll talk about smart photography techniques so you can begin with great photos, then we'll show you a variety of fun ways to enhance your photos. Along the way, we'll share some of the projects we've made with our photos. We're no good at remembering to keep up photo albums, so instead we bring our photos into our everyday surroundings by turning them into everything from mugs to quilts to CD covers to T-shirts and lots more. We'll show you how you can do the same.

What will you need to get the job done?

- **Utensils** First of all, you'll need either a digital camera or a scanner—and preferably both. Most of our projects start with a digital photo, but we'll also show you how to get great results with your scanner by scanning photos or flattish objects. Naturally, you'll need a computer too—either a Mac or a Windows PC is OK. We use both, and we've included all the information you'll need to use either one.

focus _____

We know the geeks among you—and that term's a compliment where we come from—are dying for some details, so here they are: Richard uses a Power Mac G4 tower and a PowerBook G3 Series "Wallstreet" laptop with an Olympus D-600L camera and an Apple Color OneScanner 600/27. Kate's setup includes another Power Mac G4 with an Olympus C-3000 Zoom camera and an Epson Expression 636 scanner. On the Windows side of the aisle, Richard is running a white box (no-name PC) with Windows 2000 Professional, while Kate has recently become attached to a Dell Dimension 2300 with Windows XP Home. Note that we're not using all the latest and greatest hardware—that means you don't have to either.

- **Skills** First, of course, you'll need to know how to use your camera. Second, you should already be familiar with the basic functions of your photo-editing program—or at least you should remember where you put the manual. And finally, you'll need to have a bit of a crafty bent—most of the projects in this book are pretty simple, but we don't give step-by-step instructions for constructing them. Instead, we concentrate on showing you how to create the images—so you'll have a chance to exercise your creativity in that area as well.

- **Ingredients** The first ingredient is lots and lots of photos—easy enough to accumulate if you love your digital camera as much as we love ours! To produce your own final projects like ours, you'll also need a few supplies, and we've listed suppliers in the chapters. Finally, you'll need to get out your creativity and whip it into a nice froth!

At the end of most of the chapters in this book, you'll find a collection of project ideas we think go particularly well with the photo techniques in that chapter, but don't feel you have to stick with our suggestions. You can make almost any object you can imagine, using any image you like. Here's a list of quickie ideas to get those creative juices flowing.

- Votive candle cups with a faux "stained glass" image
- Coloring books with pictures made from your favorite photos
- A screensaver of vacation photos
- Photo decals to stick on your car or your "stuff"
- Cloth-bound journals featuring iron-on transfers of your masterpieces
- Lapel pins with a picture of you, your pop music hero, or even your dog
- Paper masks of lions and tigers you shot at the zoo
- Custom matchbooks for a wedding with a romantic shot of the happy couple
- Memo pads with fun photo covers
- Napkin rings for the family featuring their pictures
- Customized tins with decoupaged images
- Stick puppets for the kids
- Birthday jigsaw puzzles made from a candid shot of the birthday boy or girl
- Counter stools with kitchen scenes or food shots on the seats
- CD labels to match the CD jewel box inserts you'll make in Chapter 6
- Tablecloths or runners embellished with your best flower images
- Decoupaged tie clips or other jewelry
- Plain flower vases jazzed up with "hand-painted" images
- Videocassette covers for home videos featuring still shots from the movie
- Shrinky Dink zipper pulls
- Elegant snack trays with "vintage" images of faraway places

Writing a book is seldom easy, and that goes double when the authors are a father and daughter who are collaborating professionally for the first time. Still, we made it through, with the help of many friends along the way: Margot Maley, Kate's sometime agent, who brought our proposal to those who could make it a reality; Margie McAneny, Tana Allen, and Patty Mon at McGraw-Hill/Osborne, whose sharp skills and good humor kept us on track; Amy Hoy, our favorite tech editor, whom we trust to make absolutely sure we get everything right; Shelly Page, who kindly allowed us to use her lovely "kid pix" in Chapter 11; Barbara Hauck Binder, without whose encouragement Richard might never have believed he could actually write this book, and without whose unflagging support he never would have made it to the end; and Don Fluckinger, Kate's long-suffering husband, who, strangely, is still on speaking terms with Kate, Richard, *and* Barbara after all these months. What would we do without all of you? We hope we never have to find out.

Now get in there and get creative!

Getting Started

1

Recipes for Images
Start with a Photo

ONE of the best things about digital photography is that you can
shoot to your heart's content. You never have to worry about trips to the
drugstore for more film, or to the one-hour joint for processing, or to the
mall for albums and tape and photo corners, or to the ATM to pay for all
of that stuff. You can take lots of pictures, learning as you go and sharing
the good ones with your family and friends.

And one of the worst things about digital photography is . . . that you
can shoot to your heart's content. Now you've had your digital camera for
a while, you've taken a few thousand pictures, and the shine has kind of
worn off. The photos are piling up on your hard drive, and you don't know
what to do with them any more. You've made a couple of Web pages and
printed a few pictures of the kids to send to Grandma and burned a couple
dozen CD-ROMs to make space for more images on your hard drive. Now
what? More Web pages? More snapshots for Grandma? More CD-ROMs?
Not necessarily. There's much more you can do, quickly and easily, to enhance
your images and make them as fun and exciting as the day you took them.
And that's what this book is about. We'll show you how you can get your
digital images off your computer, out of your closet, and into the real world.

Your Photos: More Than Just Pictures

If you're like most people, when you think of the word "photograph," you probably think something like "in a book," "on a Web page," or "hung on the wall." But look around you. You will find pictorial images everywhere: on the sides of buses, on postcards, on T-shirts, on coffee mugs, in newsletters, on shopping bags, on rubber stamps, you name it. They might not look like it, but many of those images, even the ones that look like handmade drawings, may have started out as photographs. In this chapter, we'll introduce some of the interesting ways you can turn your own photos into real-world objects that are both useful and decorative.

Turning Photos into Real-Life Objects

The first step in turning your photos into something more than fodder for those albums you keep in the front closet is to discover something you'd like to do. Last time you walked through the mall, maybe you saw one of those pushcart merchants hawking T-shirts with photos of you or your kids on them. You may have been intimidated by the nice umbrella lights and fancy videocam the operator was using. Don't be. Your own pictures are equally good candidates for T-shirts. In fact, they're probably better, because you can keep shooting until you get one you like, even if it takes all weekend to get just the right gap-toothed grin from your seven-year-old—and you won't have to pay the inflated prices those operators get. A little work with your image-editing program, and you can put that picture on as many shirts as you like.

Or maybe you just came home from the vacation of your dreams and wish you'd sent postcards to all your friends to show them all where you were. You *did* take your digital camera, didn't you? Well, you can use your own snapshots to make postcards that look as if they came off a rack in a tawdry souvenir shop—or a nice one—in Marrakech (if that's where you went, that is).

Or maybe you're the newsletter editor for a club of people who have adopted retired racing greyhounds. You'd like to come up with a new banner for the top of the newsletter you send out to announce each month's amateur race meet—a fun activity for "retired" greyhounds who aren't quite ready to stay on their couches. If you've taken your camera along with you to some meets, you're bound to have taken some good pictures of dogs coming out of the starting box or flying headlong across the finish line. It's a cinch to turn one of those pictures into a "line drawing" that will copy well and look really professional.

This is really all there is to coming up with ideas. Look around you some more, and you'll have more ideas than you'll ever have time for. In the following sections, we'll show you some different ways you can print photos and work with the results.

Printing on Paper and Other Materials

Most of us normally think of printing on paper. And that's most of the printing we do; we print letters, pictures, spreadsheets, and so on. But it's also possible to print directly onto other materials. In this section, we'll talk briefly about papers and other things to print on. We're mostly concerned with inkjet printers; laser printers are not well suited to the kinds of things we're going to show you in this book.

You probably know that there are many kinds of paper that are suitable for printing, but you may not know what makes one paper better than another for a particular use. Papers are made of wood pulp, of cotton or linen "rag" stock, or of both wood and cloth fibers. Paper for laser printers or photocopiers has long fibers for the toner powder to stick to and lodge between until it's fused to the paper. This kind of paper is nice and cheap, but it's too absorbent for use with inkjets. Inkjet paper is made with shorter fibers that are pressed more tightly together, and it's also coated with clay for a smoother finish and less absorbency. That's why it costs more than laser paper, and it's also why inkjet printouts look so much better on inkjet paper. They're sharper because they don't bleed or blur the way they would on laser paper.

flash

Don't cheap out when you're buying paper and ink for special projects. Be sure to buy paper labeled for the kind of printer you're using, and stay away from refilled ink cartridges—they can leak and ruin your printouts

But even ordinary inkjet paper leaves something to be desired when you're printing high-quality images. Paper for printing photographs is nonabsorbent and is specially coated with gelatin instead of the clay that's used on ordinary inkjet paper. When you print in photo mode, you're telling your printer to use a lot more ink. The gelatin on special photo paper for inkjets traps the extra ink and holds it in suspension where it can contribute to the image instead of being absorbed into the paper where it won't show. This is why images printed on photo paper are so much more vibrant than those printed on ordinary paper.

But you're not restricted to printing on paper. Printing on fabric can be lots of fun; you can make those T-shirts we mentioned earlier, or pillows like the one in Figure 1.1, or neckties, or more. A few years ago, we even made a baby quilt by scanning family pictures, printing them in black and white on colored squares of cotton, and piecing the squares together. Then we sent the pieced quilt top away to the baby's grandmother to be quilted.

The easiest way to put a picture on a piece of fabric is to use commercial iron-on transfer sheets that you can get at craft shops. You print on the sheet, lay the sheet face down on the fabric, and pass a hot iron over the sheet. This results in a print that looks and feels like commercial rubberized T-shirt transfers. The thing to remember when working with transfer sheets is that your image will be reversed during the transfer process, so before you print it you will need to flip it horizontally in your image-editing program.

You can also print directly on a piece of fabric. To do this, you iron a sheet of freezer paper (obtainable at kitchen stores) onto the back of the fabric and then run the combined sheet through your printer, with the fabric side facing the ink heads. One advantage this technique has over the transfer technique is that you don't have to flip your picture before printing it. Also, direct printing won't change the way the fabric feels in your hand the way the transfer will. Obviously, you are limited to pieces of cloth the size that your printer can handle. You're also limited pretty much to silk or cotton, because other materials won't absorb the ink well.

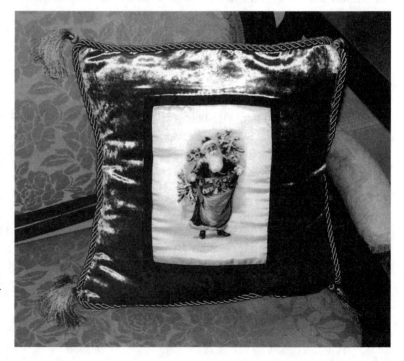

FIGURE 1.1

This decorative pillow features a 1906 image of Father Christmas that was scanned from an antique postcard and printed on silk. You could make a similar pillow using a close-up photo of your showiest garden rose or a portrait of your kitten.

flash

Before you print on cloth, you should wash it in a product such as Bubble Jet Set 2000 to make it less subject to fading in the wash. Like the printing itself, this product works best on silk or cotton fabric. You can buy it at craft and quilt stores or on the Web; we get ours from Dharma Trading Company (www.dharmatrading.com).

You can also buy specialty fabric items such as neckties that are specifically intended for printing; for most of these you'd use the iron-on transfer technique. (We've never tried to run a necktie through a printer, and we don't want to think about it.) You can find tons of information about how to do these things by searching the Web.

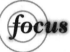

focus

Several Web sites can get you started printing on exotic materials. The BryerPatch Studio (www.bryerpatch.com/faq/bjs_q&a_page.htm) features a comprehensive list of questions and answers about printing on fabric with Bubble Jet Set 2000 from textile artist Caryl Bryer Fallert. At June Tailor's Computer Printer Fabric (www.compuquilt.com/jtprntfab.htm), you can buy letter-size pieces of cotton fabric already treated for inkjet printing—just open the package and load up your printer. For photo paper, transfer paper, CD/DVD labels, printable magnet sheets, and printable blanks for greeting and business cards, try MyInks.com (www.myinks.com). You'll find even more exotic printing materials at Printer Supply Shop (www.printersupplyshop.com/shop/novelty.htm), where you'll find puzzle blanks, bumper stickers, even silver film for a mirror-like effect. And the Imagination Gallery (www.paper-paper.com) has fuzzy paper (for printing your own velvet Elvises and dollhouse carpets) and shrink film for making your own Shrinky-Dinks—flash back to the '70s! Be sure to check out the outlet page for cool bargains.

Embellishing Printed Images

We don't want to turn this into just another craft book, but we are talking about making your pictures into real-world objects, so let's look at a few possibilities beyond plain printing.

First, you might take a fresh look at rubber stamps. Most people have rubber stamps made with their return addresses, "For Deposit Only," or a similar text message. But there's no rule that says you can't put a wild and crazy picture on one. Craft people print remarkable things with rubber stamps; they'll stamp a complicated picture and then hand-color it, or add glitter or braid or other decoration, or emboss it or frame it. You can use commercial stamps from a stamp or craft store, but you can also take any

image, preferably one that looks like a line drawing, to a rubber-stamp maker or an office-supply outlet like Staples, and have it made into a custom rubber stamp. We'll show you ways you can convert your photos into stampable images in Chapter 10, "Simple Gifts: Having More Fun with Fewer Colors."

The idea of combining rubber stamps with glitter or braid and so on, opens up the intriguing possibility of using commercial rubber stamps and combining them with your own printed images. Figure 1.2 shows two holiday cards that we made using rubber stamps. One shows a photo of Richard's front door that we converted to a line drawing, together with a rubber-stamped red "Merry Christmas." The other has a printed village combined with rubber-stamped images covered with embossing powder that you melt with a heat gun to produce a print that looks like the thick, glossy printing on some commercial greeting cards.

Of course, once you start thinking about it, there are all sorts of other materials you can apply to printed images. The Web is full of tips and techniques you can adapt to your own projects, and craft stores are a great place to visit for inspiration. At craft shops like Michaels (www.michaels .com) or A. C. Moore (www.acmoore.com), you'll find cool things like spray glitter, fake jewels, paint pens, spray "granite," braid and lace, even finger paints. Scrapbooking materials and techniques are especially adaptable for use with printed digital photos. Let your mind wander, and see what happens!

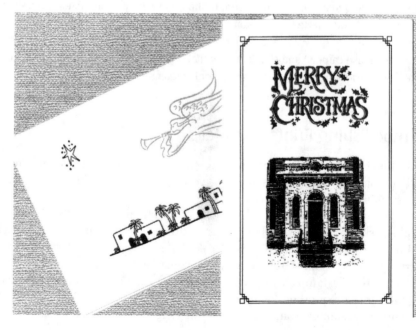

FIGURE 1.2

These holiday cards combine inkjet prints with rubber stamping.

flash

Use a piece of cardboard to mask the central portion of your printout so that you can spray glitter or other stuff around its edges without obscuring the photo itself.

Measuring and Conforming to Regulations

Most of the time you can design your projects at any size you want—or at any size your printer can accommodate, anyway. But if you're creating a piece that you'll want to mail—like the postcard we made for Chapter 13, "What I Did on My Summer Vacation: Combining Text and Images in a Postcard"—or something that needs to fit into an existing location such as a Rolodex or a brochure display rack, it's important to take good measurements and stick to them.

Postal regulations are especially strict about sizes and weights. In the U.S., you can get all the information you need about mailing regulations at the United States Postal Service's Web site (www.usps.gov); other countries have similar Web sites (for example, check out www.koreapost .go.kr in Korea). Or you can inquire at your local post office. If mailing pieces are too small or too large, or if they're too thick or weigh too much, you'll be charged extra postage, or your piece may not even be accepted for mailing. Be particularly sure to check ahead of time if you're planning on doing a large mailing—such as wedding invitations—to make sure you don't have to redo your project at the last minute.

flash

If you're creating a piece that you plan to fold into thirds, such as a brochure, be sure to make the middle panel and the cover panel wider than the third panel so that the paper folds neatly with no unsightly bulges.

How to Take a Good Picture

Most cameras come with instructions telling you how to take a picture, but very few of them actually tell you how to take a *good* picture. With a digital camera, it's easy to get the exposure right, and most digital cameras even correct for color balance, but that's not all there is to it. In this section, we'll give you a few tips that will help you to improve your picture-taking skills so that fewer of your shots fall victim to the Delete button.

Plan the Composition

The first and most important rule about taking a good picture is, *Never put your subject in the exact center of the picture.* That sounds strange, but how many really boring snapshots of Aunt Griselda or Uncle Homer have you seen? Too many, we'll warrant, and a big part of why those snapshots are boring is that they're flat, dull, and lifeless. The subject is just standing there smack in the middle of the frame, staring at the camera with a forced smile and looking very posed.

Spend a few minutes looking at some great art. You can see the paintings we describe on the Web at the Artchive (www.artchive.com).

Start with the *Mona Lisa.* She's in the middle of the picture, isn't she? No, she's not. Her face is well above the center, slightly to the left, and not aimed straight at the "camera." What's in the exact center of the picture? The middle of her chest. Not exactly the life of the party, is it? But her face, now, that's magnetic. You can't resist it. And her hands are at the bottom, perfectly balancing her face in the frame. The overall effect is one of great peace and serenity.

Now look at *Christina's World* by Andrew Wyeth and observe the composition. Christina is low and to the left, about a third of the way in from the left side and about a third of the way up from the bottom. This composition follows the rule of thirds, which is a good rule for composing pictures. Put the most important object at one of the four "one-third in, one-third up or down" points, with its position and angle leading the viewer's eye toward (or maybe through) the center of the frame. In this picture, your eye is drawn toward the distant house at the top of the picture. This particular composition radiates tension and separation.

Another picture that follows the rule of thirds, but without seeming to, is Eugene Delacroix' *Liberty Leading the People.* Here, the figure of Liberty and the young man to the right of her combine to become the primary object, and they're just where they ought to be: one third of the way from the right and (follow your eyes here) one third of the way down from the top. Liberty's pose draws your eye irresistibly toward the other side of the frame, where the mass of people balances her and the one man well. This is a dramatic composition, full of fire and very much alive.

Now, we don't expect you to go out and start taking photographs as great as these paintings. We can't do it ourselves, either. But we can, and do, think about composition. Figure 1.3 shows one of the photos that have resulted from our care to compose pictures well.

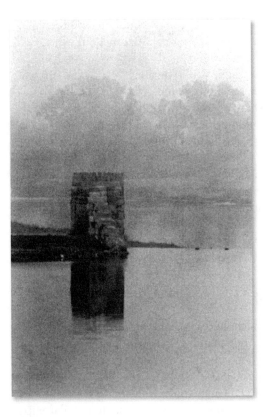

FIGURE 1.3

Richard made this photo, titled The East Tower, *to resemble art photos created by his grandfather, Paul L. Anderson, a noted pictorialist who worked in the early part of the 20th century. The picture has the appearance of an antique hand-worked "bromoil" print.*

flash

Remember to pay attention to what's in your picture besides the thing you're actually photographing. If you're shooting a person, for example, don't stand the person so that a telephone pole appears to be growing out of his or her head. For Figure 1.3, Richard waited a whole year for the fog to be just thick enough to hide the pair of 14-story apartment towers that you can't see beyond the trees.

Pay Attention to Lighting

Lighting is a complex subject that artists spend years, even lifetimes studying. We can't give you a lifetime of experience working with light in just a few paragraphs, but we can offer two guidelines to improve nearly every photo.

To start with, remember that most pictures are more interesting if the light doesn't fall on the subject from directly behind the photographer. Look again at the three paintings we talked about before (see the preceding section, "Plan the Composition"). In all of them, the light falls obliquely across the field of view. This gives the objects in the picture shape and

depth; they're three-dimensional, not flat as they would be with the light coming from the middle of the viewer's forehead. Figure 1.4 illustrates how oblique lighting improves a picture.

Second, consider what kind of light you're dealing with. There are two basic kinds of lighting: point-source lighting and diffused lighting. The sun is a point source. It casts sharp shadows that don't blur much even if they're being cast by an airplane hundreds of feet in the air. Pretty much everything else is a diffused source. Now, a single light bulb isn't very diffused, and you can often use a single light bulb to simulate a point source indoors; but the more bulbs you add, or the more reflective surfaces there are in the room, the more diffused your lighting becomes. Shadows under diffused lighting are blurry, and the farther the object is from the surface on which its shadow falls, the blurrier the shadow will be. You can use differences in lighting to achieve different effects; strong contrasts and shadows are more alive, while diffused shadows are usually more restful.

Taking Outdoor Photos

Believe it or not, most professional photographers prefer shooting outdoors when it's somewhat overcast, rather than bright and sunny. When you shoot directly under a really bright sun, the contrast is usually excessive. So, if it's sunny, try to find a bright shaded spot. For interest, try to get some clouds into the sky; but if you can't, you can always fake them in later. Use a polarizer lens, if your camera can accept one, to cut glare; it will also enhance contrast, especially in the sky. And, if you plan to desaturate your image later on—remove its color to make it a grayscale image—you can get much more dramatic skies in the final image by taking your picture with a yellow or red filter; they'll make the blue darker, with a red filter doing more than a yellow one.

FIGURE 1.4

These two simulations show a ball under different lighting. Note how much more realistic the ball appears under oblique lighting (a) than under straight-on lighting (b).

(a)

(b)

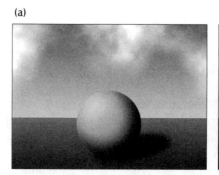

Taking Indoor Photos

When you're shooting indoors, you need to use a flash, right? Wrong. Remember how we discussed oblique lighting (see "Pay Attention to Lighting" earlier in this chapter)? For the best lighting, you want the scene to be lit at an angle, rather than with light that appears to come straight on. Unfortunately, the middle of the viewer's forehead is where most cameras' flash units are—so you need to learn to take indoor pictures using available light. Read your camera's manual and experiment with the flash turned off to see how you can get the best results from your particular camera. You can often achieve gorgeous available-light photos during the day using just the light that's coming in through your windows.

If you're using available light—no flash—you'll probably find that you need to immobilize your camera while it takes the photo, either with a tripod or by bracing it against something (a doorframe, the back of a chair, whatever's handy). With point-and-shoot cameras, the shutter speed automatically slows way down when the light's low, to make sure enough light gets to the film to create the image. And with this slow shutter speed, moving the camera even a little bit results in a blurred image.

Unlike a film camera, your digital camera will usually do a wonderful job of correcting for color balance problems. With film cameras, photos taken in ordinary room light usually have a reddish cast if the lights are incandescent or a blue-green cast if the lights are fluorescent. Digital photos rarely suffer these problems. (But if they do, you can correct them in your image-editing program.)

Finally, you can hang light-colored sheets, towels, or pieces of paper or poster board and bounce lights off them to provide very diffused lighting on your subject and reduce shadows to the minimum. This technique can also simply reduce contrast between brightly lit and shadowed areas of the image—what's called "fill" lighting—allowing the unlighted side of your object to be seen better but still appear in shadow. And it works great with that daylight we mentioned, too: just hang a sheet over the window and presto! Instant diffused lighting. Many of the pros use a sheet of insulating Styrofoam for fill lighting because it's light in weight, rigid, and *very* white.

One last idea, and we can move on to the next chapter. You don't always have to make your lighting look natural. "Unnatural" lighting (as opposed to artificial light) can give you some spectacular photos. For example, you can get some really interesting lighting effects by using aluminum foil or shiny colored foil gift wrap, crumpled and then spread out again. Try reflecting a bright light from this so that the irregular reflections illuminate a small object. You can use the foil alone, or you can use it to produce highlights in combination with other lighting. Get creative!

2

Boot Camp
Basic Training for Photo Editor Wannabes

THIS chapter is the boring part of the book. No, wait—don't stop reading now! First, stick around for a minute so we can tell you what information you'll find in this chapter, and you can come back and find it later when you need it. Or, if you're the by-the-book type, read through this chapter so you can get things right the first time and then snicker at those who come slinking back here after they've run into problems. (Just don't snicker too loudly.)

In this chapter, we'll explain what software we used to create the images you'll see in the rest of the book, as well as what hardware you'll need to have in order to use that software. We'll take a minute to discuss when you can scan an object instead of photographing it and when you'll get better results with your digital camera than you would with your scanner. Then we'll move on to give answers to some nuts-and-bolts questions about image size, resolution, and file format. Finally, we'll wrap up the chapter with information about the best way to print your image or prepare it for use on the World Wide Web.

Now you're free to skip ahead if you like—we'll see you back here later on.

Software Requirements

Before plunging into the world of photo editing, let's make sure you've got all the right tools lined up. In this section, we'll talk about the software you'll need, then we'll go on to size up your hardware—computer, camera, and scanner—in the next section.

What Programs Are We Using?

When we're shopping for software, we're thrilled to have so many choices. As the authors of this book, however, we find that the multiplicity of image editing programs brings up a tough question: How can we tell our readers how to get the same cool effects in *any* software they might be using?

The answer is that we can't. But we wanted to make this book useful for as many people as possible. So we picked five programs that we feel represent a good cross-section of what's out there for image editing software:

- Adobe Photoshop Elements 2
- Corel PHOTO-PAINT 11
- Jasc Paint Shop Pro 7
- Microspot PhotoFix 3
- Ulead PhotoImpact 8

Often bundled with digital cameras and scanners—so you quite possibly already have at least one of them!—these five programs are inexpensive but powerful. Four of the five will run you between US$60 and US$100; PHOTO-PAINT costs a bit more. Whether you're using one of these five or a different program altogether, you can still work through the projects in this book. With this in mind, in each chapter we've listed the software features you'll need to complete that chapter's projects. Check your software documentation if you're not sure whether your program has what it takes.

flash

If you already have one of the programs we've listed, but yours is an earlier version, check the developer's Web site to see if there's an inexpensive upgrade—or better yet, a free update—available. The developer Web sites for all five of these programs are listed in Appendix A, "The Software in Review."

One caveat: this isn't an introductory book—we aren't in the business of teaching you how to use your software from scratch. You'll need to know

the basics: how to create and save a new file, how to switch tools and use the tools your program offers, how to choose menu commands, and how to view palettes that contain information about your image and options for the tools and effects you'll apply.

Your Operating System

Are you a Mac person or a Windows user? You're welcome here either way, but you'll need to remember that which side of the aisle you sit on determines what software you can use. Our selection of five programs was chosen to include both Mac and Windows software, and two of the programs are cross-platform, meaning that they're available for both Mac OS and Windows. Of course, what *version* of Windows or Mac OS you have is also relevant. If you've been putting off upgrading for a while, now might be the time—or not. Take a look at Table 2.1 to see what OS you need to run your software of choice.

Most cross-platform software these days functions pretty much identically on both platforms. So just because we use Adobe Photoshop Elements on a Mac running Mac OS X doesn't mean you can't complete our Elements projects using Elements on a Windows PC.

We'll talk more about operating systems—in combination with the hardware on which they run—later in this chapter, in the "Hardware Requirements" section.

Getting Consistent Color

Yes, you read that title correctly—getting consistent color is a software function. Of course, it helps if your hardware is in good condition and not too old, but the key to great color is color management software. Invented for the publishing and textiles industries, color management software is designed to help overcome the differences in the ways cameras, scanners, monitors, and printers reproduce color.

In school (unless you went to art school), you probably learned that red, yellow, and blue are the primary colors. Well, that's just one of the many things kids learn in school that aren't *quite* true. As it happens, there are two sets of primary colors, one for pigments and one for light.

TABLE 2.1

Platform Requirements for Image Editing Software

PROGRAM	PLATFORMS
Adobe Photoshop Elements 2	Mac OS 9.x or Mac OS X 10.1 Windows 98, 2000, Me, or XP
Corel PHOTO-PAINT	Mac OS X 10.1 Windows 98, NT 4, 2000, Me, or XP
Jasc Paint Shop Pro 7	No Mac OS version Windows 95, 98, NT 4, 2000, Me, or XP
Microspot PhotoFix	Macintosh System 7.1 or higher, or Mac OS 8 or higher (including Mac OS X) No Windows version
Ulead PhotoImpact	No Mac OS version Windows 98, NT 4, 2000, Me, or XP

If you're talking about pigments—whether they're inks, paints, or crayons—the primary colors are cyan (light blue), magenta (intense pink), and yellow. Theoretically, if you combine these three, you'll get black—that's what makes them the primary colors. However, because in the real world pigments aren't perfect, we usually need to add black to the mix. These four colors—cyan, magenta, yellow, and black (CMYK)—are the four colors used for printing, both on huge printing presses and on desktop inkjet printers. Open up your printer and take a look if you want to confirm this.

You say your printer has extra colors, not just cyan, magenta, yellow, and black? That could well be the case. Some printers use extra ink colors in order to extend their gamut and make up for the imperfections in their ink pigments. Most commonly, you'll see light magenta and light cyan, but you might also run into orange and green inks. Treasure these additional colors (they're helping you get great images from your printer), but don't let them distract you from the lecture. Your printer is still a CMYK device—trust us.

OK, back from checking your printer? Great. Now, let's talk about light. Light is what's used to create color inside cameras, scanners, and computer monitors. And the three primary colors of light are the ones that, when mixed, produce white light: red, green, and blue—which happen to be the complements of cyan, magenta, and yellow. In other words, if you look at a color negative of a red T-shirt, the shirt looks cyan. Pretty cool, huh?

Enough theory; what does all this mean in the real world? Mainly, it means that when you look at a printed image, it may not look the same as it did on your monitor or your camera preview screen. That's because the printout is made with cyan, magenta, yellow, and black pigments, and the monitor image is made up of red, green, and blue light. The CMYK gamut—the range of colors you can make with CMYK pigments—isn't the same as the RGB gamut. Sure, they overlap in some places, but they're not identical, and the RGB gamut is much larger than the CMYK gamut, which means you can create colors on your computer screen that you'll never be able to print.

Now that you know some of your devices are speaking different languages, you're probably wondering just where you can find an interpreter. As it happens, interpretation is what color management is all about. Color management systems (CMSs) use device profiles, which describe in mathematical terms the color reproduction characteristics of particular devices, to translate color from one device to another. With color management, your computer knows all the quirks of your camera, scanner, monitor, and printer, and it adjusts the color as you go along to compensate for the differences between them and provide consistent color.

If you use a Windows or Mac OS computer with a fairly recent operating system, you already have a CMS installed. On Macs, it's called ColorSync, while Windows has a system called Image Color Management (ICM). To make use of these systems, you'll need to configure them with the appropriate profiles for your devices. The profiles you need may have been installed when you installed your printer, camera, or scanner, or you may need to download profiles from manufacturers' Web sites and install them yourself. Check your computer's documentation for installation instructions.

flash

If you're like us and often skip the CD installation for devices like digital cameras, take another look at what was on those CDs you didn't bother with. You might find color profiles and other useful software on them.

ColorSync and ICM constitute system-level color management. At the application, or program, level, you may need to turn on color management in the preferences. For example, in Corel PHOTO-PAINT, choose Edit ➤ Color

Management to open the Color Management dialog box. You can choose profiles for each device type, or you can choose to use your system settings, as shown in Figure 2.1.

Hardware Requirements

So you've been reading the reviews and checked your operating system for compatibility, and you've come to the conclusion that you really have to have the new version of Jasc Paint Shop Pro to get that histogram edit feature, right? Better not get your hopes up if your computer is a Macintosh. Or how about Microspot's PhotoFix, which will actually run on a machine with a puny 5MB of RAM? Forget it if your computer has an *Intel Inside* sticker on the case. How about Adobe Photoshop Elements, with its ability to use all those delicious Photoshop filters? Yeah, we can do that.

It's unfortunate but true that you can't just grab a snazzy computer and a killer program off the shelf and know they'll work together. The program has to be designed for the computer. As a general rule, you can be pretty sure a program with the Windows emblem on the box will work on a Windows PC or that a program with the Mac OS emblem will work on a Mac, but you can't necessarily be positive, in either case, that the program you want will work on *your* computer. Here's the info you need to make sure you've chosen a program that you can use—or to make sure that you can use the program that came with your digital camera or scanner.

FIGURE 2.1

In PHOTO-PAINT, Kate uses the system-level ColorSync settings, which saves having to select profiles twice.

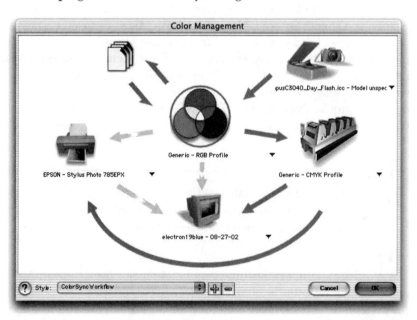

So You've Got a Mac

Since 1994, all new Macintosh computers have been based on the PowerPC microprocessor, and it's safe to assume that any Mac program you buy today will run on a PowerPC. But there are differences in just how much Mac you'll need, and—believe it or not—there's one remarkably powerful program that will still run on that ancient 68020 machine you just haven't had the heart to put up on eBay! Check Table 2.2 to find how your Mac stacks up against the program you're considering.

TABLE 2.2

Minimum Hardware Requirements for Mac Programs

MAC OS PROGRAMS			
	Adobe Photoshop Elements	**Microspot PhotoFix**	**Corel PHOTO-PAINT**
Processor	Any PowerPC	68020 or higher, or PowerPC	PowerPC
RAM	128MB with virtual memory on	Needs 3MB more than the operating system itself requires	128MB
Free Disk Space	350MB	9MB	250MB
Display	Thousands of colors, 800 × 600 pixels	256 colors, 640 × 480 pixels	Thousands of colors, 1024 × 768 pixels
Pointing Device	Mouse or graphic tablet	Mouse	Mouse or graphic tablet
Other	CD-ROM; SCSI or USB for camera or scanner	CD-ROM; SCSI or USB for camera or scanner	CD-ROM; SCSI or USB for camera or scanner

Or Maybe You Have a PC

Most Windows applications will run on an original Pentium system—you can probably kiss that garage-sale 486 box goodbye—but a few require a Pentium II or newer processor. The original Pentium has been around since 1993, though, so outdated technology shouldn't be a problem for you unless you really *are* using "your father's old machine." Table 2.3 lists the programs we'll be using together with the least machine you'll need to run them.

Your Scanner or Camera

Having a great image editor isn't going to be much fun if you don't have a source of images to edit with it. Sure, we know, you can always snag stuff

TABLE 2.3

Minimum Hardware Requirements for Windows Programs

	WINDOWS (PC) PROGRAMS			
	Jasc Paint Shop Pro	**Ulead PhotoImpact**	**Adobe Photoshop Elements**	**Corel PHOTO-PAINT**
Processor	Pentium	Pentium	Pentium	Pentium II
RAM	32MB	64MB	128MB	64MB, 128MB for Windows XP
Free Disk Space	75MB	500MB	128MB	200MB
Display	High color, 800 × 600 pixels	256 colors, 640 × 480 pixels	High color, 800 × 600 pixels	High color, 1024 × 768 pixels
Pointing Device	Mouse or graphic tablet	Mouse or graphic tablet	Mouse or graphic tablet	Mouse or graphic tablet
Other	CD-ROM; SCSI or USB for camera or scanner	CD-ROM; SCSI or USB for camera or scanner	CD-ROM; SCSI or USB for camera or scanner	CD-ROM; SCSI or USB for camera or scanner

from the Web and massage it, but—copyright issues aside—that loses its charm pretty quickly. So, since this book is about how you can use your own images, let's talk for a moment about cameras and scanners.

The Flat Truth About Scanners

These days, choosing a scanner can be as complicated as building your own system. But it doesn't have to be. What you need to know about scanners breaks down pretty simply.

First, you'll need to consider the scanner's interface: USB, SCSI, or FireWire. Most of the scanners you see today have USB, and that's great; all you need to do to connect a USB device is connect it to a spare USB port—you do have one of those, don't you?—and plug its power cable into the wall. SCSI scanners, which are becoming less common, usually cost more and require a little more setup. Older Macintosh systems have SCSI ports built in, but since the blue-and-white G3 made its appearance, SCSI has been an option for both Mac and PC. Unless you have another need for SCSI, we don't recommend that you spend for it. A few scanners are now available that use FireWire (also known as IEEE 1394), but these are more expensive than USB scanners. FireWire and USB devices are remarkably easy to connect, however, because both are hot-pluggable bus systems—meaning that you don't have to shut down your computer to connect and disconnect devices.

Second, take resolution into account. The higher the resolution, the more pixels you'll have to work with. At 600 pixels per inch, an 8.5" × 11" scanner can give you an image 5100 × 6600 pixels. But that's only if your original is that big. We often find that we need to scan something like a snapshot; and at 600 pixels per inch that's going to be about 3000 × 2100 pixels. For most work, this is plenty; but as your originals get smaller you may find that you want higher resolution. One thing to watch out for is whether the scanner can actually scan at the specified optical (hardware) resolution or whether it does what's called interpolation, in which two adjacent scanned pixels are examined and a new one, averaging the two, is inserted between them. Interpolated images can be blurry, and for this reason we recommend buying a scanner based on its true optical resolution.

We've used the term "pixels per inch" here, and we'll use it pretty regularly throughout the book. (We'll also explain what it means a little later in this chapter.) You're probably more used to seeing "dots per inch" (dpi), but that's technically not correct because dots are not the same thing as pixels. Inkjet printers, which actually do create dots of ink on the paper, make dots that are usually much smaller than a pixel, so they build up their pixels out of multiple dots.

Finally, remember that different scanners have different features. Most scanners are flatbed models; they take a flat sheet of paper or a page from a book, or other similar objects such as beer coasters. You can also scan thin 3D objects such as coins, pens and pencils, keys, and other similar small items. But be aware that many inexpensive scanners have poor depth of field; that is, these scanners are good with paper, but anything that isn't actually in direct contact with the glass will be out of focus. Some flatbed scanners offer options such as document feeders, for scanning multiple sheets in one loading, or transparency adapters, which shine light through the object instead of making the scanner rely on the light that that the object reflects. For special applications, there are slide scanners, for reproducing 35mm slides and negatives, and drum scanners, which are similar to flatbed models except that the object being scanned is placed around the curved surface of a cylindrical drum. Drum scanners are more precise than flatbeds, but they're quite expensive; these units are for serious professionals.

Cameras—A Snapshot

The choice of how much digital camera you own is up to you; you can buy cameras with resolutions anywhere from 320×240 pixels to 2500×2000, or even higher. The more, the better! And the selection of features (through-the-lens or rangefinder viewing, interchangeable lenses, optical or electronic zoom, SmartMedia or Compact Flash or Memory Stick, and so on) is enough to boggle even a genius like Stephen Hawking! What's of more immediate concern at the moment is how your camera connects to your computer to upload the photos you've taken.

focus ────────────────────────────────

We hear people misusing the terms "upload" and "download." Other people, not you. But so you can correct those other people easily, here's the difference. Uploading is the act of transferring information from a smaller, more personally oriented system (a camera or a Palm Pilot, for example) to a bigger, more central system (a desktop computer or a Web server, for example). Downloading is transferring the other way.

Most digital cameras these days have built-in USB or serial ports; some have both. Older cameras may have neither. On the computer end, PCs generally have both, but modern Macintosh systems don't normally have the older, slower, and less versatile serial ports. If your camera and your computer can't talk to each other, you'll need to figure out how to translate for them. Here, you have several options depending on just what features your camera and computer have. Obviously, simpler is better, but don't be afraid to *get creative*. (Sorry, we couldn't help ourselves there.)

Here are a couple of examples. Richard's 1998-vintage camera has no USB connector, and his Macintosh G4 computer has no serial port, so he uses a PC Card (PCMCIA) adapter to plug his camera's SmartMedia cards into a laptop and then transfers the files over his house's local area network (LAN) to his desktop Mac. That might be too extreme for you. Kate, more practical and up to date (and less geeky) uses a direct USB connection to her computer—a cable that plugs into the camera on one end and into the computer on the other end. You may even find that your printer, like Kate's Epson model, can accept your camera's storage media directly. Of course, printing images directly from the camera media doesn't give you any scope to get creative . . .

When to Scan, When to Photograph

Scanner and digital camera prices have been dropping for years now. You can't quite get a digital camera from a gumball machine at the grocery store—but we're almost there. So what to do if you have both a scanner and a camera, as many of us do these days? Both devices enable you to get an image of a real-life object into your computer, and sometimes it's hard to decide which one you should use. There are times when it's obvious that scanning is a better choice than photographing—such as when you're reproducing pictures or text documents, for example. On the other hand, it wouldn't make a lot of sense to carry your scanner outside to shoot a picture of your dog's new domicile.

Those are the easy ones. Sometimes, the choice isn't always that clear. If you spend any time on eBay, you are likely to see that many sellers scan small objects such as coins, jewelry, and fountain pens, while others photograph them. To some extent, it's up to you which way you go. Scanners automatically hold an object still, and they're fast to use—the image goes directly into your image-editing program in most cases. It's usually easier to control the size and resolution of scanned images than it is of photographs. But if you want to be able to control the lighting on your merchandise to create a professional image in hopes of attracting more buyers, you can't use your scanner. Or, even with some surprisingly small objects, your scanner may just not be up to the task. As we pointed out earlier, some low-end scanners have poor depth of field. We recently saw a scan of some fountain pens made by such a scanner. One of the pens was placed with its clip directly against the glass, and the front face of the clip was beautiful. The barrel of the pen, 1/16" away from the glass, was a useless blur.

On the other hand, setting up lighting to cast just the right shadows and highlights on small objects you're photographing, especially shiny ones,

can be very difficult and time consuming. When Richard photographs the fountain pens in his personal collection, he uses between four and six lights along with several sheets of paper to diffuse or redirect the light. (Of course, once you've figured out how you want your lighting, you can set it up the same way again next time.)

If you just can't decide, try some experiments to gain a sense of how your camera and your scanner handle reflective objects and close-up detail.

About Size and Resolution

In traditional photography, dealing with size is easy—if you want your image bigger, you just enlarge it in the darkroom by using a lens to project a larger image on the paper. If you try to make the enlargement *too* big, the resulting photo will be somewhat grainy, of course, but that's a fact of life we're all used to dealing with. Photocopiers work the same way, and we're all used to dealing with them too.

Guess what? Digital images *don't* work the same way. Read on to find out what this means to you.

What Resolution Really Means

Instead of being made up of areas of color shading gradually into each other, digital images are composed of tiny squares of color called pixels—short for "picture elements"—and each pixel can be only one color. You can see the individual pixels that make up an image if you zoom way in (see Figure 2.2).

When you look at a digital image on paper, assuming it's printed at the correct size, your eye can't distinguish individual pixels, because they're too small, so you "see" the colors smoothly shading into one another. However— and here's where the difference starts to matter—if you print a digital image at a larger size, the pixels start to become visible. The number of pixels per inch (ppi) in an image is that image's resolution, and too-low resolutions are what create the "jaggy" effect you see on Web graphics when you print a Web page. Web graphics are created at a resolution of 72 ppi for display by a Web browser. Since browsers display their images at 72 ppi, images made at 72 ppi appear at the correct size. But when you print these images, the individual pixels are big enough to see.

focus ———————————————————————————————————

If the pixels in Web images are so big, why don't you see them on-screen? You do—but your eye fools you into thinking that you don't. Lean in toward your monitor and focus on an image, and you'll see that it's made up of tiny squares. Diagonal lines and curves aren't really smooth, although they often appear smoother than they are due to a little judicious blurring of their edges, a technique called anti-aliasing.

FIGURE 2.2

The inset (a bit of whisker) shows an enlarged view of the pixels that make up this photo of a sleeping Abyssinian cat.

What Resolution Should You Use?

What all this means for you is that you'll need to take image size and resolution into account *before* you take a photo or create a new image file (such as the background textures you'll be making in Chapter 3, "Making Your Images "Touchable": Creating Patterns and Textures"). If you want to print an image, you'll need to start out with enough pixels per inch that you won't be able to see the individual pixels when you print the image— the more of them per inch, the smaller they will appear in the final printout. If you're planning to display your images only on-screen, on the other hand, you need to make sure there aren't too many pixels, too many being more than 72 per inch for the size in inches that you want the image to appear on-screen. Browsers always display images at 72 ppi, regardless of the intended resolution. This means that higher resolution images are displayed much larger than intended; for example, a 144-ppi image will be twice as wide and twice as tall on the screen as it should be.

Here's an example to give you an idea of how this size and resolution relationship works. Suppose you take a photo that's 640 pixels wide and 480 pixels high, with a resolution of 300 ppi (fairly standard for printed images). The image contains information specifying the resolution, and if you print it, it'll be 2.13" wide and 1.6" high, and the pixels will be too small for you to see without a magnifying glass. If you view it in a Web browser, on the other hand, the resolution information is disregarded and the image is displayed at 72 ppi, which makes it almost 9" wide on most monitors—quite a difference!

So, for most of the projects in this book, you'll want to make sure that your camera is set to take photos with enough pixels that you can print them at 300 ppi. You can work the math backward to determine the camera settings you'll need; if you want to print your image at 5" wide, it will need to be 1500 pixels wide. To display the same image at the same size on your monitor, though, as part of a Web page or a screensaver or a slide show, you'll only need to make it 360 pixels wide.

What about camera resolution, often measured in megapixels? In the case of digital cameras, the resolution at which they're capable of capturing a photo is often specified in two ways: as the total number of pixels per image, and as the maximum number of pixels in each dimension. A camera that can take photos at a maximum size of 1152 pixels wide by 870 pixels high is a megapixel camera, or one that can produce images containing a million or more pixels, because an image at that size contains a total of 1,002,240 pixels (1152 × 870). Remember, do the math: an image of this size will display on the Web at 16" × 12" and would be 3.84" × 2.9" if printed at 300 ppi. In general, the more you pay for a camera, the higher its resolution. And if you think the currently available resolutions are too low, wait a year—like most computer equipment, cameras just keep getting better and cheaper.

We should make it clear that 72 ppi and 300 ppi aren't the only possible resolutions for photos.

Specifying Resolution and Resizing Images

Now that you've learned all this math—admit it, it's pretty easy!—you're probably wondering where you go to put it into action. That, of course, depends on what program you're using. In Table 2.4, we've listed the commands you'll need to use to set an image's resolution and print size in each program used in this book.

TABLE 2.4

Setting Image Size and Resolution

IN THIS PROGRAM . . .	CHOOSE . . .
Adobe Photoshop Elements	Image ➤ Resize ➤ Image Size
Corel PHOTO-PAINT	Image ➤ Resample
Jasc Paint Shop Pro	Image ➤ Resize

TABLE 2.4

Setting Image Size and Resolution (continued)

IN THIS PROGRAM . . .	CHOOSE . . .
Microspot PhotoFix	Image ➤ Resize
Ulead PhotoImpact	Format ➤ Image Size

Each of these dialog boxes looks pretty much like the others, although the various controls might be labeled differently. If you're not sure what a particular setting does, check your software manual. We'll take a quick tour of the Image Size dialog box in Photoshop Elements (Figure 2.3) to give you an idea of how these settings work.

At the top of the dialog box, you see the image's current pixel dimensions. Below that, you see the document size and resolution, which are interdependent. If you reduce the resolution value, the Width and Height values go up—unless Resample Image is checked. This check box enables you to increase or decrease the number of pixels in the image using a process called resampling, in which the software essentially creates a new grid of pixels for the image and determines their colors based on the colors of the original pixels they're closest to. Reducing an image's resolution without changing its print size (called Document Size in Photoshop Elements) is called downsampling, and increasing the resolution is called upsampling.

FIGURE 2.3

Every image editor has a dialog box similar to this one from Photoshop Elements.

focus ————————————————————————

Wait a minute—we're just now telling you that you're not stuck with the original number of pixels in your photo? That you can increase the resolution and then print at any size you want? Well, sort of. The fact is that resampling requires the program to guess at what color each pixel should be. Now, the programs we're using are pretty good guessers, but upsampling tends to blur images—upsample too far and everything looks soft and fuzzy. Downsampling has less effect on an image, but you'll often be able to see a difference between an image scanned or photographed at a high resolution and then downsampled, and the same image scanned or shot at the target resolution in the first place. The image that hasn't been downsampled will be clearer and sharper. So resample if you must, but avoid it if you can.

Next to the Resample Image check box is a pop-up menu from which you can choose one of three different mathematical methods for calculating the colors of the resampled pixels. For photos, stick with Bicubic, the highest quality method.

Finally, the Constrain Proportions check box determines whether an image's original proportions are retained when it's resampled. With this box checked, you only have to enter one dimension—Photoshop Elements calculates the other dimension for you. When it's unchecked, you can scale the image so that it's stretched or compressed vertically or horizontally, something you'll do occasionally for background textures and the like but rarely for photos.

Saving Files

Saving your file is easy—you just press COMMAND+S or CTRL+S, enter a name, navigate to the right folder, and click Save. Right? Not exactly. That list of steps leaves out an important one: choosing a file format.

flash ————————————————————————

No matter which format you use, save early and save often. If your dog pulls out your computer's power plug, you'll thank us for this advice. Don't be shy about taking advantage of the Save As and Save a Copy commands, or automatic backup features (usually activated in your application's preferences) to save extra copies of your work-in-progress.

Why File Format Is Important

In architecture and industrial design, form follows function. In digital imaging, format follows function. In other words, the format in which you

save your images depends on what you're going to do with those images. For the Web, you'll use one of these three formats:

- **GIF** Graphics Interchange Format (GIF) limits the number of colors in an image to 256. If your image contains more colors, pixels colored with the "extras" are recolored with the nearest color that made it under the 256-color limit. This makes GIF a great format for logos and for images of text—any image that doesn't contain very many different colors.

- **JPEG** Photographs are better off in JPEG (Joint Photographic Experts Group) format than in GIF format. JPEG images can contain a full range of colors; the only snag you'll run into when using them is their lossy compression (see the section "Compression in a Nutshell," a little later in this chapter).

- **PNG** Portable Net Graphics (PNG), the Web format that's still looking for love, was created as an alternative to GIF (for legal reasons that we don't need to worry about here), but it hasn't been widely adopted and isn't supported by all Web browsers.

We'll talk more about these Web formats later in this chapter, in the "Creating Web Images" section.

If your image is destined for commercial printing, you'll want to use one of these instead:

- **TIFF** Tag Image File Format (TIFF) is the most common format for printed images of all kinds, including—believe it or not—faxes.

- **EPS** Use Encapsulated PostScript format (EPS) for PostScript workflows—those that rely on PostScript printers or high-end imaging devices.

And if you just want to print your image yourself, or admire it on-screen, you can stick with the native format. Read on for more information.

Going Native

In the world of file formats, there are two kinds: universal and native. The former are formats that can be read and written by most programs in the relevant category, such as those just discussed in "Why File Format Is Important." Native formats, on the other hand, are those that are specially created by a software developer to work with that company's software. Got any files called filename.doc on your hard drive? Those files are saved in

Microsoft Word's native format. True, pretty much everything can read Word format documents, but that's just because the program—like Microsoft products in general—is ubiquitous.

Some native formats can be read and even written by other programs, and others can't. That's why they're generally used only for working documents—those in-progress projects that aren't ready to be shared with others yet. Native formats are great for these documents, because they support all the features of the software to which they belong. For example, if you're working in Adobe Photoshop Elements and your project uses a lot of layers—like our postcard project in Chapter 13, "What I Did on My Summer Vacation: Combining Text and Images in a Postcard"—you'll want to save the file in native format (Photoshop format in this case) until you're ready to put it on the Web or send it out for commercial printing. By saving in Photoshop format, you preserve the layers and editable text in the file. When you're ready to put the image on your Web site, you can save a copy in JPEG format—which *doesn't* support layers or editable text— and keep the original in native format so that you can always go back and make changes quickly and easily.

Compression in a Nutshell

Have you noticed how hard drives have gotten bigger and bigger (and bigger!) over the years? In 1989, a 40MB hard drive was standard for high-end Macs. Now, your new Mac is likely to come with a 40 *gigabyte* hard drive, which holds a thousand times as much data as that old 40-megger.

File size and hard drive size constitute a chicken-and-egg problem: are file sizes larger because there's more space for them, or is there more space because we need it for all these large files? Really, it's a little bit of both. The point, however, is that files *are* bigger, and that means that compression is more important than ever before. Most graphics file formats include compression, either as an option or as an integral part of the format. This means that they use mathematical shortcuts to represent image data, saving space and reducing file size. There are dozens, maybe even hundreds, of different ways to compress image files, but you only need to worry about the compression methods used in the most common formats.

For the Web, those formats include the following:

- **GIF** Uses built-in lossless compression, meaning that its compression doesn't reduce the quality of the image.

- **JPEG** Is a format that wouldn't exist without its compression; it was designed to be a compact format for photographic images. Its compression is variable—you can choose how much compression to

apply—and lossy; compressing an image alters its pixels permanently. Don't ever use JPEG as an intermediate format, only as the final format for a copy of an image whose original is saved in another format.

- **PNG** Uses lossless compression. PNG also comes in a lossy version that's great for photos—or it would be, if anyone were using it.

If you're sending an image out for commercial printing, or submitting it to a newspaper or magazine publisher, there's only one compressed format you can use: TIFF. Compression is optional when you're saving a file in TIFF format; it uses the LZW compression routine, similar to that used in GIF images.

flash

If you send someone a TIFF image and it doesn't open or print correctly when it gets there, try saving the image without compression. You can then use Zip or StuffIt compression on the saved file to make it small enough to transfer easily. See www.stuffit.com for more information.

Printing Techniques and Media

Once you've done things to your images by following some of the techniques in this book, the next question is, how to print the results? Printing isn't just for paper anymore, and even if it were, there's more to paper than meets the eye. In this section, we'll look quickly at some of the things you might want to know to enhance your printing experience.

The Printer Family Tree

Before we talk about the stuff you can print on, let's look at the kinds of printers you're likely to see. Here's a list of the most common printer types out there:

- **Laser printers** These come in black and white and color versions. Color lasers are quite expensive and are generally seen in large companies, design firms, and copy shops. Black and white laser printers, on the other hand, have gotten fairly inexpensive over the last couple decades since they were invented. They use a process similar to photocopying to produce a sharp, waterproof grayscale image on the paper.

- **Inkjet printers** You used to be able to get black and white inkjet printers—all right, you still can, but the color ones are so cheap that almost no one bothers. In fact, inkjet printers are so inexpensive, as computer hardware goes, that they're practically on a par with Cracker Jack prizes. They print by spraying tiny droplets of colored ink onto the paper in those four primary colors discussed previously: cyan, magenta, yellow, and black. In the last few years, we've seen photo-quality inkjets enter the market—devices that produce such high quality images that their printouts can hardly be distinguished from darkroom-produced color photos. We've assumed throughout this book that most of you are using color inkjets, because they're so cheap and easy to get.

- **Other color printers** There are other color printing methods, such as dye sublimation and solid ink. If you have a printer of one of these types, you may not be able to use some of the special printing media, such as T-shirt transfers, that we talk about in this book, but you'll certainly be able to print fabulous colored images—and that's what it's all about.

All About Substrates

The substrate is the bottom layer. For printing, obviously, that's the paper. Or the fabric. Or the plastic. Or . . .

In general, you want your printing to produce true results; the reds need to be red and the greens need to be green. If your substrate is opaque, the whiter it is the more accurate your colors will be. Most papers these days come with a whiteness rating. (Whiteness, which is measured across the whole visible spectrum, isn't the same as brightness, which is measured at a very narrow band of blue.) A whiteness rating of 100 or better indicates a very white paper, while a rating of 80 or lower indicates a paper that is visibly less white. Papers that are less white will subdue your colors, just as a white shirt that hasn't been bleached will look dingy.

Sheet Paper

As we said in Chapter 1, "Recipes for Images: Start with a Photo," the kind of paper that will work best for you is determined by the kind of printer you're using. We described laser printer paper and inkjet paper and explained why they're different.

A compromise is available; it's called general-purpose paper. The label says that it's for laser or inkjet printing. Well, sure, it is—if you want less than the best results. Because it's a compromise, general-purpose paper

yields results that are okay but not outstanding. For really high-quality printing, choose paper designed specifically for the kind of printer you have, and then go the extra step to "tune" the paper to your purpose. (If you're printing photographic images, as we will be in this book, think about using paper designed just for that use.)

Dye-sublimation printers require special paper that costs more than even high-quality photographic paper for inkjets. The quality you get from dye-sub printers is spectacular; but save it for the special times when you really need it.

You're probably not going to want to invest in one, but you can buy printers that will print on sheets larger than letter or legal size. If you need to print a big wall poster, your local graphics service (Kinko's, AlphaGraphics, and so on) probably has a printer than can handle sheets 24" × 36" or bigger for you. Be sure to ask them what file formats they can accept before showing up on their doorstep with your Zip disk in hand!

Whatever paper you choose, make sure the sheets will fit into your printer's input tray—and that they will feed through the printer. You don't want to invest in a ream of high-quality 110-pound card stock only to get home and find that your printer balks at anything heavier than 90-pound stock.

Roll Paper

Some printers can accept roll paper. This stuff is perfect for printing that special going-away-party banner for the worker who just retired, or for your kid's special birthday party, or for any other use where a very long printout is needed. If your printer can't handle rolls, it may be able to accept fanfold paper that isn't perforated. This will let you make nice long banners, as long as you don't care that the paper has folds every few inches. Get creative—figure out a way to work accordions (dancing? polkas?) or pleating (sewing? home decoration?) into the theme, and you'll be able to exploit the way the paper comes instead of lamenting about it!

Fabric

With fabrics, even more than with paper, you have a great opportunity to integrate your images with other design elements—start by visiting a local fabric shop's quilting department, and think about ways to weave your stuff in with the gorgeous printed cottons you'll find there.

Plastics

Paper and fabric offer a broad range of possibilities, but there's more. Leaf back to Chapter 1, and you'll find a list of places to go for refrigerator magnets, clear plastic transfers, even Shrinky Dinks.

Special Inks

Now that we've gone on for a couple pages about substrates, we'll just offer a few sentences about inks before sending you off to learn how to make Web images. You already know you can buy two kinds of inkjet cartridges: manufacturer brand-name ones and recycled or generic ones. But did you know you can buy edible ink? Yup—it's what bakeries use to print on edible paper so they can put photos on cake tops. And you can do the same— check it out at www.tastyfotoart.com. Or see www.ink4art.com for other kinds of specialty inks, including fun fluorescent colors!

Creating Web Images

Putting your photos on the Web can be very rewarding, not only because it gives you the chance to show them off to the world but also because you don't have to limit yourself to putting up photo albums. You can integrate your images into the design of your site to enhance it by making it more useful and attractive. Most commercial Web sites are a blend of images and text, and there's nothing (except perhaps a lack of time!) to prevent you from giving your own site the same treatment. If you're interested in seeing how Richard has used many of the techniques we'll talk about in this book, we encourage you to visit his Web site at www.richardspens.com.

File Formats Revisited

The Web is a tremendously empowering resource. But it's also limiting. One of the most noticeable limits is that it takes time to download a Web page into your browser. And a page that's covered with big images can take a very, very, very long time. The best Web sites are designed with small images, used judiciously. Another significant limitation, one that you will quickly run into head-on, is that browsers can't handle the hundreds of existing file formats. You can't just upload your PHOTO-PAINT images directly to the Web, at least not if you want anyone to be able to view them.

So what formats can you use on the Web? All browsers since the very first version of NCSA Mosaic have been able to display GIF and JPEG images, and most browsers today can also read PNG (Portable Net Graphics). Each of these formats has some advantages and some disadvantages.

Having listed GIF, JPEG, and PNG as the usable Web graphics formats, we'll add that most computers these days have QuickTime software installed, and it's a free download for those that don't have it (quicktime.apple.com). With QuickTime, your browser can view formats that would otherwise be foreign to it, including Windows BMP, QuickTime movies, TIFF, and more. But we recommend that you stick with the Big Three, because other formats don't serve the need for speed as well as they do. BMP, for example, isn't compressed, so a photograph that might be 100KB as a JPEG could be more than 2MB in BMP format.

Optimization and Image Quality

On the Web, it's always a delicate balance between image quality and downloading time. Images of very high quality take longer to load than images that are not so exact. The first step in beating the trade-off is to compress your images; that is, to store them in less space than they would normally require. Your image editor compresses images by applying various kinds mathematical manipulation. For example, suppose you have an image that is 256 pixels square, with its upper half white and its lower half black. If you used this image as a Web page background, it would produce broad horizontal stripes. It would also be hideous, but let's overlook that for a moment. Suppose you created this image with a 256-color palette. Each pixel would require 8 bits (1 byte) of information to tell the browser what color that pixel is. So your image would require 65,536 bytes of information, one byte for each pixel.

Now let's look at a very simple way to compress your image. You can observe that the first row has 256 identical pixels. So you could tell the browser what that whole row of pixels looks like using only 2 bytes of information, one to specify the color and one to specify the number of adjacent pixels that are that color. Extend this scheme to the whole image, and you can compress your 65,536 bytes of information down to 512 bytes, 2 for each of the 256 rows, without losing any information at all. You'd actually need a few more bytes to tell the browser how many pixels are in each row, so that it would know how many bytes to read to figure out the number of adjacent pixels, and another few to describe the color palette. Figuring out ways to store more information in less space like this is the principle of data compression, and what we have just described is the actual method by which GIF images are compressed.

JPEG Compression

JPEG is a compressed image format that was devised specifically for photographs, which can have millions of colors. Like music, photos rarely require 100-percent fidelity of reproduction; some reduction (loss) of image quality is acceptable. JPEG, therefore, is a "lossy" compression scheme, and you can control the amount of loss by specifying how much compression to apply. The more you compress a file, the more chunky the fine detail becomes. Also, if you zoom way in on a JPEG image, you may see a bright "halo" around a dark object that is silhouetted against the sky or a light-colored wall, or you may see a splattering of dark pixels in the sky, right next to a dark object. These distortions are called "JPEG artifacts." Some image editors have features to remove JPEG artifacts from your images if your camera stores pictures in JPEG format.

GIF and Color Maps

While JPEG was developed to work with photographs, GIF was invented as a format for compressing artwork that has a limited color palette. GIF images are limited to 256 colors, but you can also create GIFs with 128, 64, or fewer colors, all the way down to 2! The smaller the palette, the smaller the file. Naturally, if you create images with only 16 colors, the results aren't going to be very impressive on photographs—and even then, you're really abusing the image format. Because GIF works best with large areas of uniform color, a GIF image of a complex photo won't be very well compressed; generally, it'll end up being larger than a fairly high quality JPEG of the same image. Most image editors that can save in both GIF and JPEG formats will give you options for viewing the results of your format choices and the file size that you'd get with each choice.

You can often improve the final result with a GIF image by exercising control over features such as dithering (described a little later) and the contents of the palette, or color map. Different palettes, such as perceptual and Web, will give remarkably different results. (The Web palette is limited to 216 colors.)

PNG, an Alternative to GIF

GIF is a patented file format, and programmers who write programs that create GIF images must pay royalties to the patent holder, Unisys Corporation. A group of programmers who were unwilling to pay these royalties created an alternate format called PNG, which they released free of charge. PNG shares some features with GIF, including 256-color palettes, but PNG is also capable of using a true-color palette (16 million colors). When you buy an image editor that can create GIF images, the royalty has

already been paid whether you ever create a GIF file or not, so you might not see the value of using PNG just to avoid using GIF, especially since some older browsers cannot display PNG images. Most other people haven't seen the value of it, either, which is why PNG isn't very popular.

Dithering

In the previous section, we mentioned the limited color palette of GIF images. One technique that you and your image editor can use to work around that limitation is called *dithering*. When you dither an image, you place pixels of different colors next to each other in a pattern like a checkerboard. When you view a dithered image at a reasonable distance, your brain will blend the adjacent colors so that you see a third color. You can verify this feature of your brain very easily by looking at your computer monitor screen with a good magnifying glass. You'll see nothing but red dots and green dots and blue dots; but when you back away, those three colors—in varying amounts—produce all the hues that your screen can display. Most image editors can dither a 256-color palette in this way to yield an image that looks as if it has far more colors than are really there.

Progressive Images

When you view a Web page, you want to know as quickly as possible what the images on the page look like. It takes time to download an image of any significant size, though, so you're often left waiting. (Which is one reason we remarked earlier that the best sites use small images.) But most good image editors can generate *progressive* images, which appear to load much faster without actually doing so. In a progressive image, the rows of pixels are ordered differently so that a browser can display a coarse image by showing alternate rows, filling in the gaps by duplicating the rows that it has already used, and then progressively fill in with the right rows as they become available. Suppose we make a five-pass GIF that is 32 pixels square. This image file is stored so that the rows are in this order:

Pass 1: rows 1 and 17
Pass 2: rows 9 and 25
Pass 3: rows 5, 13, 21, and 29
Pass 4: rows 3, 7, 11, 15, 19, 23, 27, and 31
Pass 5: rows 2, 4, 6, 8, 10, 12, 14, 16, 18, 20, 22, 24, 26, 28, 30, and 32

Figure 2.4 shows how the browser will display the image step by step. As you can see, it's possible to get an idea of what the image will look like long before you have all of the information it contains.

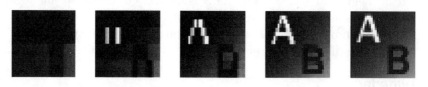

Slicing Images

If you've spent any significant time on the Web (and who hasn't, these days?), you're bound to have noticed that some pages use a large image with a few small areas that work like buttons. For example, suppose you're at an auto parts supplier's site. The page you're viewing shows a picture of a car. You move your mouse over a wheel, and the wheel glows. This is actually a concealed button, and if you click it, your browser goes to a page selling tires and wheels. But wait a minute! Big images take a long time to load, and if they had eight buttons, they'd need eight separate images, right? Wouldn't that take just about forever to download every time the image needed to change? Nope, there's a better way.

You can chop up a large image into several smaller ones, and you've seen this technique used—when that picture of a car was downloaded, some pieces came in before others; the picture had to be built up out of smaller blocks. This technique is called *slicing*, and each of the little building blocks is a slice. You could slice a 256-pixel square image into 16 slices, each 64 pixels square, for example. But how can you control where the browser will place all these little bits and pieces? Here's where you use the browser's ability to format data into tables. If you specify a table of four rows and four columns, with no space between the rows and columns and no padding within the individual table cells, you can then fill each of the table cells with one of the small graphic files, and the browser will automatically display them all exactly the way we want them. Figure 2.5 illustrates this technique.

Rollovers

But why would you want to slice up your images? The browser still has to download all the data before the full image is displayed, doesn't it? Yes, it does, and it usually takes longer to download a bunch of slices than it does to download a single big image. But we use sliced images to create those buttons that don't look like buttons (called "rollovers"). If you look at Figure 2.5 again, you'll see that one of the duckies is different. This is done by creating a modified version of our original image, with just that ducky different. We sliced the original and also sliced the modified version. Then we placed some JavaScript code into the table so that when the user clicks on the ducky we set up as a rollover, the browser will replace that slice

Find the Winning Duckie!

Click on a duckie! If you pick the right duckie, he will light up!

Chances $1.00 each

All proceeds go to charity!

Local machine zone

FIGURE 2.5

Here we are displaying a 256 pixel square image on a Web page. We have created two tables, one with space between the cells to show you the slices of the image and one with no borders to show you how the image looks normally.

with the lit-up ducky slice. It all happens in the length of time required to download only the replacement slice, and there are even ways to make the user's browser download the extra slices before they're used so that the change can happen instantly.

flash

Don't slice images just because you can. As we've pointed out, downloading sliced images is slower than downloading single files, but sometimes a sliced image can seem to download faster than a large image in one piece. When in doubt, experiment: create a large image and a separate sliced version, upload both to your Web site, and compare the experience. Does the large image seem like a longer wait? If so, use the sliced version.

Many image editors can slice images, and some can even save the proper HTML and JavaScript to insert into your Web pages. We're not going to teach you how to be a Web wizard in this book, but you will be able to use our image editing techniques to make your own Web pages really sparkle.

Patterns, Textures, Filters, and Backgrounds

3

Making Your Images "Touchable"
Creating Patterns and Textures

LIFE is full of texture. Everything we look at, everything we touch, even everything we taste has texture—it's what makes objects look real. For 3D animators, the search for ways to create realistic textures and apply them to animated objects occupies a good portion of their working days. For Web designers, a subtle texture in the background of a page makes that page seem less like something that exists in the cold, sterile, unreal world of the computer and more like a place people might want to spend some time. And for us, surface texture is a way to build our photos into something more than flat arrays of pixels. With texture, we can give our images life, dimension, and realism.

In this chapter, you'll look at two kinds of textures: those you create from scratch, and those you create from photos. And we'll show you a way to turn a finite swatch of image into an infinitely repeating background. We've placed the images used in this chapter on our Web site so you can download them and work along. You'll find them here: www.getcreativebook.com.

The examples in this chapter use Jasc Paint Shop Pro, but you can complete them using any image editor with a basic set of filters, such as emboss, add noise, blur and sharpen, and the most common editing tools, including the Clone Brush (or Clone Stamp). The names of some filters and commands may vary, but the dialog boxes and settings in any program will be very similar to what you'll read about in this chapter.

Creating Surface Textures

If you take a tour of the Web, you'll find that you're not the first person to have the idea of creating textures. And, if you're like us, you'll make use of textures you find out there. What's more, there are probably dozens of patterns and textures built into your image editor—Paint Shop Pro has a potful, and we like a lot of them. But it's fun—and easy—to create your own textures for those occasions when the ones somebody else has made just aren't quite right. We're going to start out with five textures that you can make from scratch in a matter of minutes without even using any of Paint Shop Pro's editing tools, and after we show you how to make them we'll show you a few ways to use them as components of images that use your photographs. Once you get started, it's easy to get wound up in creating lots of textures, but this *is* a book about digital photography, after all! You can see all five textures on our Web site at www.getcreativebook.com.

focus

All of the textures you'll make in this chapter are designed to display well on a computer screen, and they will also print surprisingly well at 72 dots per inch (dpi) on a good printer. If you need to print your textures at a higher resolution, you can resize the final images to 4 times the size we make (a 300 by 300-pixel document would become 1200 by 1200 pixels) and set the resolution to 300 pixels per inch. That will make a texture swatch that prints out at 4 inches square. In Paint Shop Pro, you do this by choosing ➤ Image Resize. Click the Actual/Print Size radio button, choose Inches from the X and Y pop-up menus and Pixels/Inch from the resolution pop-up, and enter the size and resolution you want. Then click OK.

Making Brushed Metal from Scratch

Look around you almost anywhere, and you're almost sure to see something with a brushed metal finish. It might be a brass desk accessory or the cap on a rollerball or fountain pen or a heavy aluminum pot in your kitchen. Brushed metal is popular in the real world because it's easy to care for. (It doesn't show fingerprints as readily as polished metal.) So let's make some brushed metal. Ours won't require a lot of maintenance either, and we think you'll find ways to put it to use. Follow these steps:

1 In the Color palette, click the left swatch at the top of the palette to choose the foreground color, and set the color picker controls to Hue: 150, Saturation: 20, Lightness: 225.

By default, the Color palette is docked along the right side of the Paint Shop Pro window, but you can undock it if you'd rather have it floating.

2 Click OK.

3 Create a new document 300 by 600 pixels in size, using the Foreground color for the image's background. You can create your document a different size if you want, but it must be twice as tall as the finished brushed metal will be, and the final document will be 300 by 300 pixels. Here's the dialog box:

New Image	✕

Image dimensions

Width: 300 Pixels

Height: 600

Resolution: 72.000 Pixels / inch

Image characteristics

Background color: Foreground Color

Image type: 16.7 Million Colors (24 Bit)

Memory Required: 527.3 KBytes

OK Cancel Help

4 Choose Effects ➤ Noise ➤ Add. Set the values to 100 percent and Uniform. Click OK.

5 Choose Effects ➤ Blur ➤ Motion Blur. Set the Blur to 40 pixels, at a 270-degree angle, then click OK. These are the settings:

Motion Blur	✕

Zoom 1:1

Direction

Angle: 270

Intensity

40 Pixels

OK Cancel Help

6 Choose Effects ➤ Sharpen ➤ Unsharp Mask. Set the controls to Radius 2.00, Strength 500, and Clipping 2. Click OK.

7 Choose Colors ➤ Colorize. Set the Hue to 160 and the Saturation to 25 percent and click OK. The dialog box looks like this:

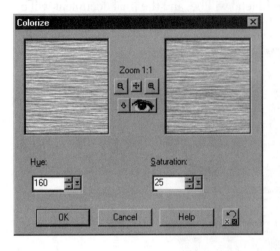

8 Choose Image ➤ Resize. Uncheck the Maintain Aspect Ratio check box. Click the Pixel Size radio button, and resize the image to 300 by 300 pixels. Click OK. Figure 3.1 shows a high-resolution version of the final image.

That's it. You may wonder why we colorized our metal instead of using a grayscale image—after all, we're making a "silver" metal, aren't we? We did it this way because most real silver-colored metals aren't really perfectly

FIGURE 3.1

Brushed silver metal looks more realistic with a bit of blue sheen added.

gray to start with, and when you put them into the real world they pick up additional color from their surroundings. Since daylight is usually bluish, we used a bluish cast for our metal. We've found through experience that a blue that leans just a little toward purple produces a very satisfactory result that looks more lifelike than a plain grayscale version. To judge for yourself, you can just desaturate your image (choose Colors ➤ Grey Scale). If you like the result better than ours, save yours. If not, undo the desaturation and save the colorized version.

This particular brushed metal is moderately dark; it looks more like steel than aluminum, for example. But it's versatile. You can easily adjust the brightness and contrast, hue, saturation, and levels to produce brass, gold, copper, silver, aluminum, and other metals.

Making Wood from Scratch

Another material that's all around you, although not as much as it used to be, is wood. Sadly, many of today's wood surfaces are actually plastic with a wood grain texture applied, but at least we're not cheating too terribly much by deciding to make some fake wood of our own. Woods come in many colors and with many different grains. One of the easiest to make is varnished golden oak. Follow these steps:

1 In the Color palette, click the left swatch at the top of the palette to choose the Foreground color, and set the controls to Hue: 170, Saturation: 15, Lightness: 120. Click OK.

2 Create a new document 50 by 3000 pixels in size, using the Foreground color as the background of the new image.

3 Choose Effects ➤ Noise ➤ Add. Set the values to 50 percent and Random, and click OK. Here's what your settings should look like:

4 Choose Image ➤ Resize. Uncheck the Maintain Aspect Ratio check box. Resize the image to 1200 by 768 pixels. Click OK.

5 Now chop off the two sides of the image. Choose Image ➤ Canvas Size. Set the size to 1024 by 768 (or any smaller size), and be sure both the Center Image Vertically and Center Image Horizontally check boxes are checked. Paint Shop Pro sometimes stretches the left and right sides of a resized image too much, so we use this two-step method of getting our image to the final size.

6 Choose Effects ➤ Sharpen ➤ Unsharp Mask. Set the controls to Radius 2.0, Strength 500, and Clipping 18. We know this mess doesn't look much like wood yet, but hang in there. This is what the settings look like:

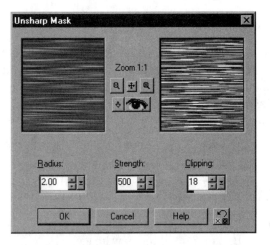

7 Choose Colors ➤ Adjust ➤ Levels. Drag the sliders on the lower scale to set the output levels to 102 and 204. This is another way of reducing contrast; we use it because it gives us more precise control than changing contrast and brightness separately.

8 Choose Colors ➤ Adjust ➤ Hue/Saturation/Lightness. Check the Colorize check box and set the controls to Hue: 35, Saturation: 50, Lightness: 0, then click OK. The final texture is shown in Figure 3.2.

And there it is, a nice panel of varnished golden oak under a bright light that picks out the highlights in the grain. You can make stained Philippine mahogany using the same technique; all you need to do differently is change the settings in Step 8 to produce a darker, redder hue as we did for Plate 3.1. (Try Hue: 15, Saturation: 60, Lightness: –60.) The colors you like to see in wood are a matter of personal taste, so feel free to experiment. (Just for the record, Paint Shop Pro has several very nice woods in its texture selection, but the two we've made here aren't there.)

FIGURE 3.2

Your wood can be any color you like, once you've created the basic texture, with a little Hue/ Saturation/Lightness manipulation.

Making Stucco from Scratch

Another useful texture, one that you won't use too often to cover the walls of a house but which you can use for a wide variety of other things, is stucco. The fact that we call it stucco, however, doesn't mean it's *only* stucco—it can be used to simulate a lot of slightly rough, uniformly colored textures. With this in mind, we've found more applications for a relatively smooth stucco than for the rougher varieties, so that's what you'll make. Follow these steps:

1 In the Color palette, click the left swatch at the top of the palette to choose the Foreground color, and set the controls to Hue: 30, Saturation: 50, Lightness: 108, then click OK.

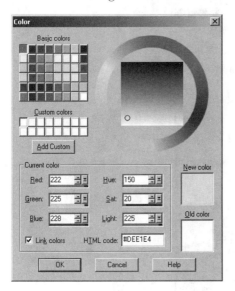

2 Create a new document any size you like, using the Foreground color as the background of the new image. Our document is 300 by 300 pixels.

3 Choose Effects ➤ Noise ➤ Add. Set the controls to 50 percent and Random. Click OK.

4 Choose Effects ➤ Blur ➤ Gaussian Blur. Set the control to 2.00 pixels and click OK. Here are the settings:

5 Choose Effects ➤ Texture Effects ➤ Emboss. There are no settings; this filter does its thing without any help from you.

6 Choose Colors ➤ Adjust ➤ Levels. Drag the sliders on the upper scale to set the Input Levels to 35, 1.0, and 150, and click OK. Your settings will look like this:

7 Choose Image ➤ Rotate. Click the Left radio button and the 90° radio button. Click OK.

8 Chose Colors ➤ Colorize. Set the controls to Hue: 30 and Saturation: 50 and click OK. Take a look at the results in Figure 3.3.

This is a basic putty colored stucco. Stucco was an especially popular wall finish during the Art Deco era, from 1925 to about 1940, because it was inexpensive and free from seams, cracks, and crevices (at least when it was new!). In places like southern Florida, where hurricanes are common, many buildings are made of concrete block for strength and are surfaced with stucco, and they come in all colors of the rainbow, from white all the way (honest!) to black, so you can feel perfectly justified in creating a mustard yellow or swimming pool green version of your stucco.

Making Sandpaper from Scratch

Yes, we know, sandpaper is already scratchy. But you can make it from scratch, too, and use it with your tools. Your image editing tools, that is. The most common kind of sandpaper is probably garnet paper, which has a red-orange color. Let's make some garnet paper. This technique is as easy as they come and uses filters that you've already put through their paces creating the preceding textures. Here's what to do:

1 In the Color palette, click the left swatch at the top of the palette to choose the Foreground color, and set the controls to Hue: 170, Saturation: 20, Lightness: 150. Click OK.

FIGURE 3.3

Stucco is a good all-around texture that makes a great background for just about anything.

2 Create a new document any size you like, using the Foreground color as the background for the new image. Our document is 300 by 300 pixels.

3 Choose Effects ➤ Noise ➤ Add. Set the controls to 50% and Random. Click OK.

4 Choose Colors ➤ Adjust ➤ Levels. Drag the sliders on the upper scale to set the input levels to 110, 1.0, and 165. Click OK.

5 Choose Colors ➤ Colorize. Set the Hue to 18 and the Saturation to 100, then click OK. Figure 3.4 shows the final texture.

And there's your garnet sandpaper. Or, if you're a car customizer who prefers wet/dry sandpaper, all you need to do differently is to set the color in Step 5 to Hue: 150 and Saturation: 50 and then choose Colors ➤ Adjust ➤ Levels and set the Output Levels to 0 and 127. Now where's that hammer and chisel?

Making Kitchen Counter Formica from Scratch

If you were around in the 1950s, you remember the hard shiny stuff that was on your mother's kitchen counter (Richard was, and he does). Today's counters are seldom shiny except after a lot of use, and they're almost always patterned very subtly if at all, but there's a nostalgic charm to the patterns they put on those old surfaces. They're easy to make, so let's make one. This is only one of a zillion different Formica patterns we've seen over the years. Follow these steps:

1 Create a new document any size you like, using a white background. Our document is 300 by 300 pixels.

FIGURE 3.4

You can try creating different varieties and grades of sandpaper with different Hue settings and more or less noise.

2 Choose Effects ➤ Noise ➤ Add. Set the controls to 50 percent and Random.

3 Choose Effects ➤ Edge ➤ Enhance. Here's what you'll get:

4 Choose Effects ➤ Texture Effects ➤ Fur. Set the blur to 0, the density to 90, the length to 11, and the transparency to 44, then click OK. Here's what the settings look like:

5 Choose Colors ➤ Colorize. Set the Hue to 150 and the Saturation to 30. Click OK. Your result should look like Figure 3.5.

You can stop here, or you can play further games. Try inverting the image (choose Colors ➤ Negative Image), then reapplying the colorization in Step 5, and finally setting the Output Levels to 64 and 255.

This is only the beginning of what you can do with textures. We've described a few slight variations on the basic textures we've created, but

FIGURE 3.5

Retro is in—and this Formica pattern is definitely retro. You can recolor it to be any of the myriad colors of the original countertops—we made ours turquoise—or invent your own.

you should feel free to experiment with all of the filters and effects in your image editor. Paint Shop Pro is especially rich with very good tools, but any program that can do the things we've done here should be able to do a lot more. And remember, you don't have to stick to realistic textures. You can invent space-invader-style neon-bright textures just as easily. This is one place where you can really go wild!

flash

Another way of adding realistic texture to an image is to scan real materials like fabric or metal or even frosted glass—anything that will fit on your scanner, in fact. For tips on getting the best results with this technique, turn to Chapter 15, "Hey, They Took My Camera! Making Good Pictures with Your Scanner."

What to Do with Textures

Now that you've got all these textures, what can you do with them? Time to get creative. You can combine photos and textures in millions of ways. This section shows a few of the projects we've created using textures.

Making Backgrounds

The most obvious (and easiest) way to use textures is as backgrounds. You can use them for wallpapers, Web pages, and countless other applications. We used our brushed metal texture to produce the desktop wallpaper image shown in Figure 3.6. It honors Richard's late father, Dr. Laurence O. Binder, who was a chemistry professor and a pioneer in curriculum improvement in math and the sciences. The image combines our brushed

metal texture with a photograph of Dr. Binder, a chemical formula that we scanned from an old encyclopedia, and some text. We applied inner beveling and a drop shadow to the text. For the formula, we applied a small inner bevel, but we found it necessary to duplicate the layer and then offset and blur the duplicate to make the drop shadow. (There's more about making good shadows in Chapter 14, "What Fools These Mortals Be: Creating Easy Trompe l'Oeil Images.") We used Paint Shop Pro's excellent Lighting control (choose Effects ➤ Illumination Effects ➤ Lights) to cast the spotlights.

For Web pages, you will probably want to create small blocks of texture and allow the user's browser to repeat them to fill the window. This is called tiling, and it's usually done because big images, while they are very pretty, can take a very long time to download over a slow modem line. And for an image that's a couple hundred kilobytes in size, even 56K is slow! To create backgrounds well using this technique, you'll need to create a texture swatch that will tile seamlessly to hide the edges between tiles; we'll show you how to make your textures do that a little later in this chapter in the "Creating Seamless Repeating Images" section.

Building Objects from Your Textures

Another way to use your textures is to cut them into pieces that you can put together to create trompe l'oeil images by combining them with real pictures. (We'll show you more about trompe l'oeil in Chapter 14, "What Fools These Mortals Be: Creating Easy Trompe l'Oeil Images.") Frames and borders are a common application for this technique. We used our golden oak and stucco textures to fabricate a picture frame around a childhood photo of Richard's father. Stucco? Yes. Remember, we said

FIGURE 3.6

With a brushed metal texture, you can make a photo look as though it's been printed on a metal plate.

earlier that giving a particular name to a texture doesn't mean that you can't use that texture for something different that just happens to look the same. We used our stucco texture to simulate mat board and our golden oak texture to create the frame. We applied an inner bevel to the stucco layer, and after we had constructed the frame we applied a different inner bevel and a drop shadow to it. As you can see in Figure 3.7 (and on our Web site), the final result is pretty convincing.

Applying Textures in 3D

You can go further and actually insert your textures into photographs so that they become real elements of the pictures. Sometimes this will require you to rescale or distort the texture fragment you use, but because many textures are fractal in nature, they will often fit well at nearly any scale, acquiring the necessary realism from the objects you associate them with. Here are two samples of how we've used some of our textures in this way. Figure 3.8 shows an 8.5" by 11" advertising handout we created for a pottery collectors' show. We photographed the pot on Richard's back stoop and then replaced the steps with our kitchen counter Formica. A quick levels adjustment on the step (no modification on the riser), a new cast shadow using the shape of the original shadow (which we saved as an alpha channel—choose Selections ➤ Save to Alpha Channel), a nice black border, and the image was ready for use.

Another easy texture application is the Web page banner shown in Figure 3.9 (it's on our Web site in color), using our garnet sandpaper as the surface of some 3D text, with a metallic gradient for the edge stroke

FIGURE 3.7

The only "real" part of this image is the portrait.

Hall Pottery
EXPO

65 Dealers
Snack Bar
October 19, 10:30 to 3:00
Elm Street Armory
Admission $5.00

FIGURE 3.8

This handout sheet features a Depression-era teapot from our collection.

on the letters. Here, we used Paint Shop Pro's Text tool to apply a texture fill to the page title text and laid in another of our textures to do a little virtual repair work on one of our tools.

Creating Seamless Repeating Images

The textures you created in the first half of this chapter are easy to make—but they're not easy enough that you'll want to make them again from scratch every time you need to use them. What if you could save them and apply them to any image? You could certainly save the images you create—but then what if you want to use a saved texture in an image that's not the same size as your texture file? Scaling it won't work—the texture won't look realistic if its details are too large or small, and that goes double if you have to change its proportions to make it fit.

FIGURE 3.9

In this image, we also slipped in a little piece of our brushed metal; the flat side of the plane was rusty, so we spruced it up a little.

That's where the concept of "tiling" can help you out. Tiling an image means repeating it enough times to completely fill a designated area. Of course, with most tiled images you're likely to see "seams" where the edges of each tile meet the edges of the adjacent tiles. Preventing that from happening, so that you can't see where one tile leaves off and the next begins (see Figure 3.10), takes a little care. Read on for a no-fail technique to create seamless tiles that you can use as backgrounds wherever you like.

Choosing an Image

You could start by creating one of the textures you mastered earlier in this chapter. But some of the coolest tiles are those that started out as photographs. You can take photos with tiling in mind, or you can look through the photos you already have and see which ones might lend themselves to tiling. These generally fall into three categories:

- Groups of small, similar items: leaves, pieces of candy, or even cheese puffs

- Objects you expect to see repeated: rows of shingles or nails, an aerial view of cars in a parking lot, or upholstery buttons on a cushion

- Unexpected objects: intertwined fingers, cuddling cats, or Escher-esque lizards

Whether you opt to start with a from-scratch texture or with a photo, the first thing you'll need to do is make sure your image is just the way you

FIGURE 3.10

If constructed carefully, a small tile image, such as these flowers that Kate shot at the Boston Flower Show (inset), can be repeated infinitely without its edges showing between repeats.

want it. Any changes you make to it after the seamless tile is completed could restore the seams, so the tile creation process should be the last thing you do with the image.

Making It Seamless

This process may seem complicated, but it's really not difficult. What you'll do is move the edges of the image tile to the inside so you can see them and smooth them out. Then you'll move them back out to the edges of the image and save the image so that you can use it as a pattern within Paint Shop Pro or as a Web page background or computer desktop pattern. To make things simple, we'll use a relatively homogeneous image of some healthy, green bushes that Kate took while antiquing in Springfield, Ohio (Figure 3.11).

1 Open leaves.tif and make any changes you feel are needed. For instance, your evergreens might need to be purple. We tend to be pretty conventional, so we'll stick with green. Feel free to modify the image in any way you desire, though—it's all yours.

2 Switch to the Select tool, then display the Tool Options palette and choose Square from the Selection Type pop-up menu.

3 Click and drag in the image to make a square selection of the area you want to use for your tile. If you want to move the selection box you've drawn, switch to the Move tool, right-click within the box, and drag it to where you want it to be.

FIGURE 3.11

These leaves will make a calming, naturalistic desktop wallpaper for one of our computers.

flash

When you're selecting the area for your tile, try to choose a relatively uniform section of the image. The more different colors and objects within the selection, the more work you'll have to do to make the tile seamless. "Flatter" areas are easier to work with, and their repeats are less obvious in the finished tiled texture.

4 Once the selection is positioned to your liking, choose Image ➤ Crop to Selection to delete the rest of the image.

5 Now you have a square image that contains the part of the original photo that you want to tile. But before you continue, you need to make the image an appropriate size for your purposes. In this case, you'll make the image a low-res file that you can use on-screen. Choose Image ➤ Resize and click the Actual/Print Size button. Set the Width and Height values to 3 and choose Inches from the units pop-up menu, then make sure the Resolution is set to 72 pixels per inch. Click OK.

flash

What size and resolution should you make your tile? That depends on what you want to do with it. Most computer monitors display 72 pixels per inch, so if you want to use your tiled pattern strictly on-screen, you should set the resolution to 72. For printing, stick with 300 pixels per inch. As for size, look at the size of the object on which you'll be tiling the pattern and figure out how many times you want the pattern to repeat. If you want to print a four-inch-square swatch of silk with 16 total repeats of your pattern, for example, then set the size to 1 inch square—which will give you four tiles across and four down on the final print.

6 Choose File ➤ Save As to save the image tile with a new name; browse to the folder in which you want to save it and give it a name that you'll remember. You're halfway there! Now you need to move those edges to the middle so you can clean them up. To do that, define this image as a pattern.

7 Press SHIFT+I to view the Image Information dialog box and make a note of the image's pixel dimensions. Ours is 216 by 216 pixels. Now click Cancel to close the dialog box.

8 Next, press CTRL+N to create a new image. Make its dimensions twice those of the pattern tile—in this case, 432 pixels wide by 432 pixels high.

9 Switch to the Flood Fill tool—what's known as the Paint Bucket in most programs. In Paint Shop Pro, you use the Flood Fill tool to fill a document or a selection with a pattern; if you're using another program, you may need to use another tool or command, such as Photoshop Elements' Fill.

10 In the Color palette at the right side of your screen, click and hold down the mouse button on the upper Styles swatch. From the little pop-up palette, choose the third option—Pattern. Then click the swatch to open the Pattern dialog box, where you can choose a pattern to use for your fill.

11 Click the Edit Paths button, then click one of the Browse buttons and navigate to the folder containing the image file you saved in Step 6. Make sure Enable This Path is checked under the path you've chosen, and click OK. Now click the arrow next to the pattern swatch in the Pattern dialog box and choose your pattern from the pop-up menu, then click OK. Here's what the dialog box looks like:

12 Click anywhere in the new document window with the Flood Fill tool. You'll see four copies of your original tile image appear in the window. Take a look at the seams between them. There they are, big as life—and right where you can get at them and clean them up. But before you go on to that step, choose Image ➤ Canvas Size and enter the dimensions of the original tile image (216 pixels square in our case), then make sure Center Image Horizontally and Center Image Vertically are both checked. Click OK. Now you have a tile that's the same size as the original; choose File ➤ Save As again and save this tile with a new name. Here's what it looks like:

13 Here's the fun part—and the part that we're going to leave largely to your imagination. The object of the game at this point is to get rid of the obvious seams running through the center of the tile image, and you can use a variety of techniques to do that. Here are a few of the ways we get the job done:

- **Paint Brush and Airbrush** If you have any artistic talent—or even if you don't, but you can stay in the lines—you can use these tools to draw in connections between objects on either side of a seam. Zoom way in, and use the SHIFT+click technique to draw short, straight lines as much as possible. You can also copy and paste bits of images from elsewhere in the image—we copied and pasted leaves to cover parts of the seams, and in Figure 3.10 we used bits and pieces of petals to rebuild flowers whose edges had been cut off by the cropping.

- **Clone Brush** Also known as the Rubber Stamp or Clone Stamp, depending on the program you're using, this tool enables you to copy bits of the image from one place to another. You'll want to use a smallish, soft-edged brush shape and go slowly. Use this tool to copy edges, in particular, from similar shapes, and then fill the edges in with colors from similar areas of the image.

- **Retouch** In Paint Shop Pro, this multifunction tool takes the place of such classics as the Smudge, Blur, Sharpen, Dodge, and Burn tools used in other software. All of these functions come in handy when you're trying to obscure seams. Again, go slowly and use Undo if you get a result you don't like. The Dodge and Burn tools are especially useful for lightening and darkening pieces copied from other areas of the image so that they blend in with their new locations.

Here's a look at our tile with its edges halfway eradicated, zoomed way in so we can see what we're doing:

flash

You may find it useful to lower the opacity of your tools, particularly the Clone Brush, so that the new pixels blend invisibly with the old ones.

14 Take special care near the edges of the image window so that you don't create discontinuities that will show up when you tile the image. If you can't avoid it, then repeat the offsetting process (Steps 6 through 11) and clean up any new seams that you've inadvertently created.

15 When you're satisfied with the image, that's it—you're done! Press CTRL+S to save the tile in the patterns folder you designated in Step 10. Figure 3.12 shows the final tile and a screenful of the pattern; you can see both in the color section in Plate 3.2.

In the next section, we'll look at a few ways you can use the tile you've created.

How You Can Use Tiled Images

With the image saved in the designated pattern folder, it will always appear in the Patterns dialog box so that you can use it with the Flood Fill tool to fill images or selected areas of images. But what if you want to use it outside of Paint Shop Pro? Here are two places you might want to use your image tile.

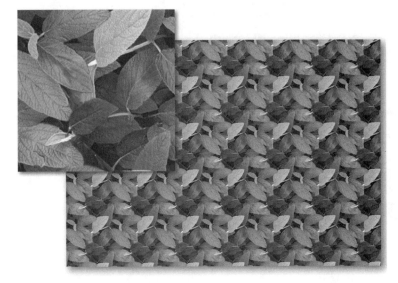

FIGURE 3.12

The final tile repeats effortlessly, with no visible seams. We'll use it for a desktop wallpaper in the dead of winter to remind us that the world will be green again in spring.

Tiled Web Backgrounds

In HTML, the language of the World Wide Web, you can specify an image to be tiled across the background of your Web pages. Usually, you can drag and drop an image into your page when you're creating it in a Web design program. Figure 3.13 shows what the HTML for a tiled background looks like, alongside the resulting page; head to our Web site (www.getcreativebook.com) to see the color version of this Web page.

To be able to display an image in a Web page, whether you're using it as a background tile, a logo, or any other kind of image, you'll need to save it in the correct format first. Although some Web browsers can display other formats, to be sure everyone can view your image you'll need to save it in either GIF or JPEG format. Use GIF for images with a limited number of colors, such as logos and graphs, and JPEG for full-color photos such as our evergreen image.

FIGURE 3.13

This Web page uses a brightly colored background pattern (confetti.jpg) that plays on the business's name to evoke playfulness and a sense of fun.

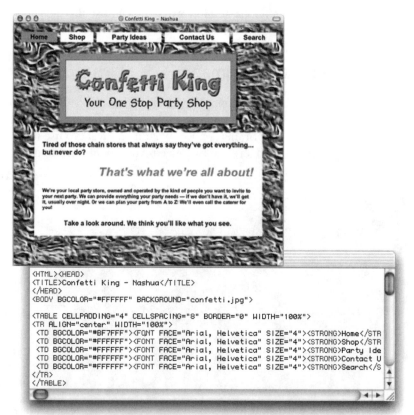

Tiled Wallpapers

While many people these days use full-screen photos as desktop wallpaper on their computers, sometimes a pattern is a better choice. With full-screen photos, you usually end up with areas that are too busy or too dark for your desktop icons to be easily visible over them. Tiled images, on the other hand, are consistent across the entire desktop, and you can create your tile to be dark enough overall (or light enough) that icons will be clearly visible, so your icons will show up clearly (see Figure 3.14). Here's how to use your tile as desktop wallpaper:

If you're running Mac OS X:

1 Choose Apple menu ➤ System Preferences and click Desktop.

2 From the Collections pop-up menu, choose Choose Folder and find the folder where your image is stored, then click its thumbnail.

3 From the pop-up menu under Current Desktop Picture, choose Tile.

If you're running Mac OS 9:

1 Choose Apple menu ➤ Control Panels ➤ Appearance and click Desktop.

2 If you already have a desktop picture, click Remove Picture.

FIGURE 3.14

Yum! McIlhenny Company of Every Island, Louisiana, offers free wallpaper tiles featuring its famous TABASCO® Sauce bottles and logos. Check them out at www.TABASCO .com.

3 Click Place Picture. From the Open dialog box that pops up, find the folder where your image is stored.

4 Click your image in the list to select it, then click Open. This returns you to the Appearance control panel.

5 Click Set Desktop and then close the control panel.

If you're running Windows XP:

1 Right-click the desktop and click Properties.

2 Click the Desktop tab, click Browse, and locate your image.

3 In the Position drop-down menu, choose Tile.

Earlier versions of Windows work almost the same way.

More Great Ideas

Now that we've reviewed the usual suspects, think about all the other places you could use a repeating pattern. Here are a few more ideas:

- Jazz up your next club flyer by giving it a tiled background pattern. To create a lighter area where the text will be, select the area and fill it with white at partial opacity. Our color garden tour announcement, shown in Figure 3.15, "pops" much more than the previous year's black and white photocopied version—and you'll be amazed to find out how inexpensive color printouts are at your local copy shop.

- It's easy to make your own gift wrap with your inkjet printer. First, create a new image file the same size as the largest sheet of paper your printer will take. Then it's time to get creative! You can repeat a single image over the entire sheet by copying and pasting it, or you can work with one large image and embellish it with filters, text, or bits and pieces of other images—let your creativity run wild! One caveat: Keep in mind the size of the present you're going to wrap, so that you don't end up with a big image that can't be seen because it wraps all the way around the package. If you do want to wrap a big package, try using legal paper or even roll paper, if your printer accepts it.

- Print your pattern on silk or cotton with your inkjet printer and sew with it—make a throw pillow stuffed with spices, a patch pocket on your silk

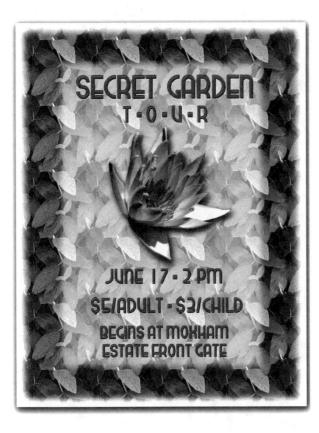

FIGURE 3.15

These leaves make the perfect botanical background for our tour flyer; see it in color in Plate 3.3.

bathrobe, or a drawstring bag to store your stuff in. Add it to a quilt! Make it into a checkbook cover! The possibilities are endless, now that you're not limited to the patterns you can find at the fabric store.

- Use a strip of the pattern as a vertical accent on a Web page. Open the image and use the Eyedropper tool (or the equivalent in your software) to choose coordinating colors from it that you can use for the text and other elements on the page.

- Create a set of cool nesting boxes by wrapping them with a funky pattern. You can use them as gift boxes, jewelry boxes, or just as a display piece.

- Decorate your own votive candle cups by covering them in beautiful patterns printed on backlight film. Make sure you put the film on the outside of the cups, rather than the inside next to the candle.

4

Out of Thin Air
Creating Backgrounds from Scratch

WE have to confess, we've never been fans of walk-in portrait studios. You know the ones—you dress the kids up, drag them to the mall, and stand in line for an hour while waiting for the photographer. Then you get to choose a background and stand in front of it while hoping that the kids aren't crossing their eyes or sticking out their tongues behind your back. After all, Grandma would really like to have a *nice* photo of the family this year.

There is one aspect of those mall photo studios that we like, however—the backdrops. They enable you to transport your family to Venice, a farmyard, a sylvan glade, or anywhere else that strikes your fancy—what fun! Portrait photographers have traditionally placed their subjects in front of artificial, stylized backgrounds, whether painted or made up of props. Take a look at the mid-nineteenth-century portraits in Figure 4.1, for example; these two photos feature just enough background to suggest a setting for the subject. In many cases, early backgrounds such as these were also intended to

> We created the projects in this chapter with Jasc Paint Shop Pro, but you can use your favorite program as long as it has a few basic filters—such as Gaussian Blur and Add Noise—and some essential image adjustment features, including a levels command.

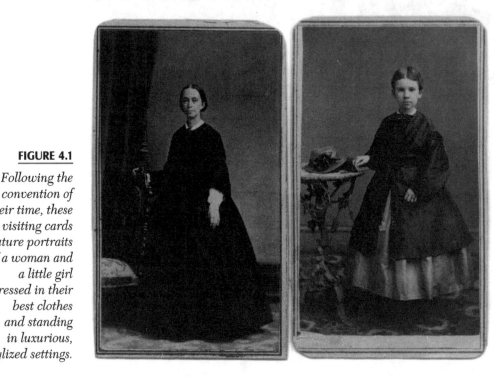

FIGURE 4.1

Following the convention of their time, these visiting cards feature portraits of a woman and a little girl dressed in their best clothes and standing in luxurious, stylized settings.

make the people pictured look wealthier or more sophisticated than they really were.

Exchanging visiting cards, or cartes-de-visite, was one of the great fads of the latter half of the nineteenth century. Slightly larger than modern business cards, cartes-de-visite were printed on heavier cardboard than photos today and were taken with special cameras that made multiple simultaneous or successive exposures. Photos of famous people were also popular, and some photographers made a mint selling these inexpensive souvenirs to collectors, who kept them in special albums. Varied backdrops and props were vital equipment for photographers who produced cartes-de-visite.

Most of the time, however, the idea is simply to provide some visual interest and a context for the subject without distracting the viewer—you don't want your background to be more interesting than the person in front of it, after all. And the possibilities are endless, from unobtrusive damask drapes to faux landscapes of every description. Of course, most

photo studios don't have that many choices—and that's where your computer enters the picture (so to speak).

focus

100 years ago, Sears, Roebuck & Co., and their competitors sold photo backdrops. The 1907 Sears catalog offered backdrops hand-painted in oil on muslin, in a variety of styles; prices ranged from 75 cents for a 4-foot-square clouded backdrop to $11.80 for a 12-foot by 15-foot scenic backdrop with a floor extension. For scenic drops, the purchaser could even specify whether the light in the painting was to fall from the right or left side.

If your candid photos look anything like ours, you have lots of images of great subjects with boring, distracting, or just plain ugly backgrounds. Fortunately, with a little creativity it's easy to remedy this problem by creating and inserting your own custom backdrops. In this chapter, we'll show you how to make background images, and then we'll offer a few suggestions for making sure your foreground images blend in nicely with their new backgrounds.

flash

To insert an image in front of a faux background, you'll first need to silhouette the image—in other words, you'll need to get rid of the background it's starting out with. To learn about silhouetting, turn to Chapter 11, "No Scissors, No Paste: Creating Elements for a Photomontage."

Making a Curtain Call

Rich draperies are a timeless backdrop used by portrait photographers and painters alike, and they're surprisingly easy to fabricate when you apply a Warp filter to a carefully constructed gradient. Follow these steps, and you'll see what we mean.

1 First, create a new document 1280 pixels square. Set Resolution to 300 and Image Type to 16.7 Million Colors (24-bit), and don't worry about the Background Color setting.

2 Next you'll need to create a gradient to form the vertical folds of a curtain. Click and hold the Foreground pop-up menu to switch to Gradient mode, then double-click the gradient swatch to open the Gradient dialog box. Click Edit to display the Gradient Editor

dialog box. Here's where you'll do most of the heavy lifting for this project, and the idea is to end up with settings like these:

3 Refer to the software documentation to brush up on creating gradients, if you need to. The point to keep in mind is that you'll need to make a gradient with several alternating color stops as shown in the illustration. Click OK to return to the Gradient dialog box when you're done creating the gradient.

flash—

If you're not in the mood for tweaking your own gradient, you're in luck. We saved the settings from our radient; you can download the file (curtain.grd) at www.getcreativebook.com and import it into Paint Shop Pro to save some time.

4 To apply the gradient, click the Linear Gradient button in the Style area, make sure your new gradient is the one selected—the swatch shows how it will look in your image—and change the Angle to 90 so that the curtain will hang vertically. Then click OK to return to the image. Switch to the Flood Fill tool and click in the image to fill it with the gradient (see Figure 4.2).

FIGURE 4.2

If you like plain, straight drapes, you can stop at this point.

5 Now, to draw the curtains back with an artistic swoop, choose Effects ➤ Geometric ➤ Warp and enter these settings:

Warp ☒

Zoom 1:10

Center offset
Horizontal: -100
Vertical: 100

Settings
Size: 100
Strength: -60

OK Cancel Help

flash

For the specified Warp settings to work, your image must be square. If your image isn't square, you'll need to experiment with the sliders in the Warp dialog box to get the same effect.

6 The curtain's drape is starting to take shape. To bring it completely into line with our vision, apply the Warp effect again, only this time with Vertical set to 60, Size set to 50, and Strength set to –70.

7 Switch to the Freehand tool and use it to select the wall behind the curtain. Start by clicking anywhere in the shadow area below the edge of the curtain, then click again to make "corners" for your selection and work your way around the edge of the visible wall until you're back where you started.

flash

If you make your document window bigger than the image, you can click outside the bounds of the image to be sure you aren't leaving any bits along the edge unselected.

8 Now you can change the wall to a color that contrasts with the curtain color. Choose Colors ➤ Adjust ➤ Hue/Saturation/Lightness and make these settings:

These settings yield a deep burgundy that complements the gold curtain. Click OK to change the color.

9 Choose Selections ➤ Invert so that the curtains are selected, then choose Effects ➤ Artistic Effects ➤ Brush Strokes. With this painting effect, you can produce a textile effect—in other words, you can make the smooth curtains look as though they're made of brocaded fabric. Here are the settings we used:

Brush Strokes ☒

Zoom 1:1

🔍 ✛ 🔍
⬇ 👁

Strokes
Length: 5
Density: 10

Presets:
Last used ▾
Save As... | Delete

Brush
Bristles: 100
Width: 10
Opacity: 10

Softness: 5

Lighting
Angle: 40 🖌
Color: ▮

OK | Cancel | Help | ↺✕▣

flash

Don't forget, you can see what effect your settings will have on the whole image by clicking the Preview button in any dialog box—that's the button with a large eye on it.

After clicking OK to apply the effect, choose Selections ➤ Select None to drop the selection.

10 Now you need to create a tie-back for the curtain—something to hold its folds back in the position you've put them in. Start by choosing

Layers ➤ New Raster Layer, then click OK in the dialog box to create a new layer. Switch to the Paint Brush and make these settings in the Tool Options palette:

11 Set the Foreground color to R: 104, G: 74, B: 12 and click anywhere in the image to create a single stroke of the paintbrush. Then choose Effects ➤ Artistic ➤ Topography and set the Width to 88, the Density to 22, and the Angle to 340. Click OK, and you'll see that the tie-back looks three-dimensional. Switch to the Move tool and drag the tie-back into position, as shown in Figure 4.3, and you're done.

Of course, you can choose any colors you like for the curtain and the wall behind it, and feel free to try other effects filters on the curtain to change the fabric's texture. Once your curtain background looks just the way you want it, you can silhouette your portrait subject and copy it into the curtain image. You can see a few of our friends in front of this classy background on our Web site at www.getcreativebook.com.

FIGURE 4.3

Once the tie-back is in position, the drapes look much more realistic.

Other Settings

Remember how we started out talking about the endless possibilities for creating and using your own backgrounds? It's true, there are myriad ways to jazz up your photos by swapping out dreary, cluttered backgrounds for neat, exciting ones you create yourself—but we don't have room to show you all of them here. That's one of the disadvantages of traditional publishing; we keep running out of pages before we have a chance to show you all our ideas.

For example, we created a really snazzy starry sky using Add Noise, Levels, and a few other standard filters, topped off with a single application of the Sunburst effect to add a supernova in a far corner of the cosmos. Check it out—you can see this backdrop combined with a photo of one of our friends on our Web site.

Another cool effect is to transport your subjects to the beach, complete with sand, waves, a serene blue sky, and a blazing sun—sounds like fun, right? We did it by dividing our image into three areas—the beach, the water, and the sky—and filling two with different-colored gradients and one with a solid color. We applied a few filter effects to get the right textures, and we added another Sunburst to create a warm, golden sun in the sky. You can see the results on our Web site.

Fortunately, we do have a Web site—as you've probably noticed by now—and that's where you'll find some of our favorite techniques that didn't make the cut for this book. We've put up step-by-step directions for creating the starry sky and the beach, as well as the gradient settings files, at www.getcreativebook.com.

Combining Photos and Settings

Light, shadow, and edges are the three keys to successfully combining a foreground image with a background image. You want to make sure the light in both images is the same color and intensity and that it comes from the same angle. To underline this effect, the shadows in both images must be the same density and shade, and they must appear on the same side of the objects casting them. Finally, you'll want to avoid sharp, jagged, or uneven edges around the foreground object that make it stand out too much from the background. Here are a few specific tips to help you get great results:

- Use layers whenever possible. Put your background on a layer, then add your subject on a different layer. If you're getting creative by

inserting props, put those on layers too. That way you can hide and show layers to judge the impact of your composition in different configurations, and you can also add layer effects such as drop shadows.

- Something to watch out for when you create simulated photo backdrops is that the lighting you create in the backdrop should correspond to the lighting in the picture of the person you're putting in front of the backdrop. If Aunt Nellie has bright sunlight shining on her face, it wouldn't look cool to give her a backdrop like our beach, with the sun in the sky over her shoulder.

- When you take flash pictures indoors, the light usually comes from somewhere around the middle of your forehead. This can make Cousin Philomena (or whatever you're photographing) look really flat and featureless, as we illustrated in Chapter 1. You can often ameliorate this effect with your image-editing program's Inner Bevel feature. In Paint Shop Pro, this feature is one of the 3D Effects filters; other programs may have it as a Layer Style or in some other place. Try using a convex rounded bevel, with a size in pixels of about one-third the diameter of the subject's head. Make the bevel as soft as you can so it'll just appear as rounding of the subject's body. Set the depth, or intensity, to a pleasing amount. If there's no strong oblique lighting in the picture, try setting the lighting angle to about 120 degrees, over the subject's right shoulder (to your left as you view the image).

- If your subject is on a separate layer, you can use several techniques to blend its edges with the background more smoothly. Start by looking for a Defringe command—this feature is designed to trim any pixels around the edge of a silhouetted image that look as though they might be left over from the original background. If you don't find a Defringe command, or it doesn't do what you want, try this: Select the transparent areas of the layer holding the foreground image, then expand the selection by a pixel or two. Next, feather the selection by the same amount, and press Delete to give the selection a nice soft edge and simultaneously trim any leftover background pixels.

More Great Ideas

The great thing about making your own backgrounds is that you can make them in any size, shape, and color scheme to work for whatever's in your picture. And you're not limited to slapping them behind head-and-shoulders portraits to put in those little standup frames for your desk; you can use

those virtual backgrounds virtually anywhere. You can also combine artificial elements with elements of real photos to make things even more realistic.

- Work in a cube? Promote yourself to an office with a view by creating a window through your computer's desktop. Ours (see Figure 4.4) features a photorealistic brick wall we created to provide appropriate surroundings for the gateway into a lush garden. You can download this image from our Web site at www.getcreativebook.com.

- If you're bored with the view, think how much more bored your fish must be. Give them a change of scene—print a landscape from your vacation or create a fantasy setting and stick it to the back of their fish tank for a backdrop. You can make new backdrops to suit the holidays, the seasons, or just your fancy!

- Many analog clocks (the kind with hands—remember those?) these days have faces that are just paper. You can make your own clock face with a pretty background on it. Print it on sticky paper that you can get at your local office supply superstore, and apply it over the face that's already there.

- If you spend a lot of time in the kitchen—or even if you don't—you might enjoy making a set of refrigerator magnets with photos of your family on them. Create a snazzy background; you could even steal

FIGURE 4.4

The brick wall—modeled after a real Art Deco brick wall in our city—contrasts pleasingly with the brightly lit garden that's seemingly just through the doorway. You can see it in color on our Web site.

some bricks from the garden wall shown in Figure 4.4 and tile them to fill the area of your magnet.

- As much as you may love your computer, you may also sometimes wish it weren't, well, quite so prominent. Try camouflaging parts of it! Toss that electric-blue mouse pad and use a commercial foam-rubber mouse pad kit to make a mouse pad with a top surface that matches the surface of the desk it's sitting on. (For a fun and easy *trompe l'oeil* effect, include a life-size photo of your hand on the mouse; see Chapter 11, "No Scissors, No Paste: Creating Elements for a Photomontage" for instructions on silhouetting the hand and mouse.)

5

Roll Over, Michelangelo
Turning Photos
into Art with Filters

No matter how much you like taking and playing with photos, the time will come when you just don't want an image to look like a photo. Maybe you were envious of the art majors in college, with their palettes and boxes of pastel chalks. Or maybe you just don't feel right putting an image into a fancy gold frame on the wall unless it looks as though it came from the hand of van Gogh (or at least Grandma Moses).

If this sounds familiar, you're in the right place. In this chapter, we'll take a look at some of the ways you can create faux masterpieces without ever having to take your hand off your computer's mouse (see Figure 5.1). We're in filter territory now—the effects shown in this chapter are achieved through the use of plug-in filters, most of which are designed to enable you to simulate painting, mosaic tile, fresco, or any other medium with a single button click. Naturally, we prefer to add our own special touch when using these filters—we think the results are better when we

Our projects for this chapter were done using Ulead PhotoImpact, but the techniques you'll use to follow along are easily adaptable to any program—more so than almost any of the others in this book. Support for layers is useful, but you can get by without it. A good variety of basic effects filters will provide the tools for these techniques.

FIGURE 5.1

It's New Orleans' French Quarter, that's for sure, but is it a photo or a watercolor? You tell us.

mix and match them. It's all a matter of how much experimentation you're willing to do.

Our experimentation for this chapter took place in Ulead PhotoImpact, a program with a solid but not overwhelming set of effects filters. After you complete a couple projects, you'll be well equipped to do some experimentation of your own, and we'll have some tips for you at the end of the chapter. So let's get started—we have a ways to go if we want to get to the Louvre by dinnertime.

Oh, one last thing—all the files you'll need to complete this chapter's projects are available on our Web site for you to download. You'll find them at www.getcreativebook.com.

Painting with Pixels

Here's a word association game for you: We say "fine art," and you say... what? Probably "painting." When people think of art, they think of paint on canvas. When we're not playing word games, we like to play another game called Painting with Pixels. Don't feel left out if you haven't heard of it; we'll show you how to play.

By now, this should sound quite familiar: Start with a photo. Then see how many different ways you can make that photo look like a painting. Don't settle for the tame built-in painting filters your image editor may offer—such as PhotoImpact's Painting and Oil Paint effects—you can do better. And we'll show you how. Let's see what we can do with a photo of an old friend of ours, Oakley (see Figure 5.2).

1 Open oakley.tif. We've already removed the background for you—it was dark and distracting, so you'll be better off without it.

flash—

When you don't feel like silhouetting an image, or if you don't like the effect of an object against a stark white background, you can always try blurring the background instead. This is easier if your software has a Blur tool, rather than just a Blur filter; if you use a filter, you'll still need to select all the way around the edges of the foreground object.

2 Press CTRL+A or choose Selection ➤ All to select the entire image, then bring down the Selection menu and check to make sure Preserve Base Image is checked. If it's not, select it to check it. Once it's checked, choose Selection ➤ Convert to Object to create a copy of the Oakley image on a separate layer, or object.

FIGURE 5.2

Oakley, a fawn brindle greyhound, was nine years old when Richard took this photo, and she was a truly lovely lady.

focus

There are two reasons for making sure you preserve the base image at this point. First, you'll need it to create a selection in Step 6. And second, when the "painted" image is complete, you can toggle between showing and hiding the object to see the original image on the background. It's a great way to see how much difference your filter experimentation has made in an image.

3 Choose Effect ➤ Artistic ➤ Painting. Yes, we're making use of PhotoImpact's Painting filter, but we have a few improvements up our sleeve—starting with customizing the settings to suit *our* taste, rather than the software developer's taste. Start by clicking to choose Painting Template 19.

4 Here's where the fun starts—we could play with these settings all day. In fact, we did, and here's what we came up with in the end:

You can click the Preview button to see how your settings will affect the image. If you like what you see, click OK. If you want to keep making adjustments, click Continue.

5 The Painting filter has applied brushstrokes to the image, but the result could use an adjustment or two. The brushstrokes give Oakley's shape rough edges, not the sleeker lines that are more suitable with this subject. To smooth them down, first display the Layer Manager (press F10 to show the AccessPanel and click the first button at the top of it). Click the eyeball icon to hide the object and display the background, which still contains the original photo. Then click in the

empty area of the palette below the object to deselect the object so that you can operate on the background.

 flash

PhotoImpact places a rather heavy dotted line around the edges of an object whenever that object is active. If you find this marquee as distracting as we do, choose View ➤ Show Marquee to turn it off.

6 Choose Selection ➤ Color Range. In the Color Range dialog box, you click the eyedropper in the left-hand thumbnail to choose the color you want included in the selected area; the right-hand thumbnail shows you a preview of the selection in black and white. Click in the white area of the left-hand thumbnail. Make sure Invert is *not* checked, and click OK. Then modify the selection by choosing Selection ➤ Expand/ Shrink, entering 2 next to Shrink, and clicking OK. Finally, soften the selection (choose Selection ➤ Soften) by 4 pixels.

7 Back in the Layer Manager, click the object to activate it again, then click the box where its eyeball icon used to be to make the object visible again. Press DELETE on your keyboard or choose Edit ➤ Clear to remove the extreme outer edges of the brushstrokes you applied in Step 4. Now Oakley looks like her old sleek self again, only more artistic.

8 To finish up the image, drop the selection, then choose Format ➤ Hue & Saturation and make these settings to lighten and brighten the image:

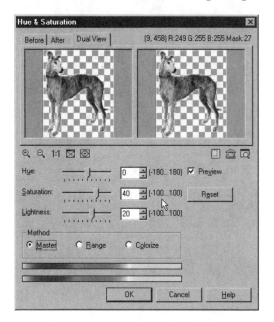

That's it—Oakley's a work of art (see Figure 5.3, and check www.getcreativebook.com for the color version).

We combined the "painted" image of Oakley with a quotation from noted dog trainer Barbara Woodhouse:

> A well-trained dog is worth its weight in gold: it is up to you to see you are a well-trained owner.

We printed Oakley's image on heavyweight paper with this quotation and a soft border (also created using the Painting filter), and we placed the result in an attractive gold frame. It made a wonderful raffle prize at a fund-raising gathering of local greyhound lovers.

focus ───

What? You don't remember the late Barbara Woodhouse? For heaven's sake, drop what you're doing and go here immediately: www.bbc.co.uk/cult/ilove/years/1980/tv1.shtml. Here the BBC showcases the TV version of Ms. Woodhouse. Of course, as dog owners, we also enjoy her books, including the one from which our quotation is taken, **Dog Training My Way** (first published in 1970). She may have amused a generation of TV watchers around the world, but she also knew her stuff when it came to dog training—as Oakley could testify.

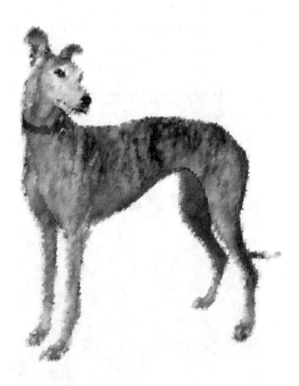

FIGURE 5.3

The soft brushstrokes are especially effective on Oakley's eye, which looks much more "drawn" than it would if it had remained round as in the original photo.

Making a Menu Marvelous with a Mosaic

Painting, of course, isn't the only art form. One of our favorites is mosaic, probably because we're fans of the lovely mosaics found in the Roman city of Pompeii. Turning any photo into a mosaic ought to be easy—surely there's a filter for that. And as it happens, PhotoImpact does indeed have a Mosaic filter. Why don't you go apply it to an image and then come back and let us know what you think?

Hey, you're back. What do you think? Yuck, you say? Doesn't look like a real mosaic at all, you say? We're with you on that one. Although there are certainly uses for this sort of filter, which you may see in other programs under the name Pixelate, turning a photo into a realistic image of a mosaic is definitely not one of them. Fortunately, we've hit on a pretty good technique to do just that, combining a little pixel-shuffling in PhotoImpact with the use of a neat product called embossing powder.

In this project, we wanted a mosaic effect on a menu for a fancy autumn dinner party. So we stepped out into the yard, grabbed a few colorful leaves, and photographed them against a white sheet. Then we opened the image in PhotoImpact and silhouetted it to remove the background—having used a white sheet made it easy to erase the background along the edges of the brightly colored leaves. Once the leaves were standing alone on their white background, we were ready to go, and this is the stage at which you'll pick up when you download the leaf image, leaves.tif (see Figure 5.4). Here are the steps we followed:

flash

If you need to brush up on your silhouetting technique, turn to Chapter 11 to get the details on our preferred method. In PhotoImpact, layers are called objects, and you'll need to use the Object Paint Eraser tool to remove pixels from layers, but the principles are the same.

1 First, open leaves.tif. It's a nice photo—they sure are colorful leaves—but we want something a little more stylized and less realistic for our menu. The first step is to smooth out the rough, grainy texture of the leaves. Choose Effect ➤ Material Effect ➤ Texture Filter. In the Texture Filter dialog box, click the Stone thumbnail in the Effect area

FIGURE 5.4

These leaves are lovely shades of orange and gold—one of the advantages of living in New Hampshire. Turn to Plate 5.1 to see them in all their glory.

at the bottom, then make these settings in the Parameters area of the dialog box:

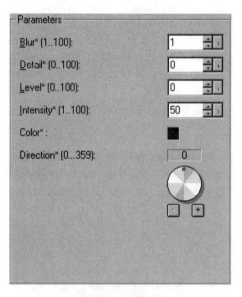

Click OK, then choose Apply Current Frame Effect to Image in the pop-up menu. The Stone texture breaks the image down into flat areas of color—an effect similar to posterizing, but with colors that more closely match the ones in the original image.

flash

If your program has an Underpainting filter, it will work nicely to achieve the effect for which we're using the Stone texture here.

2 Next, choose Selection ➤ Color Range. Make sure the Sampled Colors radio button is selected, click in the white area surrounding the leaves, then click the Invert check box. Click OK to see the resulting selection. It should include the leaves and exclude the white background.

3 Choose Effect ➤ Blur ➤ Gaussian Blur and click Options to see the effect's controls. Enter 2 in the Radius field and click OK. By selecting the leaves before blurring them, you'll maintain their sharp outer edges while softening the color transitions within the leaf shapes.

4 Applying the Gaussian Blur filter with a selection active has turned that selection into an object, floating on a transparent layer. Before going on to the next step, choose Object ➤ Merge to merge the leaves back down onto the white background.

5 Now you'll make some mosaic tiles. Choose Effect ➤ Material Effect ➤ Tile and click Options to see the Tile controls. Make these settings before clicking OK:

6 Now you have tiles, but they're a bit sharp-edged, and they're too closely spaced. To fix that, choose Selection ➤ Color Range again, and once more click in the white area of the left-hand image thumbnail to select the white areas of the image. This time, however, uncheck the Invert box before clicking OK.

7 Choose Selection ➤ Expand/Shrink and click the Expand radio button, then enter 2 next to it. Click OK to expand the selection. Immediately, choose Selection ➤ Soften and enter 2 here as well, then click OK. The selection is now both larger than before and feathered along its edge.

focus ——————————————————————————————————

Feathering a selection means that pixels near the edges of the selected area will be only partially affected by any changes you make to the image before dropping the selection. In this case, the white fill you're about to apply to this selection will have slightly softened edges.

8 One last step: choose Edit ➤ Fill and click the white color swatch, then click OK. This operation makes the white areas between the tiles larger, setting the tiles apart more clearly. You're done! The final leaf mosaic is shown in Figure 5.5 and in color as Plate 5.2.

When we completed our mosaic image, we placed it in a QuarkXPress document that also included a ruled border, a heading, and the text of our menu. We printed the file on a color inkjet using the special embossing paper that came with our embossing powder, then covered the menu text

FIGURE 5.5

The final image shows clearly the basic elements of the mosaic effect: softly shaded colors and—of course—the tile shapes.

with a piece of paper and sprinkled the rest of the page with a generous helping of the powder. Finally, we heated the powder gently with a heat gun, playing it over the page for a few minutes as the powder melted and puffed. The resulting effect is similar to the raised thermal printing used on business cards—only, of course, much cooler. You can see it in the color section in Plate 5.3.

flash

You can find embossing powder at your local craft store, in both clear—which is what we used, so that our image would show through—and myriad colors. Although the special paper isn't strictly necessary, we like to use it because its hard finish ensures that the printer ink stays wet long enough for the powder to stick to it. You can order a kit like the one we used at Web sites such as www.thecraftypc.com.

Tips for Budding Pixel Artists

By now, we hope you've caught the bug. Playing with different settings to achieve new "artistic" effects is a great way to learn your way around a new program. And the images you'll create make wonderful presents, ornaments, and cards, to name just a few of their uses. Here are a few tips to get you started on creating your own artistic masterpieces:

- Never accept the default settings for a filter without at least trying a few tweaks. True, the defaults are often there for a reason—because they're tried and true settings—but that doesn't mean they're always right for your image and your taste.

- Don't stop with one filter. Apply one, then another, then another on top that. Use Blur and Sharpen filters to smooth or enhance the effects of other filters.

- Remember that you don't have to operate on the entire image at once. You can select certain areas, by color range or by drawing a selection marquee, to restrict filter effects to the areas where you want them.

- Layers, or objects as they're called in PhotoImpact, are always useful, but especially so when you're working with filters. You can use them to tone down an effect by reducing a layer's opacity (place the original image on a layer below the filtered one), or to preserve various stages of your image as you experiment with different settings.

- Another way to work with layers is to change their blending modes, sometimes called merge attributes. These are called things like Difference and Exclusion, and they change the way the pixels on a layer combine with the pixels on the next layer down. Try them all—some will hardly affect the image at all, and others will send you spinning into the world of surrealism.

Turn to the color section and check out Plate 5.4 to see a variety of filter effects. Remember, think outside the frame—"art" means more than just painting-and get creative!

More Great Ideas

The best photos to turn into "art" are those with strong lines and clear shapes—remember, you'll lose some of the detail when you apply filters, so be sure that the photo will stand on its own. Here's a selection of our favorite ideas for "artsy" projects:

- Create a mobile by printing your favorite photos, then gluing them to a sheet of Styrofoam. Trim around the photos—you can leave them rectangular or outline their shapes—then decorate the backs of the pieces with more photos, paint, glitter, or whatever you prefer. Hang the pieces using fishing line or colorful yarn.

- Decorate a dresser set—brush, comb, and handheld mirror—with a misty, romantic "watercolor" on the backs of the brush and mirror. This makes a great birthday gift for a young girl.

- To please your sweetie on Valentine's Day, make your own candy box by decorating a plain white cardboard box with lace, tissue, and your own artsy, romantic images printed on sticker paper. Then, of course, fill the box with the fanciest chocolate truffles you can find!

- Brighten up a corner of your home with a scenic lamp. Start by converting a landscape from your collection of vacation photos into a "watercolor" or "oil painting," then print it on backlight film and attach it to a cylinder lamp like the one shown here in Figure 5.6 (and in color as Plate 5.5).

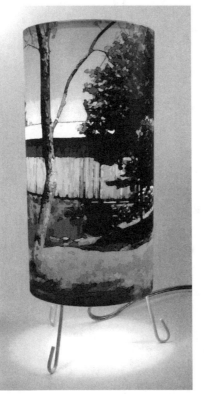

FIGURE 5.6

We got our lamp at the local A. C. Moore craft shop—it came with a sticky surface ready for us to apply a printed image. We made our image big enough to go all the way around the lamp and then split it into halves for printing, but you can also make a great lamp with two different images, each of which goes halfway around.

- Collectible vintage matchbooks have the neatest tiny images on them—but you can make your own cool matchbooks as party favors or just for fun. Buy matchbooks with plain covers, then print a bunch of tiny copies of a funky image on sticker paper, trim, and attach to the matchbooks.

- Night lights aren't just for kids—they're a great way to light a dark staircase, hallway, or bathroom in case you need to get up in the middle of the night. Try replacing the clear or colored panel in front of a store-bought night light's bulb with your own image, printed on transparency film.

Colors and Tinting

6

Deal Yourself a Winning Hand
Play Games with Color

SINCE its invention more than 175 years ago, photography has come a long way. To see just how far, you can view the oldest known photograph in an online exhibit put on by the University of Texas (www.hrc.utexas.edu/ exhibitions/permanent/wfp/).

This image was made by Nicéphore Niépce in 1826, on a pewter plate coated with bitumen (a tarry substance). The exposure took eight hours!

You can see in Niépce's photo that lighting can be a problem in really long exposures; there's morning sunlight shining onto the walls at one side of the picture, and there's afternoon sunlight shining onto the walls at the other side. But photographic technology improved in the years following Niépce's initial experiments. By the end of the 1830s, the most common form of photo was the daguerreotype, made directly on a sensitized plate of silver polished to a mirror shine. The daguerreotype in Figure 6.1 shows one of our ancestors. This exposure was made in about 1850. It took ten minutes, and the subject was held rigidly in position by a steel frame that clamped her head from behind.

> The examples in this chapter use Adobe Photoshop Elements, but you can complete them using any image editor that can adjust an image's gray levels, contrast, hue, and color balance. The names of some commands may vary, but you'll find that the dialog boxes and settings in any program will be very similar to what you'll read about in this chapter.

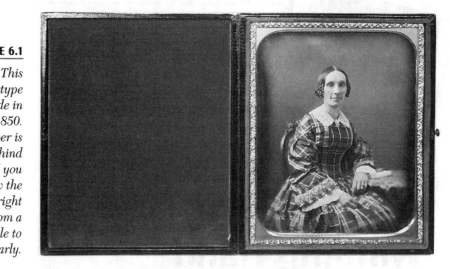

FIGURE 6.1

This daguerreotype was made in about 1850. The silver is protected behind glass, and you have to view the mirror-bright image from a slight angle to see it clearly.

Today you, with your fast digital camera, need not worry about this kind of problem. There are other ways in which modern photography differs from antique, however, and in this chapter we'll talk about some of them and illustrate how you can compensate for those difference—or, if you like, take advantage of them for some interesting effects.

We've placed the images used in this chapter on our Web site so you can download them and work along. You'll find them here: www.getcreativebook.com.

Making a Good Black and White Photo

The most obvious difference between color photos and their black and white counterparts is the presence or absence of color. But a color photograph isn't just a black and white image with color added; nor, conversely, can you simply remove the color information from a good color photo (which is called "desaturating" it) and come up with a good black and white picture. Because of the way color information is recorded, there will be differences in contrast and levels between your color image and a good black and white image of the same scene. In the next few sections, we'll take some color photos that we like and play with them in black and white to show you how you can create good black and white images from your own color photos.

You may wonder why you would ever want to make black and white images. There are many reasons. Most of the photos published in newspapers—or in your club's monthly newsletter—are black and white.

More to the point of this chapter, though, if you're making pictures for artistic purposes, you may find that a given picture works better in black and white. Color is a sensual medium; color pictures grab your senses. But black and white is an aesthetic medium; it works on your mind instead of your senses. Look back at *The East Tower*, Figure 1.3 in Chapter 1, to see what we mean. If you're like us, you don't have to work very hard to imagine a castle, maybe that of Sir Gawain or Sir Lancelot, on the edge of a lake, crumbling to dust along with the hero who inhabited it, until only the tower and a bit of the wall remain standing. (That's not the real subject of the photo, of course, but a picture, after all, is what you make of it.)

Compare and Contrast

We'll start with a moody early-morning picture called *The Mill in the Mist*, shown in the color section (Plate 6.1). Richard took this photo of the 19th-century New England textile mill across the river from his house on a brisk November morning.

flash

If you see something that looks like a good picture, shoot it now. Don't wait ten minutes, or even five minutes, hoping that the light will be better or that someone will come and move that car that's ruining your composition. Richard saw the mist in this picture when he went out to get the morning paper. He ran for his camera, slid down to the riverbank, and took the photo—and the mist was entirely gone five minutes later. So take your picture while you're sure you can. Then, if you have time, wait for a better one. If the better one never comes, you'll not have lost out entirely; you'll have one that you can work on. It's not all that difficult to retouch a car out of existence, is it?

What happens if we remove the image's color? We opened it in Adobe Photoshop Elements and chose Enhance ➤ Adjust Color ➤ Remove Color to desaturate this color version, yielding a black and white image. Look at Figure 6.2 to see the results.

The blandness of this image is due to the fact that, although the picture looks good in color, it really contains very little contrast. Desaturated, it has lost many of the visual cues that color imparts, and it looks more like an average cloudy day than like an early-morning salmon-tinted sunrise. But you can improve it by adjusting the contrast. Choose Enhance ➤ Adjust Brightness/Contrast ➤ Brightness/Contrast and increase the contrast to +20. (This is what a photographer does in the darkroom by

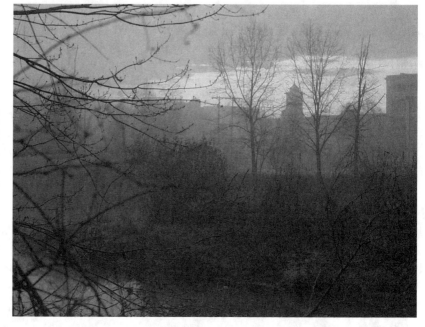

FIGURE 6.2

We desaturated the color version of The Mill in the Mist. *The result is pretty bland because the loss of color has further weakened the effect of the already low contrast.*

choosing a higher-contrast paper to print on.) As you can see in Figure 6.3, the image is now surprisingly more lifelike than before. But it's still not where it ought to be, because enhancing the contrast has darkened the shadows and detail is lost. How do you fix that?

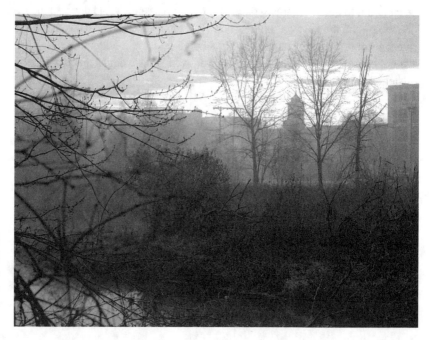

FIGURE 6.3

Increased contrast sparks the picture and makes it more vivid.

On the Levels

When a photographer prints a picture in the darkroom, contrast isn't the only factor to consider. Also important is the overall balance of gray levels throughout the range from black to white, for example. You're faced with the same concerns when you edit your digital images. Digital image editors represent gray levels with a graph called a histogram, and you can use the information it contains to lighten the picture proportionally—a little in areas that are already light and more in areas that are too dark. Most image editors have a way to control levels, but they may use different names for the feature. In Elements, it's called Levels, but in Corel PHOTO-PAINT, it's referred to as Contrast Enhancement. For this image, change the location of the gamma point—the point at which 50 percent brightness falls—by dragging the middle slider in Elements' Levels dialog box. Choose Enhance ➤ Adjust Brightness/Contrast ➤ Levels and make the settings shown here:

Each vertical line on the histogram represents the number of pixels within the image that are a particular shade of gray, ranging from the darkest pixels at the left end of the graph to the lightest ones at its right end. By moving the gamma point, you're changing the image so that parts that were darker than 50 percent are brightened to 50 percent. This method of adjusting the image's contrast retains the histogram's smooth curve, brightening not only the midrange areas but also the lighter areas (adding to the misty effect) and the shadows. Unlike a simple brightness adjustment, working with the histogram in this way retains the full black of the image's darkest areas so the image still has the overall light/dark range that you want. The final result is shown in Figure 6.4. It's not as evocative as the original color version, perhaps, but you can at least get a pretty good sense of what the scene was like on that morning.

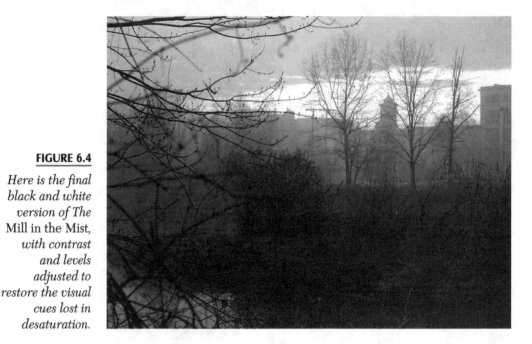

FIGURE 6.4

Here is the final black and white version of The Mill in the Mist, with contrast and levels adjusted to restore the visual cues lost in desaturation.

Light and Easy

Remember what we said in Chapter 1 about the importance of lighting in composing a photograph? Think about how flat the Niépce photo looks because the lighting just doesn't work—it's almost impossible even to recognize the shapes of the buildings. Let's talk a bit about how you can enhance lighting to improve a black and white image.

First of all, once you've taken the picture, you're stuck with the overall lighting you started with. This means you can't change where shadows fall, at least not without a lot of manipulation—but at least you can take an instantaneous picture with the shadows approximately the way you'd like them. Then you can change the relative brightnesses of different objects, and the results can be very striking. (Think Ansel Adams.)

Environmentalist and photographer Ansel Adams (1902–1984) was best known for his spectacular black and white photos of the American West. He used varying dilutions of chemical developer and a selenium toner in the darkroom to manipulate the contrast in his images, and it took hours to finish each photo. You can see more than 1700 of his images online at photo.ucr.edu/photographers/adams/.

Plate 6.2 shows a nice color picture of Richard's house. Of course, this isn't quite the way the image started out—it used to contain a TV antenna and some power wires that we, um, *disappeared*. (Turn to Chapter 16, "Better Than Perfect: Creative Retouching for Fun and Profit," to learn how we made these modifications.) This picture has very brilliant color; the grass was greener than usual that day, and the sky, as it so often is here in New England, was a brilliant deep blue. No, we didn't fiddle with that sky! We did think about wiping the fire hydrant out, but we managed to restrain ourselves. Making an image *too* perfect reduces its credibility—the viewer won't be convinced, deep down, that the subject of the photo is real.

If you desaturate the house picture, you end up with Figure 6.5. This is a very ordinary snapshot, one that might have been taken with somebody's Kodak Brownie box camera in about 1950, and you can certainly spark it up a little. Let's take a look at some techniques you can use to make this ordinary grayscale image look more like one of the stunning black and white images Ansel Adams was famous for.

You've already played with contrast and gray levels; now you'll add color modification to your bag of tricks. One thing that helps make a really good scenic photograph so lovely is a dramatic sky. Let's see what you can do to make the sky more dramatic. The first thing to notice is that dramatic skies are darker, and their clouds contain more contrast. Let's go back to the

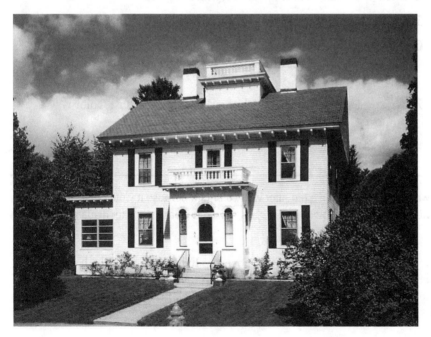

FIGURE 6.5

Here is a nice, but not exciting, picture of Richard's house.

original color image and change the color balance to simulate what happens when you shoot with a red filter.

When you look at a color spectrum, you see that blue and violet are at one end and red is at the other. A red filter blocks much of the blue and violet parts of the light passing through a camera lens, making blue and violet areas lighter on the resulting negative. Then, when the negative is printed, those areas of the image are darker than they would otherwise have been. You can simulate this effect in an image editor by turning the image's saturation way up—increasing its color intensity—and then adjusting the lightness of the various colors before you desaturate the image.

Here's how to achieve this effect in Elements:

1 Starting with the color image, choose Enhance ➤ Adjust Color ➤ Hue/Saturation and crank the Saturation slider up to +70. Don't worry about how horrible the picture looks now, because it's going to get worse before it gets better.

2 Now choose Reds from the pop-up menu at the top of the dialog box so you'll be working on just the red parts of the image. Adjust the Lightness slider to +80.

3 Change to Yellows and set the Lightness to +80.

4 Change to Greens and set the Lightness to +40.

5 Change to Blues and set the Lightness to −100, then click OK.

6 Choose Enhance ➤ Adjust Color ➤ Hue/Saturation/Lightness again. Choose Blues and set the Lightness to −100. The sky is now really, really dark. Click OK.

7 Now desaturate the image (choose Enhance ➤ Adjust Color ➤ Remove Color).

focus

You wouldn't normally use a red filter with color film because it would make everything look as if you're viewing it through a piece of red glass—which is what a red filter actually is, anyway!

The picture looks a lot better now; see Figure 6.6. The sky has darkened, the grass and trees have gotten lighter, and the brick plinths under the stair-side planters have pretty much faded into oblivion.

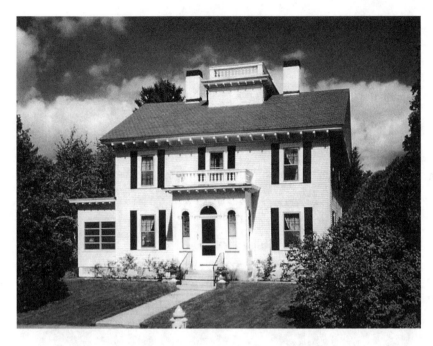

FIGURE 6.6

Here is the house picture with its color balance altered and color removed. It looks more like a professional photo and less like a snapshot.

But that sky just isn't cool enough yet. The clouds are a little to washed out. You can punch them up by doing some careful selection and contrast adjustment, following these steps:

1 Switch to the Magic Wand tool, which enables you to select areas of similar color by clicking. In the Options bar, set the Tolerance to 20 and check the Anti-Aliased and Contiguous check boxes.

2 Select the clouds by clicking in the middles of the big patches, holding the SHIFT key down with each click to add the new area to the selection.

3 Gradually extend the selection by SHIFT+clicking slightly darker areas nearer the borders—but don't go too far here! You should select almost up to, but not onto or past, the very edges of the big cloud masses. Don't bother with the little wispy bits of cloud, and don't worry if you pick up some of the leaves and branches on the trees.

4 You'll probably find that you've selected the white chimneys on the house. Switch to the Polygonal Lasso tool, hold down OPTION (Mac) or ALT (Windows) for the first click, and carefully deselect the

chimneys by outlining them. Here's what your selection should look like after the chimneys are deselected:

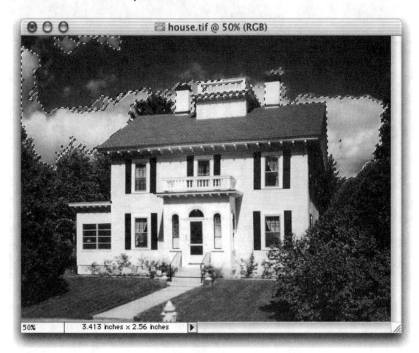

5 Now choose Enhance ➤ Adjust Brightness/Contrast ➤ Brightness/Contrast and adjust the Contrast to +30. Click OK.

6 Choose Select ➤ Deselect. You will see that the edges of your selection are hard and have too much contrast. Let's fix that.

7 Switch to the Blur tool. Choose the 17-pixel soft-edged round brush, and set the mode to Normal and the strength to 50 percent. Work over the harsh edges of the clouds to blur them and blend them in with the surrounding areas. You may need to make several passes.

The final result looks like Figure 6.7. If you're bothered by the fire hydrant, you can retouch it out by using the Clone Stamp tool to copy grass from nearby. (As we noted earlier, you'll find more info about making this kind of change in Chapter 16, "Better Than Perfect: Creative Retouching for Fun and Profit.")

FIGURE 6.7

Here is our final Ansel Adams-ized photo of Richard's house. The enhancement is not earthshaking, but the picture definitely looks much more professional and exciting than it did before.

Simulating Period Color

Early photographers didn't have today's wonderful color films, of course. They didn't even have the panchromatic, or "pan," black and white films that pro photographers take for granted. The word *panchromatic* means "sensitive to all colors," and modern films respond uniformly across the spectrum. Older films didn't work quite that neatly—they emphasized some colors more than others, which is what gives old photos their characteristic "look." Of course that look varies from era to era, which means that simulating it is the key to making a photo look as though it's from a particular era.

Now that we've introduced the idea of modifying color and contrast to enhance an image, let's step into a time machine and visit the olden days. We're going to make two stops, one in the 1940s, when commercial color photography was still young, and one in about 1900, when color photographs got that way by being tinted one at a time, by hand. Hang on!

focus ───

With panchromatic film, a red object appears the same in a picture as a blue object that is of equal brightness. This, you will remember, is why The Mill in the Mist lost some of its impact when we desaturated it. With no difference between a green leaf and a blue or brown stone next to it, you can't easily take in what the picture is about. And it's also why we simulated the effect of a red filter for the picture of Richard's house; by filtering the light in that way, we enhanced the image just as a photographer would do when taking the picture with a film camera. But for the most part, panchromatic films work well because they provide an accurate point from which to start.

A Visit to the 1940s

In the 1930s, Kodachrome slide film became widely available. Kodachrome and other color films, both slide films and negative films, are panchromatic, but they work differently from a black and white pan film. Color film has three separate layers of light-sensitive material, sensitive to blue, green, and red. The chemicals for processing the film include blue, green, and red dyes. When the film is developed, each layer absorbs the corresponding dye and becomes the color of the light that it responded to. When you add all three layers together, you get a full color spectrum.

But that early Kodachrome wasn't a truly accurate pan film. Its colors weren't quite true. If you've seen the color pictures in *National Geographic* magazines from the '30s and '40s, you know what we mean. You can reproduce this characteristic color inaccuracy to come up with a color picture that looks as if it had been taken in the 1940s. A picture like this would be great for any number of nostalgic purposes, such as posters for a Big Band concert or the cover of your PTA cookbook.

To demonstrate this technique, we assembled a still life that might be used on one of those little pamphlet cookbooks that used to come with pressure cookers, mixers, blenders, and other appliances indispensable to the 1940s housewife. But digital cameras are very good at accurate color reproduction, and this picture doesn't look old at all. (You can see it on our Web site at www.getcreativebook.com.) Leafing through those old *Geographics*, we see that the most obvious difference is easy to handle: the color balance is wrong. Like most image editors, Photoshop Elements has an easy-to-use way to adjust color balance:

1 Choose Enhance ➤ Adjust Color ➤ Color Variations.

2 Find the slider in the lower left corner of the dialog. As you slide it back and forth, you will see that there are "notches" into which it will

fall so that there are seven possible settings. Slide it to the setting that is one notch to the left of the middle.

3 Click the Highlights radio button. Click Increase Red, and then click Decrease Blue.

4 Click the Midtones radio button and repeat the above adjustment.

5 Click the Shadows radio button and repeat the adjustment.

6 Click OK.

7 The image is a lot warmer now, and that's the way those old color pictures look. But it's not quite right. The old color films also had much more contrast than modern films. Choose Enhance ➤ Adjust Brightness/Contrast ➤ Brightness/Contrast and set the contrast to +20. Click OK.

And that's it. The picture has been transformed from a twenty-first century digital photo to a warm, inviting cookbook cover from just after the Second World War. (You can see this new version on our Web site too.) Now all the image needs to become a cookbook cover is some text. We'll show you in Chapter 13, "What I Did on My Summer Vacation: Combining Text and Images in a Postcard," how to add some interesting text effects to your images, but for now you can look at Figure 6.8 to see how you might spruce the picture up for your local PTA.

FIGURE 6.8

Here is a cover for a mythical cookbook put together by an imaginary elementary-school PTA. We don't know what the recipes inside taste like, but some of these little fund-raising cookbooks have some real gems inside those covers. And just look at that price!

6

A Visit to 1900

Now let's turn our time machine back another 40 years or so. We are going to imitate something called *orthochromatic* film, whose name means "accurately reproducing colors." Don't you believe it. Ortho films were a vast improvement on the films that came before them, but they still didn't respond very well to reds. Actually, they're still used today in some printing processes, and this is why printers can use a red light in the darkroom when they develop film images of book pages.

Let's set up the little still life again and shoot it with simulated ortho film. Follow these steps, starting from the original modern version:

1 First, so you'll be able to see how the image has changed when you're done, choose Enhance ➤ Adjust Color ➤ Remove Color to desaturate the image panchromatically. Print the result or save it as a separate file, and then undo the desaturation.

2 Choose Enhance ➤ Adjust Color ➤ Hue/Saturation and drag the Saturation slider all the way over to +100. The image looks really garish at this point—feel free to put on your sunglasses if you need them.

3 Choose Reds from the Edit pop-up menu, and set the Lightness to −50.

4 Choose Yellows and set the Lightness to −50.

5 Choose Cyans and set the Lightness to +40.

6 Choose Blues and set the Lightness to +70.

7 Choose Magentas and set the Lightness to +70. The image looks really odd, but go ahead and click OK.

8 Now choose Enhance ➤ Adjust Color ➤ Remove Color to desaturate the image. You're done.

Figure 6.9 shows the finished orthochromatic version of the still life. Notice that the brightly colored fruit is darker and the light-colored patterns on the china are lighter than in the version you created in Step 1. The apples, being red, wouldn't register very much at all on orthochromatic film, so the areas where they are recorded would be light on the negative and would print darker on the print in the same way as the blues printed darker in the Ansel Adams-ized "red filter" picture. The yellow bananas would register only a little bit more on the film. This means that they come out lighter than the apples but still much darker than they would be with a pan film. The crossover point, the point at which sensitivity begins to correspond between pan and ortho films, is somewhere around cyan.

FIGURE 6.9

Here is the way an orthochromatic film from about 100 years ago would render our still life.

If you print an ortho negative so that most of the things in an ordinary picture, such as the grass and the sky, are approximately as dark as they should be, the reds will come out entirely black. So we had you boost the curve a little, brightening the blue/violet end of the spectrum more than it really should be, in order to get something other than black on the reds. In the darkroom, you'd achieve this effect by shortening the exposure when making the print.

Where do we go from here? Easy. Take note of the fact that tinting photographs by hand with transparent oil paints was a very popular pastime a century ago. (You couldn't use watercolors because the surface of a photograph is gelatin, which absorbs water and makes coloring very difficult.) Many merchants sold kits of the colors for hobbyists, and you can still find the products of those hobbyists in antique shops and flea markets. In fact, you can still buy hand-tinting supplies in craft and hobby shops—if you feel like doing it the hard way. We prefer to make life easier on ourselves by using a computer—and that's exactly what we'll show you how to do in the next two chapters. In Chapter 7, you'll hand-color a portrait, and in Chapter 8 you'll create an old-fashioned hand-tinted note card.

More Great Ideas

Playing games with color covers a lot of ground—you could go vintage, as we've described in this chapter, or you could go futuristic, or anywhere in between. If you've got the winter blahs, dig out one of your favorite images, try some colorful techniques, and turn it into one of these projects:

- Turn your photo into a stained glass window or a mosaic. First, print the image, then glue it to light cardboard and cut around the major elements of the image. Leaving about a quarter-inch of space between the pieces, glue them back down on a black background (for stained glass) or a colored one (for mosaic).

- Never lose your keys again—create a colorful image and print it on oven-shrink film, then shrink that dink. Drill a hole in the shrunken version and attach your keys to your new, individualized keychain (see Figure 6.10).

FIGURE 6.10

Our keychain was made from a jaguar photo we took at the zoo, modified to be, well, just a bit more colorful, then printed out on shrink film and popped in the oven for a few minutes. You can see the color version on our Web site at www.getcreativebook.com.

- Why use those boring old plain checkers when it's so easy to make a custom checkers set using cool photos printed on sticker paper and attached to each checker piece. You can use just two photos, with all the red pieces and all the black pieces the same, or you can put a different photo on each piece.

- Tattoos are more popular than ever-and so are temporary tattoos. They're a great way to have some fun with body art without the commitment of a real tattoo. Now you can make your own temporary tattoos from your most colorful images with a kit you can mail order (www.papilio.com is one supplier).

- Save time making your own scrapbooking pages by "vintage-izing" some photos, laying them out onto pages using a layout program, then printing the sheets. You can jazz them up with photo corners, just like the ones used in old-time photo albums. (Some image-editing programs can even add the photo corners automatically for you!)

- Just got married? Get a head start on your thank-you notes by taking the best photo of your wedding cake, colorizing it to suit your artistic fancy, and putting it on the front of home-made thank-you cards.

7

Turning Back the Calendar
Hand Coloring Portraits
(and Other Photos)

THESE days, when you go to Olan Mills or Sears
or some other portrait studio, you walk out again with a
nice color portrait. You get nice color when you take your
significant other's portrait with your digital camera, too.
But we must admit, we think the color in those portraits is
so, well, *ordinary*. Even with a professional photographer
pushing the button, it's just the same as the color in
everybody else's portraits. Come on, now, you can do
better! In this chapter we'll show you how to go about
destroying the color in a portrait and then putting it
all back again—by hand, and not necessarily the way it
was before.

> We used Ulead
> PhotoImpact for the
> project in this chapter,
> but you can use any
> image editing program
> that enables you to
> adjust contrast, hue,
> and saturation. Support
> for layers will be helpful
> but isn't essential.

Back in the Olden Days

Everything started somewhere, some time. Hand-colored photographs are
no different. Think back to Chapter 6 for a minute. As we pointed out just

a few pages ago, color film photography hasn't existed for all that long, relatively speaking; and before there was color photography there were black-and-white photographs. Even black and white photos weren't always the way they are now, though, and in Chapter 6 we showed you how to simulate the results obtained from old black-and-white films by altering color balance and then desaturating. But in the days when that's what photos looked like, the real world wasn't like the movie *Pleasantville*; it wasn't all black and white—or even shades of gray—any more than it is today. So people wanted to do with their photos what they could do with painted portraits. They wanted to give them color. Where there's a will there's usually a way, and it wasn't long after photography was first invented that people started making colored photos.

For a while, virtually all photographs were portraits; although Nicéphore Niépce had started the whole thing back in 1826 with a scenic shot (as we mentioned in Chapter 6), most people weren't interested in spending large sums of money for fuzzy pictures of nothing in particular when they could buy lovely paintings of their houses, horses, and so on. But photographic portraiture caught on very quickly because a daguerreotype was an exact likeness and also far less expensive than the work of a portrait painter skilled enough to produce as good a likeness—even though it cost far more than photos today. Okay, now we have photographs, where's the color? The daguerreotype back in Figure 6.1 is a black-and-white image, but the portraitist carefully tinted the visible skin areas a subtle pinkish color using a fine transparent oil paint. Some portraitists went further than just the skin areas, and the results of their work are often really lovely, aglow with subtle hues.

As time went on, other photographic techniques were developed: ambrotype, tintype, and more. The advent of the wet collodion plate, a glass negative that could then be printed on paper multiple times to make a positive image, was the turning point not only for photography in general but also for hand colorists working with oils. With Daguerre's technique, you ended up with a single image that couldn't be duplicated, but glass negatives yielded as many prints as you wanted—and cheaply, too. Just as with daguerreotypes, the first tinted prints received only slight skin coloring, but the technique soon blossomed. Figure 7.1 shows a hand-colored print made in 1863 from a collodion plate; you can see it in color on our Web site (www.getcreativebook.com).

When the pros get a good thing going, there are always amateurs waiting to join in the fun. It wasn't long before tinting photos became a popular hobby, and catalog merchants such as Spiegel and Sears Roebuck sold kits of the transparent oil colors for home use. You can still buy these kits today from hobby suppliers, but you don't need them for your digital

FIGURE 7.1

This hand-tinted photo of a Civil War soldier is a portrait of Henry Bultman, Richard's great-grandfather.

photos. You have all the color you want, and more, right inside your image-editing program.

Rolling Back the Years—Making a Hand-Tinted Portrait

We began this chapter by talking about hand-tinted portraits. Now we're going to show you one way to make them. First, let's get one thing straight. A hand-tinted portrait is not a color photograph. It isn't supposed to be. Yes, you'll start with a color photograph, but you will immediately blow away all the color and then add your own color. Your final result will look like, but not like, the original. It'll look, well, hand-tinted.

From Here to There: The Procedure for Tinting a Portrait

We'll start with a portrait we shot of our friend Matina (Figure 7.2). You can see the original color photo in Plate 7.1. We've placed the images used in this chapter, along with some pictures of the intermediate steps below,

FIGURE 7.2

Matina's a natural straw blonde with pale skin. We'll make her an ash-blonde 1940s movie star in our tinted version of her portrait, but you can use any colors you prefer—she could end up as a green-skinned, purple-haired alien from Star Trek.

on our Web site so you can download them and work along. You'll find them here: www.getcreativebook.com

To work along with us, open the file named matina.tif and follow these steps:

1 Choose Format ➤ Hue & Saturation and set the Saturation to –100. Click OK. You now have a black-and-white image, but it exists in a full-color space (meaning, within an RGB color file) so that you can color it.

2 Choose the Zoom tool and drag a zoom rectangle just big enough that all of Matina's hair is within the marquee (including the bit that's peeking around from behind her neck). As you follow the rest of this process, feel free to zoom and scroll around as much as necessary to make the job go smoothly.

3 Double-click the Paintbrush tool to switch to it and bring up the Brush Panel. On the panel, click the Shape tab and set the Brush Height and Brush Width sliders at the left to about 20 pixels in both

directions, giving you a circular brush. We're not going to tell you every time you might want to change the brush size; but you can change the brush's size as you work by adjusting the Shape value in the Attributes toolbar; for now, here's what your settings should look like:

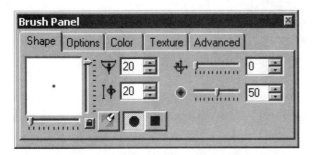

4 Click the Options tab in the Brush Panel. Choose Colorize from the Apply Method pop-up menu, and set the Transparency slider next to the pop-up to 95 percent. (In other programs, this might be referred to as setting the opacity to 5 percent.) As you go through the rest of the process, you should note the color and transparency settings for each step. (You have this book to refer to while you do *this* image, but our settings won't help you when you're doing a portrait of one of *your* friends.) You can change the Transparency setting in the Attributes toolbar, but for now make the settings shown here:

5 Click the Color tab and then click the color swatch to bring up the Color Picker. Set the color to H: 50, S: 5, B: 100. Click OK. You can also click the Tool Panel's Foreground color swatch or the color

swatch in the Attributes toolbar to set your colors. The Color Picker will appear as shown here:

6 If necessary, click the title bar of the image window to return focus to the image. Now it's time to take the plunge. Start out by painting a few strokes over Matina's hair. You will notice that you have to move slowly to cover the area completely, and you'll probably be going back over an area several times. This is because the brush, with its high Transparency setting, is building up color little by little, and it's a good thing. It's easy to put more color in, but it's not easy to take color out. (Yes, we know about Undo, and we use it regularly, but it's easier to get things right the first time.) When you're satisfied with the almost-but-not-quite white color in the hair, you can move along to the next step.

7 Set the color to H: 50, S: 10, B: 100. Paint the darker parts of Matina's hair, leaving the paler color in the brightly-lit areas. This is the point

at which you will begin exercising your artistic judgment; only you can decide when the image is right. (It's handy to keep a separate copy of the original image open for comparison, but remember that you're not trying to duplicate the original.)

8 Set the color to H: 180, S: 100, B: 70. Paint Matina's blouse. Don't miss the portion on her right shoulder (to your left as you view the image), but don't bother to get the little piece that shows between her arm and the velvet she's resting on; it's too small for this size brush, so you can get it later on.

9 Set the color to H: 25, S: 25, B: 100. Set the brush size to about 48 pixels, and paint all of Matina's skin. Don't worry about hitting her lips, but stay out of the eyes and teeth because we want to keep the white color there. The image should look like Plate 7.2a.

10 Set the brush size back to 20 pixels and the color to H: 10, S: 25, B: 100. We might think of a person's skin as being one color, that's not usually the case even when there's not a nice suntan involved. Paint the darker parts of Matina's skin: along her hand, on her cheek, next to the hair covering her ear, under her chin, and so on. If you look closely at the original, you'll see that her chest is also a little pinkish, so you might tint that as well. Be careful not to color these areas too intensely; you should blend with the previous color, not replace it wholesale. Now set the color to h: 5, S: 50, B: 70, and apply a little rouge to Matina's cheek.

11 Set the color to H: 355, S: 100, B: 60. Set the brush size to 5 pixels. You are going to do some fine detail now. Set the Transparency to 0 percent and the Apply Method to If Darker. Paint Matina's lips. Stay carefully within the lip area (big zoom here!). Lipsticks in the 1940s were velvety in appearance, not glossy wet, and by painting the entire lip area you are damping the gloss. Now set the color to H: 355, S: 70, B: 40. Set the Apply Method to Darken, and paint over the upper lip and the darker part of the lower lip (to the side of Matina's face), and along the lower edge of the lower lip. This second color adds a 3D appearance, although when you look right at it you can barely see that you did anything.

12 Set the color to H: 80, S: 30, B: 60. Paint the irises of Matina's eyes. Stay out of the pupils and the whites of the eyes because you should

keep the black and white colors there. The image should look like Plate 7.2b. Here's a closeup of Matina's face at this point:

13 Set the color to H: 30, S: 100, B: 100. Paint the velvet that Matina's resting on a nice bright orange that will contrast well with the cyan of her blouse. (This is a good time to use a much larger brush.)

14 Set the color to H: 210, S: 10 B: 100. Paint the wall behind Matina. The velvet and the wall are distinctly more colorful than in the original, but—again—we're not duplicating the original.

15 Set the color to H: 45, S: 60, B: 100. Set the Transparency to 50 percent and paint the necklace and bracelet. (Back to the 5-pixel brush again.)

16 Now is the time to be glad you saved all the settings you used. Keeping your brush size at 5 pixels, set the Transparency to 95 percent, then go back and touch up all the areas you missed. Didn't get the eyelids close enough to the eyes? That'd be the first skin color (Step 9). How about the part of the hand and arm right along the velvet? That's the second skin color (Step 10). Remember the part of the blouse we told you not to worry about in Step 8? Go back and get it now.

17 To really accentuate the '40s look, we'll give Matina dark pencil-thin eyebrows. Set the color to H: 10, S; 100, B: 30. Set the brush size to 4 pixels and the Transparency to 0 percent. Carefully pencil in a pair of eyebrows, following the general curve of Matina's real ones, as shown here:

18 The area above Matina's left eyebrow, the one that's closer to the camera, looks pretty ragged because she wasn't intending to live in the 1940s, when women plucked their brows so that they could apply pencil lines like ours. You need to clean up this area. Set the Apply Method to If Lighter. Choose the Eyedropper tool and click on the clear skin of Matina's forehead above her real eyebrow. Do this toward the left side of the eyebrow in the image, nearer the middle of her face. Switch back to the Paintbrush and paint over about 1/4 of the part of Matina's real eyebrow that shows above the pencil line. Switch to the Eyedropper, move about 1/4 of the eyebrow's length to the right, and pick up another color, then paint it in. Repeat this procedure until you've gone along the entire upper side of the pencil-line brow. Now choose the Blur tool. Set the Size to 20, the Level to 5, and the Soft Edge value to 50. Blur over the area you just painted, to blend it

more subtly into the skin of Matina's forehead. You should now have something that looks like this:

19 If you stand back and look at your work, you might notice that you missed coloring in some golden brown areas on the blouse. Set the color to H: 45, S: 60, B: 100, the Transparency to 50 percent, and the brush size to 20 pixels. Now paint in the gold spots on the blouse.

20 Finish by taking a good hard look at the picture. You may feel differently, but we think that it needs an overall boost in saturation to spark it and give it that vibrant 1940s look. But not on the mouth; neon lipstick was still a decade in the future. Choose the Lasso Selection tool, set the mode to Add, and carefully outline the mouth. Double-click inside the selection to activate it. Choose Selection ➤ Invert to select everything except the mouth. Then choose Format ➤ Hue & Saturation, and set the Saturation slider to +20. Click OK. Choose Selection ➤ None to drop the selection. This is the end of the process, and your image should now look like Plate 7.3.

How did we use our tinted image once we'd finished it? We adjusted the resolution so that the picture would print at the size we wanted, printed it on special photo paper, and framed it in an antique desk frame. Figure 7.3 shows how it looks sitting on the dresser in our guest room.

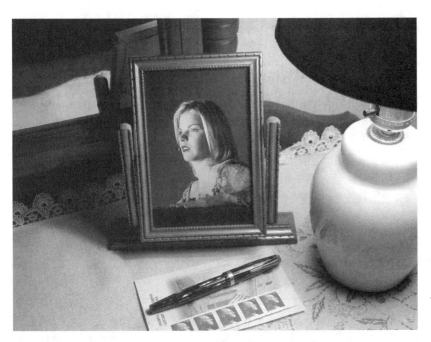

FIGURE 7.3

Here is our completed tinted portrait, framed and sitting on a guest room dresser.

Now that you've tinted Matina's portrait, the obvious question is, what if you don't like the color of her blouse? That's not a problem. Just choose a different color (Step 8) and have it your way. Don't like her blonde hair? How about a nice auburn? Just change the settings in Step 5.

An Alternate Method for Tinting

We tinted Matina's portrait on a single image layer. It's easy to do the work this way, but you might also want to use layers (called objects in PhotoImpact) as a safety net, especially when you're new at the game.

You can use layers to preserve each step in your colorizing process so that you can return to it later on. Before you start tinting an image, create the first layer (object) by following these steps:

1 Choose Selection ➤ All.

2 Choose Selection ➤ Convert to Object. When you do this, look at the menu to be sure Preserve Base Image is checked. If it isn't, choose Selection ➤ Preserve Base Image first and then choose Selection ➤ Convert to Object.

3 Desaturate this new layer so that you will still have the original image in full color as the document's base image.

4 Now that you have a layer, you can keep track of it and any new layers you create in the AccessPanel's Layer Manager. Choose View ➤ Toolbars & Panels ➤ AccessPanel and click the first button at the top of the panel to see a list of layer objects and their attributes.

5 After each step of the coloring process, duplicate the current layer by right-clicking it in the Layer Manager and choosing Duplicate from the contextual menu. Then hide the old layer by clicking its eyeball icon.

6 Target the duplicate layer for painting by clicking its name. You now have a new canvas to apply the next step, and you can easily hide and unhide it to compare it with the base image beneath.

This way, you'll always be able to fall back to a known good version if something goes horribly awry, even if the disaster happens several steps after the stage to which you want to return.

flash

If you're using a program that supports the creation of new empty layers, such as Corel PHOTO-PAINT or Adobe Photoshop Elements, you can create a new layer before you start applying paint. That way your base image is always preserved untouched, so you can erase paint and reapply it without affecting the base image. You can put all your color on one layer or use a different layer for each part of the image or each color; it all depends on how careful you want to be.

Other Uses for Doctored Portraits

It turns out that this colorizing technique isn't restricted to fine portraiture, as much fun as that is. It's also useful for more mundane tasks. Suppose you are dithering about whether to change your own hair color. Have a friend snap a head shot, load it into your image editor, and colorize just your hair. For this, you don't need to desaturate the entire image; just select your hair and use the Hue/Saturation command to desaturate that area alone.

You can also liven up a portrait by replacing a background like the plain one that was in our original picture with a prettier one, maybe a scenic vista. This is a standard photomontage technique, and we'll explain how to do it in Chapters 11 and 12. For our scenic portrait of Matina, we used a stock photo of the Arc de Triomphe and another image showing a gorgeous sunset sky. To achieve the necessary image harmony, we adjusted the hue and contrast on the arch and then applied a delicate overall orange cast to the portrait of Matina so it looks as though she's really sitting there in the lush, golden light of a Parisian sunset. You can see the result on our Web site at www.getcreativebook.com.

But wait! It gets better. You can easily extend the techniques in this chapter to other objects and see whether your house might look better painted a nice mossy green instead of the lavender that was there when you moved in—ten years ago. Or see if you might want to order your next car in Arrest Me Red instead of your usual Champagne Beige. The possibilities are endless.

Making a "Vintage" Photo

Before you start coloring, you'll need to prepare your photo. In the preceding Step 1, you simply desaturated the photo to remove its color. But if you'd like your photo to look authentically old, you can use a couple of the following techniques for producing old-looking pictures without applying very much color—if any at all. (As we'll show you in more detail in Chapter 9, sometimes less is more.)

That Contrast Thing Again

Let's start by skipping ahead to take a quick look at Plate 15.2. This bluish image shows very poor contrast; there's no truly white area, and there's no area that's dark enough to pass for anything approaching black. Low contrast is characteristic of many old photos, and you can deliberately reduce contrast to simulate this appearance. Figure 7.4 shows how we adjusted the contrast on a modern photo in this way. For this image, we chose Format ➤ Brightness & Contrast. We bumped the contrast downward 20 and kicked the brightness up 30.

FIGURE 7.4

This modern photo of Spadina House, in Toronto, Ontario, has been adjusted to look like a very old image.

Color Balance Revisited

Actually, we cheated on Figure 7.4. Remember, in Chapter 6, our discussion of orthochromatic and panchromatic films? Ortho films produce prints in which the blue end of the spectrum is brighter than the red end, and films older than ortho were even more severely skewed; to reproduce this effect, we used the technique we showed you in Chapter 6 to fiddle with the color balance in Figure 7.4 before desaturating the image and adjusting the brightness and contrast.

Not Up to Speed: Slow Films

Another way to make a photo look old is to take into account the fact that old films were slow and could not record rapid motion. When you look at a 1910-vintage photo of a racing car or a moving train, you're likely to see traces of motion—but not always in the subject itself. Most photographers back then were expert at *panning,* or moving the camera to follow the subject. When you pan to shoot a fast train, you get motion in the scenery behind it. With a little careful editing, you can introduce this effect of motion into a picture that lacks it. Figure 7.5 shows a railroad excursion train powered by the Southern Railway's classic locomotive 4501, before and after the addition of motion blur. (Richard made this photo on black-and-white film in 1970.)

To produce Figure 7.5b, open the image file named 4501_ky.tif and follow these steps:

1 Click and hold the Standard Selection tool to reveal a menu of other selection tools, then choose the Lasso tool.

2 Use the Lasso tool to select the train. First click the Addition button at the left end of the Attributes toolbar so that each new lasso selection is added to the existing ones rather than replacing them. Then click once to begin the selection, and click your way around the edge of the object you want to select. When you complete the selection, double-click in the middle of it to activate it.

3 If you've selected an area that's not part of the train, click the Subtraction button on the Attributes toolbar and lasso around the area to remove it from your selection.

(a)

FIGURE 7.5

Here is 4501 sidling along a railroad in Kentucky. The original image (a) shows only traces of motion blur because the train was moving slowly. The modified image (b) looks as if the train were speeding down the tracks.

(b)

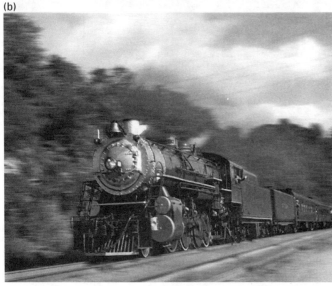

flash

Unless you're picky, you don't need to worry about deselecting very small bits of the scenery that show between parts of the train, but you should subtract larger bits such as the bushes showing through the ladder at the front of the locomotive.

4 When you've lassoed all the train's parts, choose Selection ➤ Invert or press the SPACEBAR to invert the selection so that it encompasses the scenery around the train rather than the train itself.

5 Choose Effect ➤ Blur ➤ Motion Blur. Click the Options button. Click Camera Shake and make the settings shown here:

6 Click OK.

If you look closely at the rods beside the locomotive's drive wheels in Figure 7.5b, you'll see that we blurred them as well. PhotoImpact doesn't have a radial blur filter, so we repeatedly selected small portions of the rods and applied very slight motion blurs at angles that we thought looked right.

To enhance the old-time effect on this image, you could adjust contrast and brightness as you did for Figure 7.4; but for now, let's leave it as it is.

flash

If you look at enough portraits from the 1860s and 1870s, you'll begin to see that people didn't always hold perfectly still, even when their heads were clamped in position. Applying a slight motion blur to just part of an arm is a great way to give the impression that a portrait is old rather than new.

Applying Color Without Applying Colors

That's not really as odd as it sounds. One of the easiest ways to color a black-and-white photograph is to tone it by putting it through a toning bath in the darkroom. Toning changes the overall hue of the picture, and toned photos can be very attractive. Among the most common toning solutions in the late 1800s were selenium compounds, which produce a brown tone that can be varied by the strength of the solution and the length of time the print is left in the toning bath. Another popular toner is sepia, which gives a warm reddish-brown hue. Plate 7.4 shows 4501 with brown tone (a) and with sepia tone (b).

To apply a brown tone, open your blurred version of the 4501 image and follow these steps:

1 If you want to preserve your original grayscale image, choose Format ► Data Type and make sure that Create New Image is checked. If you don't care, make sure that it's unchecked.

2 Choose Format ► Data Type ► RGB True Color.

3 Choose Format ► Hue & Saturation. Click the Colorize radio button and then apply the settings shown here:

4 Click OK.

To create a sepia-toned image instead of brown, use settings of Hue: –157 and Saturation: –60 instead of those just shown. This produces a redder image that is more saturated.

Where to Look for Inspiration

So how do you decide what portraits to colorize? Start with those of people you see every day, so you can get a feeling for the real-life colors those people wear on their skin, in their hair, and on their clothing. Choosing colors is easy; make the people look natural (with a little room for artistic freedom, as we suggested earlier), and make their surroundings any colors you think appropriate.

As for styles, look at portraits made by great photographers. (Don't restrict yourself to photography; remember, we hand-tinted a photograph deliberately so it would look less like an ordinary photo. Painted portraits can be a good source of inspiration, too.) You can often find some of the best photographs in unlikely places, such as magazines. *Harper's Bazaar* and *Vanity Fair* are wonderful idea sources because they feature superb photography—even in their advertisements. On a more mundane plane, *Life* is a great font of creative impetus. Or your image editor may have come with a CD of images. Look there for image ideas.

More Great Ideas

Colorizing portraits is fun, and there are lots of ways to use the resulting images. Here are a few thoughts to get you started:

- Photo soap? Sure, why not! Scan an old graduation picture, hand-color it, and print it out at a smallish size. Then stick clear packing tape on both sides. Fill a soap mold halfway with a clear glycerin soap mixture, drop the photo in, and fill the mold the rest of the way. See our version in Figure 7.6 and in color in Plate 7.5—it made a great anniversary gift.

- Make a little girl a very special doll—start with a photo of Mom, Grandma, or even herself. Trim the image to just the face, then colorize it, print the image on cotton, and make it the basis for a custom rag doll.

- Remember that locket your grandmother gave you? It's sitting in your jewelry box because you don't have any suitable photos to put in it, right? Well, get busy!

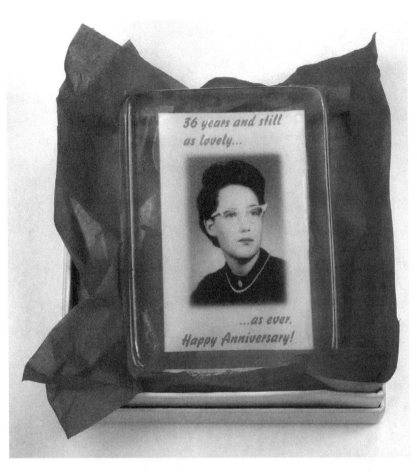

36 years and still as lovely...

...as ever.
Happy Anniversary!

FIGURE 7.6

With clear glycerin soap, it's easiest to see the photo, but feel free to experiment with colored soaps, too. Try using clear soap for the top surface and colored for the bottom.

- Celebrate a new baby by scanning photos of family members, colorizing them, and printing them on light-colored fabric, then piecing the images into a crib quilt—a gift that will be treasured for a lifetime.

- Make a set of coasters featuring all your girlfriends. Colorize a picture of each of your friends, make a coaster of each one, and give the set away at your next get-together. This works with boyfriends, too.

8

Housewarming, 1850s Style
Creating "Vintage" Hand-Tinted Postcards and Coasters

IN Chapters 6 and 7, we played games with several aspects of a photograph in order to achieve various vintage looks. We adjusted levels, contrast, hue, saturation, and overall tone, and we "hand colored" a portrait of our friend Matina. In this chapter, we're going to combine several of the techniques we used in the last two chapters and add one or two more to produce a hand-tinted photo that looks very different from the image of Matina. If you look back at Figure 7.3, which shows how we used our hand-tinted portrait of Matina, you'll see a pen lying on some stamps and a pile of postcards that show the front entrance of Richard's 1846 house. We enjoy creating postcards like this to use ourselves and also to leave in our guest rooms for guests to use. For this chapter, we decided to make up a matching four-folded note card for guests who might want to write more than a sentence or two, and that's when our troubles began.

We've touched before on the fact that once you've created a modified image, you can use it more than once.

We used Microspot PhotoFix for the projects in this chapter. PhotoFix is a Macintosh-only program, and it does not support layers. It also lacks a "colorize" mode for its painting tools, but we've worked out some creative ways to deal with this limitation. You can use any image-editing program that is able to adjust levels, contrast, hue, and saturation to complete these projects.

137

This is something you learn by experience: it turned out that when we wanted to create our four-folded note, we couldn't. We hadn't saved the original image! So we had to shoot another photo of *almost* the same scene, and we'll use the new image for our note card. After we create the note card, we'll use the same image to make a set of foam-rubber coasters for our guests' cold drinks.

Mass Market Color Before Color Photography

We don't want to repeat all that we said in Chapters 6 and 7, but we'd like to remind you here that before color photography became widely available, people colored their own photos with transparent oil colors. Not everyone was a James Whistler, or even a Vincent van Gogh, and as a result many of the pictures people tinted were obviously amateur work. This isn't necessarily a bad thing, especially in our time, when so much of what we use is mass-produced. As the saying goes, "Nostalgia isn't what it used to be," but we appreciate things that have been somehow worked by hand; they remind us of what we like to think of as a simpler, less harried past. With this in mind, we will make no attempt to produce a "professional" result; instead, we'll capitalize on the ease with which we can make our work look like the product of human hands. (And it actually will be, you know, because the computer and the image editing program we use are only tools, just as paintbrushes and oil paints are tools.)

focus

But what if your house isn't old? Not everyone is lucky enough—or unlucky enough, depending on how you view it—to live in a house that's more than a century old. Your own house, even if it was built just last year, will still make a good picture. Since Richard's house is old—it was built in 1846 and remodeled when it was moved in 1901— we're going to make our image look extremely old, but you can vary the techniques we'll show you, adding more color, more "grain," and so on, to produce something completely different, something that adds appeal to your own image. Get creative!

Finding Inspiration

Assuming that you'd like to make your image look like an authentically old one, how do you find out what the old ones looked like? Easy. You find some old postcards. Visit antique shops and flea markets. We know of one dealer, whose home turf is a booth in the Byfield Antique Mall in Massachusetts, who offers thousands of old postcards featuring any conceivable subject. Some are black and white, some are commercially tinted, and some, more

recent than what we're looking for now, are luridly colored—or actual color photos. We visited that old gent's booth before we started writing this book, just to collect ideas. Figure 8.1 shows one of the postcards we came home with.

flash

As you work through a project, you'll be setting the color of your paintbrush or other tool several times. It's a good idea to save each color you use, in case you need it later. One way of doing this is simply to note down your settings, and that's what we did in Chapter 7. This time we'll save ourselves all that scribbling by using PhotoFix's ability to store custom colors.

When you open an image in PhotoFix, the program chooses a dozen colors from the palette in the image and loads them into its Color Storage Area, located along the right edge of the Colors palette. To save a color that you're going to use, set the color as your Foreground color, then move the cursor over one of the boxes in the Color Storage Area and press Option. The pointer will change to a paint bucket, and you can click the mouse button to store the Foreground color in that box, as shown here:

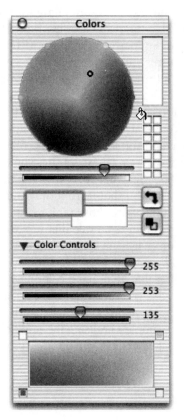

FIGURE 8.1

Here's a delicately colored (well, the original is colored) image of Calhoun Park in Springfield, Massachusetts.

G 21632 Calhoun Park, Springfield, Mass.

Choosing colors for your image is simple, right? You just keep a copy of the image as it was and dab them all back in—right? Let's stop and think about this for a moment. Suppose you're living in 1885, and you're about to begin tinting the pictures you made using your Kodak box camera while you were on vacation. In those days, people sent their photos away, camera and all, to be processed by Eastman Kodak, and Kodak sent back the negatives and prints along with a freshly loaded camera. (Sounds like today's one-use cameras, doesn't it?!) You're at your work table, with your oils all lined up; you pick up your brush, and you look over at the first color original to see what color you should start with . . . except that you don't have any color originals, because it's 1885! So, what color was that house in Waukegan that you liked so much that you shot it from the train platform during a stop for coal and water? And were those pink roses or white?

As we said in Chapter 7, there's no rule that says you have to stick with the original colors of your image—in fact, it's not necessarily even authentic to do so. You don't even have to stick with realistic or naturalistic colors; for a couple examples of "better than real" hand coloring, check out Plates 8.1 and 8.2. If you want to make your house look like a San Francisco Painted Lady or a poster for your neighborhood garage band, go right ahead. So choosing colors can be as simple as reusing the originals, but that's not nearly so much fun as using whatever colors you'd rather use—whatever they are.

Saddle Up! Preparing the Image for Coloring

Figure 8.2 shows the photo you'll be working with, a nice late-afternoon shot of Richard's front entrance. If the American flag in the picture looks a little funny, don't worry. It's supposed to be that way; it's the 28-star flag that was in use when the house was built, late in 1846. Now that we've resolved that little issue, let's move on to getting this image ready to be colored. You're going to apply a number of smallish changes to it throughout this section.

We've placed the images used in this chapter on our Web site so you can download them and work along. You'll find them here: www.getcreativebook.com.

Resampling the Image to Make It Ugly—Why?

The original image is 1024 pixels wide by 1280 high. If we just change the image size without resampling to make the image 3.5" wide, we'll end up with almost 300 pixels per inch (ppi). That's good print quality. But we're

FIGURE 8.2

Here is the front entrance of Richard's house.

going to resample the image to cut the resolution in half. We do this because we want a seriously ancient look, and the earliest photos had very coarse film grain. Also, there was a period in the late 1800s when tiny novelty "buttonhole" cameras were all the rage. Images from those cameras had to be enlarged, and the results were often poor resolution and coarse grain. As we reduce the image resolution to 150 ppi to make the picture grainier, we'll also change the print size; our changes will produce an image that prints roughly 3.4" by 4.3", the size we want for our note card. Open the image file named flag_1846.tif, and follow these steps:

1 Choose Image ➤ Resize.

2 Click the Image radio button, and make sure Keep Proportions is checked and Keep File Size is unchecked. Make the resolution and size settings shown here:

Resize			
Resize			
● Image			
○ Canvas	Image Position:		
Keep: ☑ Proportions	☐ File Size		
Size			
	New	Current	
Memory size:	960 K	3.75 M	
Resolution:	150	dpi	144 dpi
Width:	512	pxls	1024 pxls
Height:	640	pxls	1280 pxls
Unit:	Pixels		
	Cancel	OK	

3 Click OK.

You could bypass the resampling process at this point and apply it later, but doing it now will reduce the size of the image file, and this saves processing time in all the steps that follow.

Removing the Color So We Can Add It Back In

Since you're starting with a color photo, the next thing you have to do is desaturate it. But you shouldn't desaturate it entirely, because that will make it more difficult to work with later. (Image editors change saturation by multiplying by a percentage, and any percentage times zero is still zero.) Follow these steps:

1 Choose Image ➤ Settings ➤ Hue/Saturation and set the Saturation slider to about 20 percent, as shown here:

2 Click OK.

Correcting Perspective Distortion

Any time you photograph an object at an angle, perspective distortion makes parallel lines appear to converge toward a "vanishing point" on the horizon. Look at Figure 8.2 for a moment, and you'll see that the side edges of the front wall slant inward toward each other because we took the picture with the camera aimed slightly upward. This is actually how your

eye sees things, but your brain knows that those corners are really parallel, so you don't notice the distortion until you see it in a photo. Then, suddenly, it looks odd and unattractive. But if you look at professional architectural photos, they look better because there's no distortion. Why not? It's because most large-format cameras are adjustable in ways that eliminate the distortion.

With most image editing programs, you can correct your images to eliminate perspective distortion. To correct the distortion of Richard's house in PhotoFix, follow these steps:

1 Choose the Zoom tool and click in the image window to enlarge the view, or hold the OPTION key and click to shrink the view. Then drag the lower right corner of the document window as necessary to show the entire image plus a little gray background around the image.

2 Choose Selection ➤ All, or press COMMAND+A to select the entire image.

3 Switch to the Rectangular Selection tool and choose Image ➤ Distortion ➤ Perspective 3D. Resize handles will appear at the four corners of the image.

4 Click on the lower left resize handle, and drag it to the right a little. This is a trial-and-error adjustment, and you can undo it repeatedly until you're satisfied. At this point, your image window should look like this:

5 Release the mouse button and move the cursor to the center of the image. When the cursor changes to a hammer, click to apply the perspective change.

6 Check to see that vertical lines are vertical. If they are not, undo the perspective change and reapply it with a slightly different positioning of the resize handle.

flash

The easiest way to check that vertical lines are vertical is to choose the Rectangular Selection tool and draw a selection marquee so that one side of it lines up right over a vertical line near the left side of the image. If that line is truly vertical, repeat the process near the right side. If both aren't vertical (or close enough to satisfy you), you need to undo the perspective change and reapply it (Steps 4 and 5).

7 Once you're satisfied that you've corrected the perspective distortion, choose the Rectangular Selection tool and draw a selection marquee from the lower left corner of the corrected image to the upper right corner leaving out the white area that appeared along the left side. Choose Image ➤ Crop.

8 Repeat Step 7, selecting from the lower right corner of the corrected image to the upper left corner.

Simulating Film Grain

Some image editing programs include filters that simulate film grain. PhotoFix doesn't have such a filter, but you can simulate it. (We're going to simulate a simulation here, folks. Watch carefully, as the magician says, and you'll see that at no time will our fingers leave our hands!)

In fact, you've already accomplished the first step of the process; you did it when you resampled the image to 150 ppi. For the next part of the job, follow these steps:

1 Choose Filter ➤ Add ➤ Noise.

2 Check the Monochrome check box, and set the Amount to 50.

3 Click OK.

There'll be one more step to this grain-ifying process, and it comes later on as part of the coloring procedure.

Adjusting Levels

We said earlier that a common characteristic of very old photos is a lack of contrast. To reduce the contrast in this image, follow these steps:

1 Choose Image ➤ Settings ➤ Levels.

2 Set the Output levels to 50 and 255.

3 Click OK.

Vignetting the Photo

You're almost there—you just have one more little procedure to get through before you can start coloring. A fairly common technique for making a photo just that little bit prettier is to vignette it. Nineteenth-century portraits were frequently vignetted with an ellipse that gradually faded the image to white. We'll use the fading technique here, but we won't use an elliptical shape because it's not appropriate for the note card we're creating. To create the vignette, follow these steps:

1 Choose Selection ➤ All or press COMMAND+A to select the entire image.

2 Choose Selection ➤ Feather/Transparency. Set the Radius to 24 and the Opacity to 100%, as shown here:

3 Click OK.

4 Choose Selection ➤ Invert—this changes the selection to encompass the edges of the image rather than its center.

5 Press the DELETE key five times. Each time you press the DELETE key, a little more of the feathered border inside your selection marquee is knocked out.

6 Drop the selection by choosing Selection ➤ None or pressing COMMAND+D.

You have now finished the advance preparation, and you're ready for the fun part. Figure 8.3 shows the image at this point.

Applying Colors

Photographic paper for printing black-and-white film images in the darkroom is usually sold in white or cream color. We're going to simulate the use of cream-colored paper for the photographic image on our note card. (We could make the entire front surface of the note card cream, and that's an option you might consider; but we like the idea of having just the picture itself with a cream-colored base tone.)

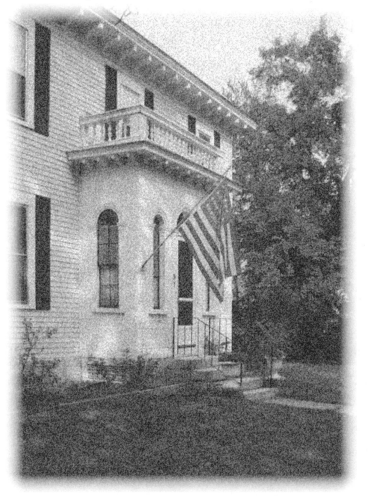

FIGURE 8.3

Here is the house image resampled, with its levels adjusted, the start of grain added, and the edge vignetted.

As you go through the colorizing procedure, feel free to zoom and scroll around as much as you need so that you can work comfortably. This procedure looks long, but once you get going, it will move along very quickly.

To color the house image, follow these steps:

1 Choose Selection ➤ All or press COMMAND+A to select the entire image. Choose Edit ➤ Copy or press COMMAND+C to place a copy of the image on the clipboard. This is the first step in creating a mask for applying an all-over tint.

2 Choose File ➤ New or press COMMAND+N to create a new image. In the New File dialog box, make the settings shown here:

New Image
Dimensions:
Resolution: `150.00` dpi Width: `2.93` in
Unit: `Inches` Height: `4.17` in
☑ Keep proportions
Format: ○ Custom Contents: ⦿ Empty (white)
⦿ Clipboard ○ Screen shot...
○ Passport photo ○ Clipboard
○ Postcard
○ US Letter
Palette: `RGB color`
Cancel OK

Don't worry if the dimensions of your new image are slightly different from ours; the discrepancy occurred when we (or you) cropped the image after adjusting its perspective. The Clipboard option in the Format section of the New File dialog box ensures that the new image will be the same size as the image on the Clipboard.

3 Click OK.

4 Set the Foreground color to Red: 51, Green: 51, Blue: 51.

5 Choose the Paint Bucket tool and click anywhere in the image window to fill the entire image with gray.

6 Return to the house image. Choose Selection ➤ Load Mask. Click the From Image radio button and observe that the pop-up menu shows "untitled," as you can see here:

Untitled is the gray image you created in Steps 2 through 5. You'll use this image, which is 80 percent gray, as a mask to block out 80 percent of the color you're about to apply to the house image.

7 Click OK.

8 Set the Foreground color to Red: 255, Green: 233, Blue: 135. This yellow color is more intense than you'll have at the end of the process; the mask you'll apply in the next step will temper the color, as will the brightness and contrast changes we'll make at the end of this project.

9 Choose the Paint Bucket tool and choose Edit ➤ Fill to flood the entire image with the Foreground color. The mask you loaded in Step 6 allows the Paint Bucket to affect the image only to an intensity of 20 percent, as if you had applied an overall colorization. This is one of the ways you can work around PhotoFix's lack of a colorizing mode. Without the mask, the Paint Bucket would simply fill the entire window with the yellow color, covering the image.

10 Choose the Lasso tool and select all the grass and the bushes along the front of the house. The easiest way to do this is to select a part of the grass, then hold down the SHIFT key to switch to Addition mode, and start the next part of the selection. Once you've begun dragging around the area you want to add to the selection, you can release the SHIFT key. To subtract areas that you don't want to paint, hold down the COMMAND key as you begin dragging around the area you want to remove from the selection.

flash

To create a straight selection edge with the Lasso tool, let PhotoFix finish a selection, instead of trying to close the selection yourself by drawing all the way around the area you want to select. For example, to select a square, start a selection at the upper left corner of the square. Drag the Lasso to the center of the square, then drag it to the lower left corner and release the mouse button. PhotoFix will finish this triangular selection by drawing a nice straight line where you want the left side of the square to be. To select the rest of the square, hold down SHIFT and make three more triangles, overlapping each added area with the already-selected area.

If you like, you can also include the bushes to the right of the house, but it's not necessary. Also, because the outer edge of the image is feathered, you can't select all of the grass. (You can't even be positive where it ends!) For this feathered portion, choose a middle line somewhere between the fully opaque grass and the fully transparent border.

11 Set the Foreground color to Red: 53, Green: 153, Blue: 0.

12 Choose the Paintbrush tool. Using the Tool Settings palette (View ➤ Show Tool Settings), make the settings shown here (Size: 256, Opacity for Dark Tones: 20%, Opacity for Bright Tones: 20%):

Settings
256 16 32 16 16
Brush Tool Size: 256
Opacity:
Dark Tones: 20 %
Bright Tones: 20 %
Change the shape...

13 Paint the grass with three clicks, using the tool outline circle to gauge where to place the tool pointer. Pause between clicks if necessary to allow PhotoFix to update the image. (Do not even think about trying

to get absolutely uniform coverage; if we wanted to do that, we would create a mask.) We started toward the right side, then clicked about in the middle, and finished to the left as shown here:

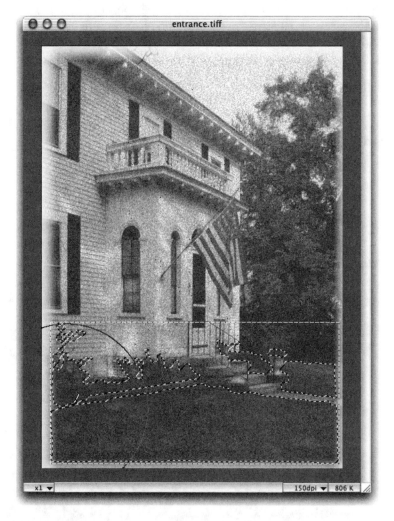

14 Select the trees. Change the foreground color to Red: 31, Green: 93, Blue: 0, and paint the trees the way you painted the grass.

15 Select the flag's stripes. Change the Foreground color to Red: 255, Green: 0, Blue: 0. Position the brush over the center of the selected area and click three times, pausing to allow PhotoFix to update the image. This will make the stripes nice and bright—you'll make them even brighter later.

16 Select the canton (the blue field) on the flag. Deselect very small areas, just two or three pixels in diameter, where it appears that there should be a star, to leave these areas uncolored. PhotoFix will select adjacent pixels to make a slightly irregular shape, and each one will be a little different. Change the Foreground color to Red: 0, Green: 0, Blue: 83 and paint the canton as you did the stripes, but with four clicks this time. Figure 8.4 shows what the flag should look like now.

17 To paint the sky, use a partially feathered selection. Choose Selection ➤ All or press COMMAND+A to select the entire image.

18 Choose Selection ➤ Feather/Transparency. Set the Radius to 24 and the Opacity to 100%, just as you did to vignette the image.

19 Choose the Lasso tool and deselect the house, the trees, the grass, and everything else except the sky. Leave the bigger bits of sky that show through the trees selected. (This is a good time to use Subtraction mode repeatedly to build a bigger area that is not selected.)

20 Set the Foreground color to Red: 128, Green: 192, Blue: 255 and paint the sky.

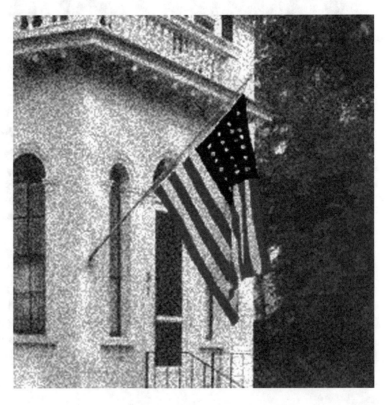

FIGURE 8.4

Here's a zoomed-in look at just the flag area from the image after it has been colored.

21 The image looks a little pallid all over. Now you're going to brighten it up and at the same time finish the simulation of film grain that you started so long ago. Choose Image ➤ Settings ➤ Bright/Cont & RGB. Set the Brightness and Contrast to 65 and 70, respectively, as shown here:

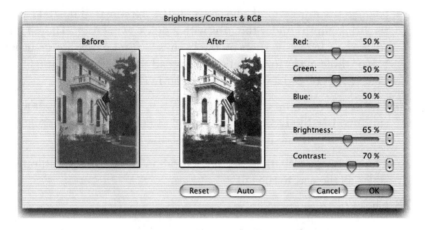

22 Click OK.

23 You're almost there. It's time to paint the flowers and the brick plinths under the urns beside the steps. Set the Foreground color to Red: 69, Green: 133, Blue: 255. Set the Paintbrush size to 6 pixels. Now change the Opacity to 0% on Dark Tones and 50% on Bright Tones, as shown here:

24 Paint the flowers on top of the urns. By changing the Opacity settings, you are compensating in another way for the lack of a colorizing mode; with the settings as they are now, PhotoFix won't apply any color on darker areas under the paintbrush.

25 Change the Foreground color to Red: 161, Green: 0, Blue: 0. Paint the brick plinths under the urns with a quick swipe each. Then dot in some roses in artistic spots on the bushes in front of the house, using two or three clicks for each flower. Spread the clicks out a little to make each colored area a little irregular in shape.

26 The final step of the colorizing process is to blacken in the door and shutters. Use the Lasso tool to select these objects, remembering to use the straight-line technique we described earlier.

27 Choose Image ➤ Settings ➤ Hue/Saturation and move the Saturation slider all the way to the left.

28 Click OK.

29 Choose Image ➤ Settings ➤ Bright/Cont& RGB. Set the Brightness and Contrast sliders to 40 and 50, respectively.

30 Click OK.

If we've all done our jobs right, your image should look like Plate 8.3. Now let's take a break—after 30 steps, you deserve one. Why don't you get up and get yourself a nice tonic? If you're not in New England, that's a soda. Or a pop. You know, that fizzy stuff with sugar in it.

Making a Four-Fold Note Card

We're back. A four-fold card is simply an ordinary sheet of letter paper, folded into quarters. To make one using the house image, save an extra copy of the image as it is now (for later use), then follow these steps:

1 Set the Background color to white.

2 Choose Image ➤ Resize. Click the Canvas check box and click the center box in the Image Position grid.

3 Set the pop-up Unit menu to Inches, and then set the size to Width: 4.25, Height: 5.5. These dimensions are exactly half the size of a sheet of letter paper in the USA. (If you're in a country where A4 paper is used, set the Unit menu to Centimeters and set the size to Width: 10.5, height: 14.85.)

4 Click OK.

5 Choose Image ➤ Resize. First, make sure the Canvas button is still selected. Then, click the lower right box for Image Position. Set the size to Width: 8.5, Height: 11 (or, in metric countries, Width: 21.0, Height: 29.7). This will position the image exactly in the center of the lower right quarter of the paper.

6 Click OK.

7 Print your image. PhotoFix does not complain about an image that is larger than the area your printer can print; instead, it politely positions the printable portion of the image properly. Since the printable part of this image is within the printable area for virtually every printer made, none of the image should be clipped off.

8 Fold the paper in two, with the printed image outward, by folding the top edge of the paper down backward to meet the bottom edge. Line up the corners and crease the fold line carefully.

9 Again fold the paper in two, again with the printed image outward, by folding the left edge across backward to meet the right edge. Line up the corners and crease the fold line carefully.

Plate 8.4 shows the finished note card. You can buy envelopes for cards like this at most office-supply superstores; they're usually called "invitation" envelopes.

A Picture Needs a Dozen Words

The note card you made is useful when you want to send a personal note; it's got lots of blank space to write in. But you can also use this same basic design (with a different image, perhaps) as a greeting card or a party invitation. All you need is to add some text that will be folded up inside. Here's a brief description of how to do this.

To make a text panel, create a new image 4.25" by 5.5", with a resolution of 300 ppi. (In metric countries, set Width: 10.5, Height: 14.85.) Use PhotoFix's Text tool to create the lines of your text and place them into the image. As you create each line or group of lines, drop the selection (Selection ➤ None or COMMAND+D). When your text panel is finished,

rotate it 180°; it must be upside down on the printed page to come out right when the paper is folded. (PhotoFix doesn't have a "rotate 180°" function, but you can just rotate 90° twice.)

To merge the text panel with your note card, you first need to resample the 150-ppi note card to 300 ppi, preserving the print size. (This will quadruple the size of the image file.) If you're using a program that offers a choice of resampling modes, choose Nearest Neighbor so that your image will retain its coarse, rough appearance.

Now copy the text panel image to the Clipboard and paste it into the note card image. PhotoFix will paste it in the upper left

corner, aligning the edges of the floating text panel so that they're exactly at the edges of the page. The following illustration shows how the finished page should look.

Here we've added text to the note card to make it into an invitation for a housewarming.

Bottoms Up—Making Custom Drink Coasters

Now that you have this delightful tinted image, you can do other things with it. Plate 8.5 shows a set of drink coasters we made using the Imagination Gallery E-Z Transfer Coaster Kit from Micro Format, Inc. (on the Web at www.paper-paper.com).

To make coasters, create a circular image by following these steps:

1 Open the version of the image that you saved before you resized the canvas to make the note card. You did save it, didn't you?

2 Choose the Oval Selection tool. Click the Constraint check box in the Tool Settings dialog as shown here:

Settings

○ No constraint

● Constraint

Size : [Other... ⇕]

Width: 1.00

Height: 1.00

3 If the Width and Height are not both set to 1.00, choose Other from the Size pop-up menu and set the size as shown here:

Proportion Setting

Width: [1.00] Height: [1.00]

(Cancel) (OK)

4 Click OK if you needed to set the size.

5 Click in the extreme upper left corner of the image and drag a selection downward and to the right until your selection marquee is exactly the width of the image. Release the mouse button.

6 Choose Selection ➤ Feather/Transparency. Set the Radius to 24 and the Opacity to 100%.

7 Choose Selection ➤ Invert so that the area outside the circle is selected.

8 Press the DELETE key five times. This leaves a circular image with a feathered edge like the edge of the original rectangular image. The right edge isn't quite perfect because you already feathered it away, but it'll look just fine when it's transferred to the coaster material.

9 Choose Selection ➤ Select None or press COMMAND+D to drop the selection.

10 Choose Image ➤ Flip Horizontal. You have to do this because the transfer material you'll print on is transparent and will be placed printed side down on the coaster. Figure 8.5 shows what your image should look like now.

11 Choose Image ➤ Resize. Click the Image radio button, and make sure both Keep Proportions and Keep File Size are checked.

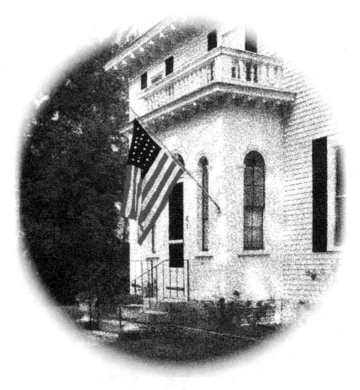

FIGURE 8.5

Here is the house image, vignetted in a circle and flipped horizontally for printing onto the reverse side of the transfer material.

12 Choose Inches from the Unit pop-up menu, and set the Width value to 3.75. This changes the image resolution to 125.59 ppi, which is plenty for printing on the coaster material.

13 Click OK.

14 Choose Selection ➤ All or press COMMAND+A to select the entire image.

15 Choose Edit ➤ Copy or press COMMAND+C to copy the image to the clipboard.

16 Choose Image ➤ Resize. Click the Canvas check box and click the upper left box in the Image Position grid.

17 Set the pop-up Unit menu to Inches, and then set the size to Width: 7.5, Height: 10.

18 Click OK.

19 Choose Edit ➤ Paste or press COMMAND+V to paste in a copy of the image. This automatically chooses the Rectangular Selection tool. Click in the middle of the pasted image and drag it to the right until

the selection marquee just touches the right edge of the canvas. (We moved the copy downward a little too, to give ourselves more white space between the printed images. This made it easier to trim around the coasters after the images were applied.)

20 Choose Selection ➤ None or press COMMAND+D to deselect the image you moved.

21 Repeat Steps 19 and 20 to paste in two more copies of the image, moving these copies to the lower left and lower right portions of the canvas. Figure 8.6 shows the final version of the image, ready for printing.

FIGURE 8.6

Four coaster images will be printed on one sheet of paper.

flash

You don't have to make all your coasters the same; you could make a set of the Twelve Days of Christmas, or one in which each coaster shows a different animal from Old MacDonald's farm, or . . . anything your creativity inspires you to design!

You can now print your "four-up" image onto the coaster transfer material and complete the coasters following the manufacturer's directions. There's a similar kit available to make mouse pads—just think of the possibilities!

More Great Ideas

Hand-tinted images are usually delicate and old-fashioned, although they can be bold and modern. There are lots of ways you can use images like the ones in this chapter:

- It's simple, but it's a classic: Why spend a mint on greeting cards when you can make your own so easily? Exercise your creativity when it comes time to send cards for birthdays, thank-yous, anniversaries, new babies, weddings, and more.

- We turned one of our favorite vacation images—the Red Lion Inn in Avebury, England—into a mug by hand-tinting the photo, printing it, and inserting it into a plastic mug kit we found at A. C. Moore. You can see the result in Figure 8.7.

- Making your own return address labels is easy—first create your image, then follow the instructions in a package of Avery or other brand inkjet labels to set up your image and text so that they'll print on each label. Be sure to get label stock designed for use in an inkjet printer, so it won't smear.

- How about making a necktie? No, it won't fit through the printer, but you can buy blank silk neckties from Dharma Trading Co. (www.dharmatrading.com) and use iron-on transfers to make them wholly your own.

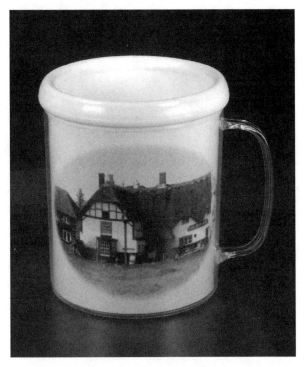

FIGURE 8.7

We think this mug was intended to hold a piece of cross-stitch embroidery, but we like it better with this hand-tinted photo.

- Make a sassy tote bag for your friend: Take a hot-pink canvas bag, scan in that old black and white postcard you have of Audrey Hepburn or Catwoman, colorize the image, iron it onto the bag, and give it to your friend for her birthday.

9

With Color, Less Really Can Be More
Creating Duo-, Tri-, and Quadtones

COLOR is great, but photographers know that some images improve when viewed in plain black and white. Black and white photos show contrast better, enabling the viewer to concentrate on shapes and the interplay of light and dark within the image. But isn't it a shame to give up the eye-catching appeal of color in exchange for these advantages? Duotones, and their siblings tritones and quadtones, represent a way to have your cake and eat it too. And just as a bonus, turning your photos into old-fashioned or arty-looking duotones is one of the easiest projects in this book.

In this chapter we'll create several duotones, and we'll turn one of them into a CD cover for one of our latest mix CDs. After we've thoroughly explored the world of duotones, we'll show you a quick-and-dirty way to fake duotones that you can use if you're in a hurry or if your software doesn't support real duotones. To follow along with us, you'll need to download the images from our Web site; you can find them at www.getcreativebook.com.

The examples in this chapter use Corel PHOTO-PAINT, but you can complete them using any image editor that has a duotone color mode. You can also create simulated duotones in any program that can adjust an image's hue and saturation or that enables you to apply different blending modes to layers. The names of some commands may vary, but the dialog boxes and settings in any program will be very similar to what we'll show in this chapter.

What's a Duotone?

Duo, of course, means "two," which means that a duotone is an image made up of two tones, or colors. Most of the photos we see are either black and white—meaning that they're composed of shades of one tone, gray—or full color. Duotones, tritones, and quadtones fall somewhere in the middle. Take a look at Figure 9.1 to see an example of a quadtone effect—the color version is on our Web site at www.getcreativebook.com.

It's the Color, Stupid!

No, of course we don't think you're stupid—it's just that this paraphrase of Clinton campaign strategist James Carville's famous expression from the 1992 U.S. presidential race really says it all. Duotones are all about taking a black and white photo and throwing color into the mix—not so that you can simulate a color photo, as we did in Chapters 7 and 8 when we played with hand-tinting. No, with duotones the idea is to add color arbitrarily to generate a completely new effect. To create a duotone, you start with a

FIGURE 9.1

Richard created this record album cover from one of his beloved train photos. It's definitely a vintage look—just one of the many applications of duotones.

grayscale (black and white) image and apply just one other color to it, without regard to the real-life colors of the objects in the photo.

Duotones were first used to save money in the printing process. If you reduce the number of printing inks used to create a color image, you're also cutting the press setup time, the number of passes the paper must make through the press, and the clean-up time—not to mention using less ink. All this makes duotone photos cheaper for printers to produce than full-color images, and therefore they're cheaper for printers' customers too. If you're printing a newsletter, for example, you can cut costs by turning your photos into duotones and printing with two colors rather than printing with four colors.

Both printers and their customers have noticed over the years that, as well as appealing to the frugal among us, duotones actually look pretty good. In fact, they can combine the best of both worlds by giving an image the contrast and clean lines of black and white photos *and* the warmth and visual interest of color images. That's why designers love to use duotones even when printing costs aren't a primary concern. Adding a lightish gray ink when printing a black and white photo can reveal shadow detail and add warmth, and a duotone made with black and a warm brown ink can make a brand-new image look like a vintage photo.

Let's Talk Levels

You can create duotones from black and white photos, or from color photos that you convert to grayscale first. To make a duotone in the traditional world of printing presses, you'd start with a grayscale image and duplicate it. You'd create a printing plate from the original for black ink, then you'd adjust the levels of the duplicate and create a plate for a single colored ink. Generally, you'd lighten the shadows and darken the midtones in the image that would be used to print the color, so that the color would gain intensity in the gray areas of the image without being printed too darkly over the black areas of the image.

You can get all kinds of different effects by manipulating a duotone's levels. For example, the train photo shown in Figure 9.1 doesn't look much like a photo at all because its levels curves have been tweaked to the extreme. The photo you're about to work on, however, will still look like a photo when you're done—just a much cooler photo!

Now that we've revealed the wonder of duotones, let's take a look at how they're made. You say you've only got an inkjet printer and you weren't planning on buying your own printing press any time soon? Hey, that's OK! Although duotones were invented by printers for their own purposes, that doesn't mean that you can't print them on your inkjet printer or turn them into Web images. Think of them as a special effect rather than as a printing process, and the possibilities will open up before your eyes.

Duotone It the Easy Way

Naturally, PHOTO-PAINT makes it much easier to create a duotone than all that rigmarole with printing plates. The same is true of any image editor that supports duotones. In general, you'll follow four or five easy steps to create one:

1 Open the image file—by now you should have this one down pat.

2 Convert the image to grayscale mode. This is optional; some programs require it, and others can start directly from the color version of the image and include the grayscale conversion within their duotone function.

3 Switch to duotone mode, a simple matter of a single menu selection.

4 Choose your colors using a standard color picker.

5 Adjust the curve for each color. Things get slightly—*just* slightly— more complex on this step. But don't panic—we'll walk you through it.

Now that you've got the theory down, let's put it into practice. First you'll play with a photo of a cozy domestic scene that we shot one winter afternoon. Later in the chapter you'll move on to some real projects that you can make with duotones.

What a Difference a Duotone Makes

Let's see just how much difference you can make in the impact of this photo by turning it into a duotone. It's a cluttered color image of our friend Cecelia making cookies in Kate's kitchen. While the scene is appealing, it's hard to focus on what Cecelia's doing because of all the objects in the image. Reducing the number of colors might just bring the distraction level down enough to make this image really shine. Ready? Let's go:

1 Open the cookie-baking image shown in Figure 9.2 (cookies.tif, available on our Web site).

FIGURE 9.2

The cookies smelled great the day Kate took this photo, but the image isn't quite as tasty.

2 Don't worry—you can salvage this photo! First, turn it into a grayscale image. Although PHOTO-PAINT allows you to go directly from a full-color image to duotone mode, you'll usually get better results if you stop at grayscale on the way and adjust the levels. With that in mind, choose Image ➤ Color Mode ➤ Grayscale (8-bit).

3 Now make a slight levels adjustment. Choose Image ➤ Adjust ➤ Contrast Enhancement. Make sure that the Histogram Display Clipping check box is unchecked (and click Reset if it was checked),

then drag the Gamma Adjustment slider to the 1.30 point on the scale and click OK. Here's what the dialog box looks like:

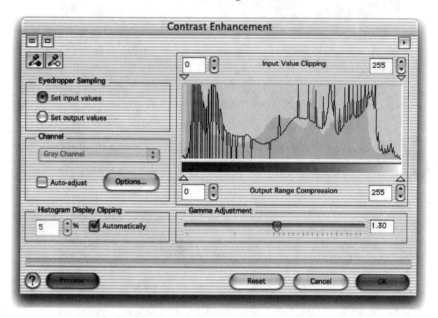

4 Now choose Image ➤ Color Mode ➤ Duotone (8-bit). Unlike Grayscale, which does its work with no dialog box, this command lands you in the Duotone dialog box, where you can choose your mode (Monotone, Duotone, Tritone, or Quadtone), pick ink colors, and adjust an ink coverage graph for each color.

5 At this point, the image is a monotone, meaning it has just one color. In this case, that color is black, but you can change that to any color. Let's move on to duotones, however—you can come back and play with monotones any time you like. To make this image a duotone, choose Duotone from the Type pop-up menu at the top of the dialog box.

6 Now you'll see two colors listed in the ink list below the Type pop-up menu. If this is the first time you've played with the Duotone dialog box, those two ink colors are PANTONE Process Black C and PANTONE Process Yellow C. Despite their long names, these are our old friends black and yellow from the CMYK color mode—in other words, they're two of the four colors used for four-color process

printing. Now that you know that, let's change 'em! (Unless you really like the effect of using black and yellow—click Preview to see it.) Double-click PANTONE Process Yellow C to open PHOTO-PAINT's Select Color dialog box and choose PANTONE 720 C (a warm beige that matches the original color of the cookie dough). You can choose the color from the Name pop-up menu in the lower right corner of the dialog box, but if you know the color number you want it's often easier to click once in the dialog box to highlight the name and then type in just the number (720 in this case). Click OK. Here's what you'll see in the Select Color dialog box:

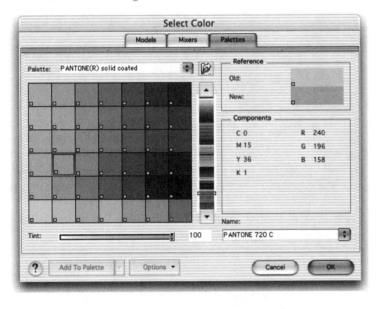

focus —————————————————————————————————————

Pantone, Inc. rules over printed color in the U.S. and much of the rest of the world. This company doesn't make printing inks—but it makes the swatchbooks and other color-matching tools that printing companies and designers use to make sure they're talking about the same colors. Pantone swatchbooks contain ink "recipes" that printers can use to mix up the inks designers specify when they're preparing designs for print. Duotones usually use black for the first color and a Pantone color for the second color.

7 Now you'll need to adjust the ink coverage for this color. Click the beige color swatch so that its levels graph is displayed in the right half of the dialog box—you can see that the graph line is beige so you can be sure what color you're adjusting. Click on the line to create points, and drag them to the positions shown here:

By modifying the graph this way, you're increasing the amount of beige ink in the light areas of the image so that the color shows up more.

flash

As you work through a project, you'll be setting the color of your paintbrush or other tool several times. It's a good idea to save each color you use, in case you need it later. One way of doing this is simply to note down your settings, and that's what we did in Chapter 7. This time we'll save ourselves all that scribbling by using PhotoFix's ability to store custom colors.

8 Now double-click the black swatch and choose PANTONE 242 C in the Select Color dialog box—it's a dark red that matches the original color of the raspberry jam Cecelia's putting on the cookies. Click OK to return to the Duotone dialog box, then click the red swatch and adjust the curve as shown here:

9 Click OK to apply your settings. That's it—you're all done! You can see both the original and our final versions of this image on our Web site at www.getcreativebook.com.

Take a look at the effect of the changes you've made to this image. If you use PHOTO-PAINT's Undo palette (Window ➤ Palettes ➤ Undo) to switch back and forth between the original color version of the cookie-baking image and the final duotone version, you'll see a complete transformation take place. The image is less colorful but much more attractive; it's warm and appealing, and it's much more integrated—the viewer's eye is able to focus on the action rather than flitting all over the image trying to sort out the different objects pictured.

flash

When you apply a special-effects filter, such as a blur, it's usually permanent—once it's done, it's done, and there's no way to go back and see what setting you used or even change that setting. But you can always go back and change a duotone's settings just by returning to the Duotone dialog box. Your color choice and the colors' curve graphs are still there, just the way you left them.

Choosing the Right Colors

In the first example, you used black and a Pantone beige for your two colors. But it's important to remember that you're not limited to using black and another color—you can make a duotone from any two colors. Here are a few ideas for you to try out on your own images:

- **Black with gray** Feeling artistic? Some of the most beautiful duotones we've ever seen have been made using black and gray. This combination results in a grayscale image that looks superficially the same as the original, but it has added depth, detail, and warmth.

- **Black with another color** This is what we did with the kitchen image. It's tempting to stick with light colors that don't interfere too much with the photo, but try abandoning subtlety and experimenting with dark and intense colors. Did you click Preview in Step 6 to see how the kitchen image looked with yellow as the second color? We think the effect is, to use a technical term, yucky—but maybe it would be just right for a different image. How about deep cobalt blue? Or fire engine red? Or safety orange?

- **Two different colors** Now it's time to jettison that boring old black. Start out by subbing in a dark color—navy, pine green, or deepest maroon—for black, in combination with a light second color. Then spread your wings and try the most outlandish combinations you can think of. Don't forget to experiment with adjusting the levels curve for each color, too.

- **Built-in combos** So you're not the adventurous type? Then you'll be pleased to know that some image editors come with preset duotone combos that you can apply to your images. In PHOTO-PAINT, just click the Load button in the Duotone dialog box to load a duotone file (filename extension .cpd)—which could actually contain settings for a duotone, a tritone, or a quadtone. Even Ulead PhotoImpact's limited duotone effect (choose Effect ➤ Artistic ➤ Duotone Effect) has six presets, including one using black and gray.

In the next section, we'll extend the range of possibilities even further by layering additional colors to create tritones (using three inks) and quadtones (using four inks).

The More Colors, the Merrier

There's not much to learn about tritones and quadtones—they're just like duotones, but with more colors. We do have one tip regarding color

choice: In general, you should make sure your colors are different from each other but not *too* different. If they're too close to each other, there's no point in using different colors, and if they're too far apart they may end up canceling each other out, resulting in a muddy, nondescript image. (On the other hand, with care you can create some really wild effects. The record cover in Figure 9.1 is a quadtone that uses black, maroon, blue, and yellow to achieve its period look. After the image was complete, Richard converted it to RGB color before adding the type.)

Duotones are usually created with the second or lighter color applied primarily to the image's midtones, or medium gray areas. Tritones, on the other hand, are traditionally done with black ink and a second, darker ink occupying the full tonal range of the image and a third light color printed in the midtones. You'll probably notice that PHOTO-PAINT's tritone presets generally follow this rule of thumb. Feel free to follow the rule or violate it, as you prefer. Each photo has its own special quality that will lead you to the right settings for that image.

One of our favorite recent photos was taken during an outdoor training session in a greyhound-only obedience class. It's a motion-blurred shot of a greyhound and his owner Michele playing a retrieval game; take a look at Figure 9.3.

FIGURE 9.3

Egypt and his owner look as though they're racing each other, but they're really playing a much-loved game.

We were so entranced with this image when we pulled it off the camera that we immediately started looking for a place to use it. Eventually, it ended up on the cover of one of the mix CDs we've been making like crazy lately. Although the original image was, of course, full color, we turned it into a tritone to use it for the CD cover. Follow along to see how we did it.

flash

Although most of the special effects you see in this book's photos were applied via software, you shouldn't lose sight of the fact that you can also manipulate photos using your camera before the images ever make it onto your hard drive. Kate achieved the snazzy motion blur effect in this photo of Michele and Egypt by simply panning the camera to follow the action—and if you think it's easy to move the camera fast enough to keep up with a running greyhound, think again! Anyway, the point is that you should always keep experimenting with your camera as well as with your computer.

1 Open the greyhound image shown in Figure 9.3 (egypt.tif).

2 First, you'll resize the image to the correct dimensions and resolution for a printed CD cover, which should be 4.75" square at 300 pixels per inch—a high resolution since you'll be printing the final cover in high quality mode. Choose Image ➤ Resample and make these settings in the Resample dialog box:

Resample					

Image size

Width:	21.3	4.75	22	%	inches
Height:	28.4	6.33333	22	%	

Resolution

Horizontal:	72	300	dpi	☑ Identical values
Vertical:	72	300	dpi	

Original image size:	9,437,184 bytes	☑ Anti-alias
New image size:	8,124,400 bytes	☑ Maintain aspect ratio
		☐ Maintain original size

(?) (Reset) (Cancel) (OK)

3 Now you need to crop it to make it square. It's already 4.75" wide, so you'll need to trim a bit off the top and bottom to make it 4.75" high as well. Choose Image ➤ Paper Size and enter the settings shown here:

You can use the Center setting in the Paper Size dialog box for this image. Other times you might want to trim all the extra from the top or the bottom, or different amounts from the top or bottom; in these cases you can just click and drag the image preview within the dialog box to determine how it's trimmed to the specified size.

4 As we mentioned when we were working with the cookie-baking image, we like to convert images to grayscale and adjust their levels before going to duotone mode. Choose Image ➤ Color Mode ➤ Grayscale (8-bit).

5 Let's pump up the contrast a bit: choose Image ➤ Adjust ➤ Brightness/ Contrast/Intensity and drag the Contrast slider to about 12.

6 Now it's duotone time! Choose Image ➤ Color Mode ➤ Duotone. Set the Type pop-up menu to Tritone and click Preview. Wow—a little dark, but pretty intense. And this is just with the default colors of black, yellow, and magenta! Think what you could do with custom Pantone colors. But, actually, we like this color combination pretty well. It just needs some tweaking of the curves to be perfect. Check Figure 9.4 to see how you should adjust the curves for each color.

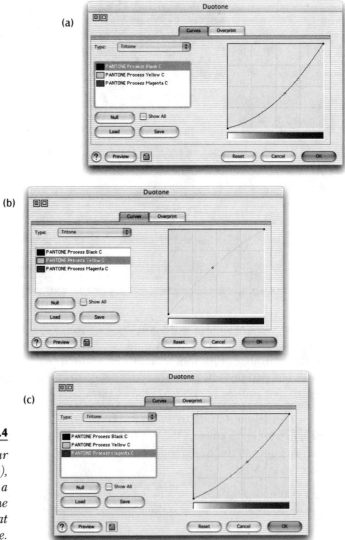

FIGURE 9.4

Each of the colors in your tritone—black (a), yellow (b), and magenta (c)—needs a custom curve to determine where and how intensely that color is laid down in the image.

Remember, to change the curve, click the color's name or swatch on the left, then click and drag the graph line on the right until it looks like the one shown in the figure.

7 Now you have the image; all you have to do is add the CD's title. First, though, convert the photo back to RGB color mode by choosing Image ➤ Color Mode ➤ RGB Color (24-bit) so that you'll have a full selection of colors to use for the type. Since you'll be printing the final image on an inkjet printer, it doesn't have to stay in duotone mode.

flash

One way to make sure that the color of your type will harmonize with the image over which it's laid is to choose the color directly from the image. You'd be surprised how many colors you can find in any image if you zoom in and scroll around a bit.

8 Switch to the Eyedropper tool and click in the image to pick a medium peachy orange color for the type; we used R: 219, G: 159, B: 107. You don't want it too dark, or the type won't stand out against the dark area in the upper left corner of the photo where you're going to put it.

9 Click in that dark area to set the type cursor, then set your font and point size in the Property Bar to Gill Sans and 24 points, respectively. If you don't have Gill Sans, use another typeface that you like.

10 Enter the album title. Ours is called *and we ran*. Here's what it looks like:

11 Now switch back to the Object Pick tool and choose Object ➤ Text ➤ Render as Object. This turns the text into pixels so that you can apply filters to it.

12 Choose Effects ➤ Noise ➤ Add Noise and use the default settings (Gaussian, 50, and 50), then click OK.

13 Choose Effects ➤ Distort ➤ Ripple and make the settings shown here in the Ripple dialog box:

14 With the text object still selected, click it again so that you can rotate it. With the second click, curved arrows appear all around the object; click one of these and SHIFT+drag the text so that it runs vertically toward the top of the photo.

15 Finally, click three more times to return the object to a normal selection mode, then click and drag it into position as shown in Figure 9.5.

That's it! The final image is dreamy, like a scene half-remembered. Its deep orange tones give it the feeling of a warm late afternoon in autumn, but it's impossible to tell where or when this event might have happened. The change from full color to tritone mode has made Michele, the dog's owner, recede into the background while pushing the dog out toward the viewer—always a good thing if you like the clean, elegant lines of a running greyhound. And how could you not? To see our final color version in its new role as a CD cover, check out Plate 9.1.

and we ran

FIGURE 9.5

*The change in
the image is a
combination of
the alterations in
its color and the
changes to its
contrast and
levels.*

If you like the results of your experimentation with colors and levels,
you can save them to apply to other images—in other words, you can make
your own presets like those that come with the software. To save your
duotone, tritone, or quadtone settings in PHOTO-PAINT, click the Save
button in the Duotone dialog box, navigate to the folder where you want to
save the settings file, give it a name, and click Save again. Then click OK
to get back out of the Duotone dialog box and return to your image. You
can share your settings files with your friends, too.

focus

OK, you busted us. Yes, we decided to help you out on this one—we saved the duotone
settings we used to create this project, and you can download the settings file from our Web site at
www.getcreativebook.com. It's called dog_tritone.cpd. Click Load in the Duotone dialog box, find the
downloaded settings file and click Open to import it, then click OK to apply it to your image.

Sure, You Can Fake a Duotone

Suppose your image editing software *doesn't* have a duotone color mode—
are you stuck? Not at all—you can still achieve a duotone-like effect quite
easily. We like to call such images "fake duotones," but more polite people
in the graphic arts world refer to simulated duotones as "duotints" or
"duographs." As you know, a duotone contains two ink colors each with
varying levels, but a duotint is a single-color image printed over a solid tint
of a second color, which can be printed or can be the paper color itself.

Now, the cheapskates among you (and that's a complimentary term in
our world) have just raised your eyebrows and thought, "Hmmmmmm."
You've caught on to a trick of the design and printing trades—namely,
printing newsletters and similar pieces in one color, which need not be
black, on a paper of a different color, which need not be white. Your cost
for such a job is likely to be little more than that for printing with black ink
on white stock, but you get much more color bang for your buck.

But we're here to talk about faking duotones within your computer, and
the way you do that in pretty much any image editing program is as follows:

1 Desaturate your photo so that it appears to be grayscale—but keep it
in CMYK or RGB color mode.

2 Colorize it using hue and saturation controls.

It's as simple as that. Or, if you like, you can get a bit fancier with
this method:

1 Desaturate your photo.

2 Add a new layer.

3 Fill the layer with the color of your choice.

4 Change the color layer's blending mode to Color.

There are a couple of advantages to using this second method. First, you
can always go back and change the color of the color layer. You can also change
its opacity to reduce the intensity of the effect, and you can erase parts of the
layers so that the color is only applied in some areas of the image.

flash

If you're inclined to Web design, try creating rollover images that start out as black
and white and turn into duotones or simulated duotones when you mouse over them.
There's a great tutorial on implementing rollover images here: www.pageresource.com/
jscript/jhover.htm. You'll need to have two different images of the same size; you can turn them into
a rollover with a simple script that you can copy and paste right into your HTML.

As you might guess, we prefer to use real duotones rather than fake ones. As you experiment with both techniques, you'll see that real duotones have a greater depth and richness. They're a bit harder to work with, but it's worth practicing to see what you can come up with. And remember, although duotones, tritones, and quadtones started out as a printer's trick, you can use duotone mode as a path to achieving a duotone image that you later convert to CMYK for commercial printing or to RGB for use on the Web. Above all, enjoy yourself—and get creative!

More Great Ideas

Duotones can be really out there—or very subtle. It's up to you how exotic you want to make your image—and don't forget to experiment with tritones and quadtones, too. Here are a few things you might want to try making with duotone images:

- If you're a book lover—or if you know one—duotone bookplates are a quick and easy project that will be about as useful as they come (see Figure 9.6; the color version is Plate 9.2). Print your image on sticker paper, with several copies on a sheet—our version fits six to a page.

- Create a set of custom stationery—a wonderful Mother's Day gift for Mom or Grandma—with a cool, uncluttered duotone image along the bottom of each sheet. For note sheets, print two images side-by-side on letter-size paper and cut the sheets in half to yield 5.5" by 8.5" stationery.

- When Kate was much younger, she and her brother owned a small printing set intended to be used to create bumper stickers. The ink smeared, and there was only one color—black. You can do much better with mail order bumper sticker and decal sets designed for use with an inkjet printer. Too many colors on a bumper sticker just confuse the eye, since these images are only viewed from a distance, so duotones make great images for stickers.

- Giving a set of luggage for Christmas? Enhance your gift with a matched set of new luggage tags—buy the tags at the store, then replace the insert cards with your custom-crafted printouts featuring a scenic duotone along with the relevant contact information.

- Make a picture box (like the one you see on the cover of "Photo Art & Craft"). Assemble old pictures of your mom/grandma/friend/whoever, or pics of you and a friend on a traveling adventure, print them onto sticker paper, and assemble on each side of a box. Great gift idea!

FIGURE 9.6

Cool-colored duotones like the one on our bookplate convey an impression of serenity—the perfect feeling for someone who's about to read a book.

- Download the color copy of Figure 9.1 that's on our Web site to use for reference. Scan your favorite album or CD cover and apply a similar quadtone effect to it. We downsampled severely, sharpened like crazy, and adjusted the levels; then we applied the quadtone effect. The blue and maroon curves are nearly alike; they go all the way down to the bottom at both ends and have big humps almost up to the very top at the middle, with the blue curve's hump farther toward the dark end. When we were finished, we upsampled to blur the image and make it print well.

Plate 3.1 Adding realism and life to Web pages is a great application for textures.

Plate 3.2 The tile (upper left) turns into a seamless field of green leaves when repeated several times.

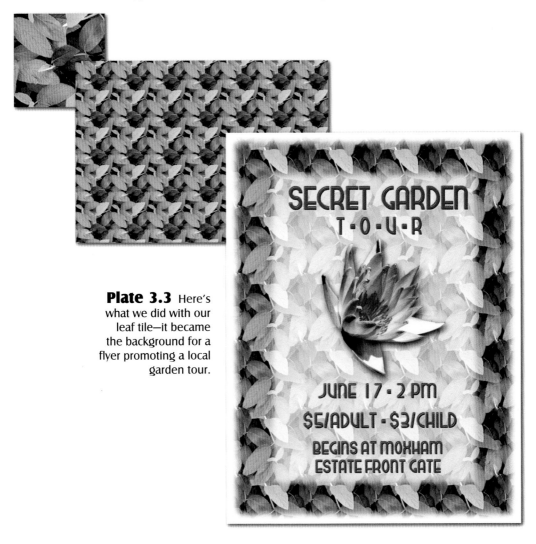

Plate 3.3 Here's what we did with our leaf tile—it became the background for a flyer promoting a local garden tour.

SECRET GARDEN
T·O·U·R

JUNE 17 · 2 PM

$5/ADULT · $3/CHILD

BEGINS AT MOXHAM
ESTATE FRONT GATE

Plate 5.1 These maple leaves were picked at the peak of freshness—or rather, at the peak of their fall color.

Plate 5.2 Making the leaf photo look like a tile mosaic, as shown here, was easy because of the leaves' bright colors and sharp-edged shapes.

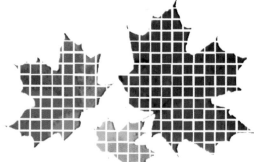

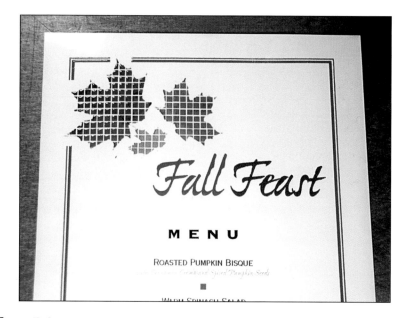

Fall Feast

M E N U

ROASTED PUMPKIN BISQUE

Plate 5.3 Applying embossing powder to the leaves image makes them look even more like a real tile mosaic. Now the final menu is ready for our dinner party guests.

Plate 5.4 Here's a selection of filter effects applied to the same image to show the wide range of what filters can do. In this case, we used Adobe Photoshop Elements; most photo editing programs have a similar set of filters for you to experiment with.

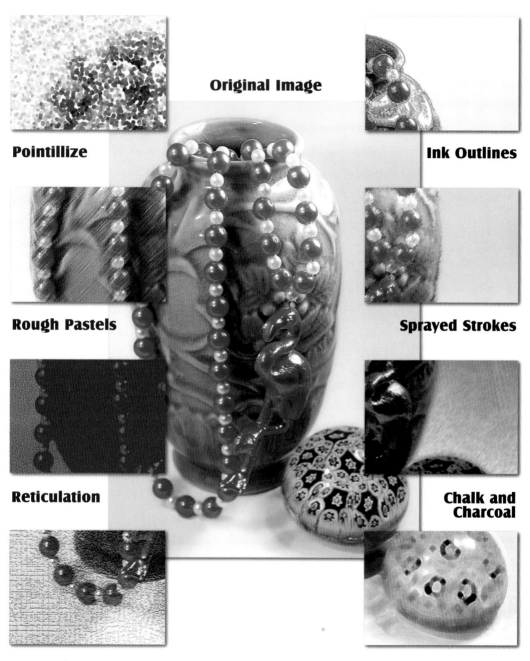

Original Image

Pointillize

Ink Outlines

Rough Pastels

Sprayed Strokes

Reticulation

Chalk and Charcoal

Craquelure

Paint Daubs

Plate 5.5 We shot this photo of a covered bridge in New Hampshire's Lake Sunapee region; once we applied a few select filters to make it more "artistic," it was a perfect image to cover our cylinder lamp.

Plate 6.2 The brilliant color in this photo of Richard's house makes the image interesting; without color, the image needs serious contrast enhancement to attract the viewer.

Plate 6.1 The Mill in the Mist was shot in color, but it's a great candidate for conversion to black and white.

Plate 7.1 This is our original color portrait of Matina.

Plate 7.2a At this point, we've recolored Matina's skin and blouse.

Plate 7.2b Here we've completed most of the coloring.

Plate 7.3 This is the finished hand-tinted portrait of Matina; compare this version to Plate 7.1, the original color photo.

Plate 7.4 Here are two copies of Richard's photo of Southern Railway 4501, one toned brown (a) and the other toned sepia (b).

(a)

(b)

Plate 7.5 Our photo soap incorporates a hand-colored graduation photo and a special message from the giver.

Plate 8.1 The original photo of the Twentieth Century Limited is on the left; below is our colored version—used as a postcard—with a bluer-than-blue sky and even a steely blue tint to the engine itself. Can you smell the coal smoke?

Plate 8.2 The Shades is a state park in Indiana that was once a resort owned by Kate's family. We scanned a black and white postcard of the image, hand-tinted it, and used it as the cover for an invitation to a family get-together.

Plate 8.3 Here is the finished hand-tinted image of Richard's front entrance.

Plate 8.4 This four-fold note card bears a handcrafted "vintage" image of Richard's 1846 house.

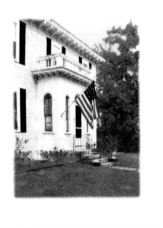

Plate 8.5 These drink coasters, bearing the same image as the note card in Plate 8.4, are foam rubber. The printed images are water resistant, so you can use the coasters for cold drinks on a hot day.

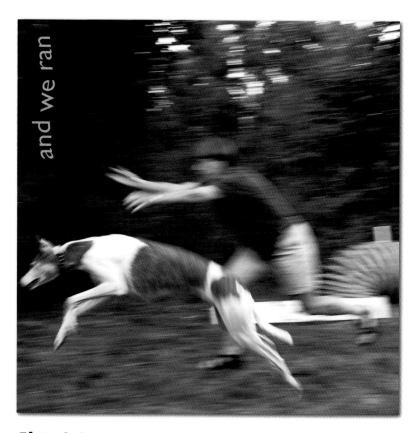

and we ran

Plate 9.1 The greyhound photo has taken its rightful place in our CD collection as the cover for a mix CD.

This book belongs to

Go, little Book! From this my solitude
I cast thee on the Waters—go thy ways.

—SOUTHEY, *Lay of the Laureate*

Plate 9.2 This bookplate is based on a duotone image we created from a photo of a salt marsh on Hilton Head Island, South Carolina.

Plate 10.1 With its bright colors, our posterized photo makes a visit to the Louisville Slugger factory look even more fun than it was in real life.

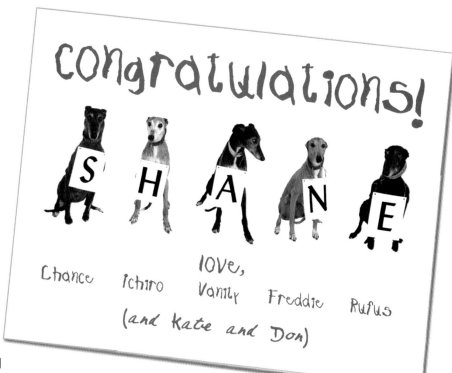

Plate 11.1
This photomontage features Chance, Ichiro, Vanity,
Freddie, and Rufus wishing our friend Shane well as he starts a new job.

Plate 12.1 To create this
photomontage album label,
we combined several of the
photos from the album with
a little text and a few special
effects filters, then printed the final
version on sticker paper and attached it to the front
of the album.

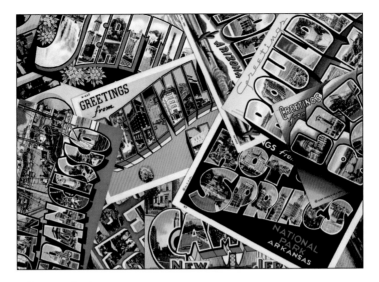

Plate 13.1 Vintage postcards, with their old-fashioned photos and colorful designs, are some of our favorite souvenirs.

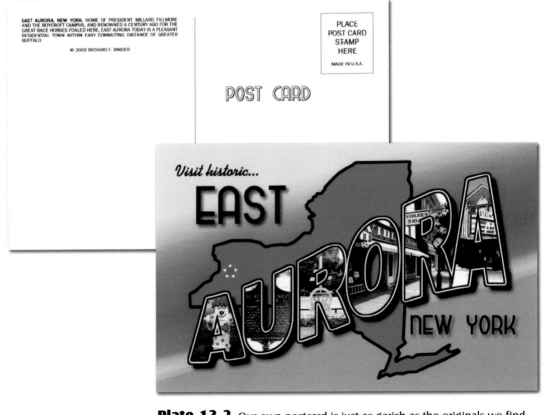

EAST AURORA, NEW YORK, HOME OF PRESIDENT MILLARD FILLMORE AND THE ROYCROFT CAMPUS, AND RENOWNED A CENTURY AGO FOR THE GREAT RACE HORSES FOALED HERE, EAST AURORA TODAY IS A PLEASANT RESIDENTIAL TOWN WITHIN EASY COMMUTING DISTANCE OF GREATER BUFFALO.

© 2002 RICHARD F. BINDER

PLACE
POST CARD
STAMP
HERE

MADE IN U.S.A.

POST CARD

Visit historic...

EAST AURORA

NEW YORK

Plate 13.2 Our own postcard is just as garish as the originals we find in antique shops—it's just not faded with age yet.

Plate 14.1 This postcard was made from a vintage card that we scanned, colorized, and combined with a digital photo of a real fountain pen.

Plate 14.2 Our gift to you is this decoupaged light switch plate. We assembled the ribbon bow and the wrapping tissue as a trompe l'oeil image and glued the print to the plate. We used thinned-down craft paint to touch up the screws so they'd blend in and sprayed the whole thing with matte polyurethane varnish to protect it from fingerprints. (Remember to mask the switches and the wall before spraying!)

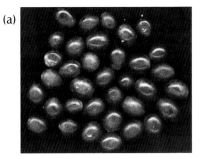

(a)

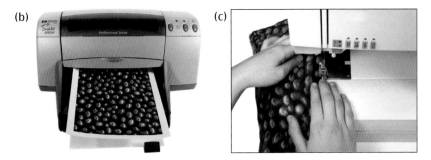

(b)

(c)

Plate 15.1 To make a gift bag for a wine bottle, we started with a scan of grapes laid on the scanner bed (a), then cleaned up the scan and tiled the image to make a big enough piece to sew with. We printed the image on silk ironed onto freezer paper (b) and sewed it into a simple drawstring bag (c)—and we liked the results so much we made another one (d).

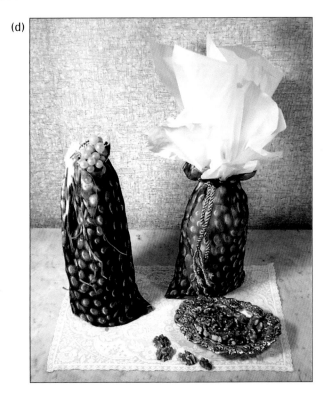

(d)

Plate 15.2 This picture is an unretouched scan of a 100-year-old cyanotype photo of Richard's house. Editing the image to enhance its contrast produced the results shown in Figure 15.6.

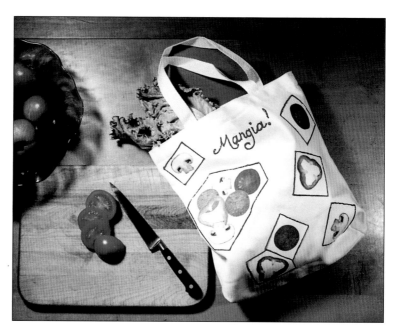

Plate 15.3 The artwork on this canvas tote bag was a useful by-product of the scanning we did to make our pizza party invitation.

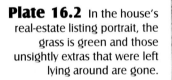

Plate 16.1 Dennis and Maggie have put their rather ordinary house up for sale. But surely we can make it look better in the real estate listing.

Plate 16.2 In the house's real-estate listing portrait, the grass is green and those unsightly extras that were left lying around are gone.

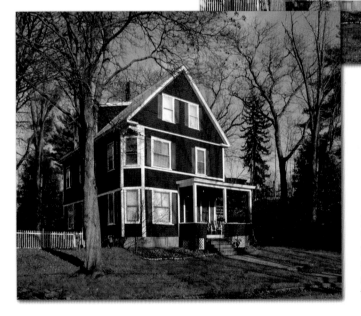

Plate 16.3 Welcome to Dennis and Maggie's house as it never was, with a nice fresh dark brown stain, green-painted shutters, and—best of all—a new wooded glade in the back yard.

Simple Gifts
Having More Fun with Fewer Colors

CLUTTER on your desk or in your closet is a bad thing—and so is clutter in your photos. Sometimes you can make a good image even better by clearing out the debris it contains. In this chapter, we'll take a look at three different—and fun—ways to completely transform an image by getting rid of or reducing the color it contains so that we can look at it in a whole new way.

The images you'll need to complete these projects along with us are available on our Web site: www.getcreativebook.com.

Line Up! Turning Photos into Drawings

Most image-editing programs include a variety of filters that allow you to transform your photos into simulated pen or pencil drawings. One of those is usually a Graphic

We did this chapter's projects in Corel PHOTO-PAINT, but most image editors have tools that will enable you to achieve similar effects. Look for a find edges effect and a motion blur filter, as well as a levels command (PHOTO-PAINT's is called Contrast Enhancement) and a posterize command. And one more thing—don't forget that in the Windows version of PHOTO-PAINT, palettes are called dockers; if you're using Windows, just substitute the word "dockers" wherever we've written "palettes."

Pen, or something similar. The Graphic Pen filter can do some pretty things, but everybody else has one, too, and we'd rather be different. We think one of the prettiest pencil-style effects is silver point. Silver point is a delicate sketch technique that uses a drawing tool tipped with real silver to make lines on special paper. Although we're going to start with a formal portrait of Richard's grandmother Charlotte Binder, you can get great results from a casual snapshot—something like what you'd get if you had your portrait drawn by one of the sidewalk sketch artists around Jackson Square in New Orleans. All you need to worry about is that there are fairly good contrasts between the subject and the background. Figure 10.1 shows the image you'll start with.

If you're using your own image, and it's in color, be sure to choose Image ➤ Color Mode ➤ Grayscale (8-Bit) before proceeding. If you need to adjust the image to make a good clear black-and-white version, go ahead and do that as well. Turn back to the section "Making a Good Black and White Photo" in Chapter 6 if you want to review our tips on accomplishing this.

Now, to turn the photo into a silver point sketch, open the file named charlotte.tif, and follow these steps:

1 Choose Effects ➤ Contour ➤ Find Edges and make the settings shown here:

Find Edges				
Edge Type:	● Soft	○ Solid	Level:	50

(?) Preview Reset Cancel OK

2 Click OK. Don't worry about those very dark lines; they'll go away later.

3 Choose the Eraser tool. Pick a hard-edged round shape from the Shape pop-up menu in the Attributes bar. Erase everything in the picture's background, leaving only the subject's head and shoulders. You can start with a big eraser, 100 pixels or so in diameter, and choose different sizes from the Shape pop-up menu as you work to make the eraser smaller as you approach the edges of the area to be cleared.

flash

To quickly increase the size of the eraser and brushes in PHOTO-PAINT, hold the COMMAND (Mac) or SHIFT (Windows) key down, then click in the image window and drag the mouse upward. To reduce the brush size, move the mouse downward.

FIGURE 10.1

We dug up a high-school graduation photo of Charlotte. This is a black and white photo, but you can start just as easily with a color photo.

4 Again using the Eraser tool, this time choose a soft-edged shape and set the size to 200 pixels. Now erase part of the bottom of the image to create a vignette, as if the sketch artist has not wasted time filling in the details all the way to the edge of the paper.

5 Choose Image ➤ Adjust ➤ Contrast Enhancement. Click the Reset button and then make the settings shown here:

Contrast Enhancement

Eyedropper Sampling
- ● Set input values
- ○ Set output values

Channel
Gray Channel

☐ Auto-adjust Options...

Histogram Display Clipping
5 ▲▼ % ☑ Automatically

Input Value Clipping 50 255

Output Range Compression 0 255

Gamma Adjustment 1.00

? | Preview | Reset | Cancel | OK

focus ———————————————————————————————————————

PHOTO-PAINT remembers the settings from the last time you used the Contrast Enhancement command and automatically applies those settings to the image when you open the dialog box. That's why we always click Reset before making our new settings. You may not need to do this with other programs' levels commands—watch to see if the image changes before you make any settings, and if it does, reset before proceeding.

6 Click OK. The image should now look like Figure 10.2.

7 In the Objects palette, duplicate the Background as an object (or layer) by dragging it to the New Object button. Use the slider to set the opacity of the new object (Object 1) to 70 percent. (If the Objects palette isn't visible, choose Window ➤ Palettes ➤ Objects.)

8 Now you'll soften the harshness of those heavy black lines and add a slight smudged effect. With Object 1 as the active layer, choose Image ➤ Correction ➤ Dust and Scratch. Set the Threshold to 56 and the Radius to 4, then click OK.

9 Add some background sketching. In the Objects palette, click the Background image to make it active. Choose Effects ➤ Blur ➤ Motion Blur, and make the settings shown here:

Click OK.

10 Choose Effects ➤ Repeat ➤ Motion Blur to apply the same effect again. This smooths out the ends of the blurred area, creating a hand-rubbed effect.

11 Choose Effects ➤ Sharpen ➤ Sharpen, set the Edge Level to 100 percent and the Threshold to 0, make sure the Preserve Colors box is unchecked, and click OK.

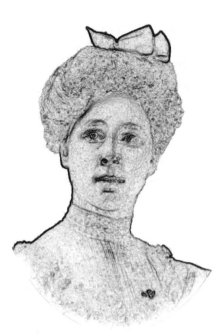

FIGURE 10.2

The filtered image is starting to look more like a drawing after we've erased the background, vignetted the bottom, and enhanced the contrast.

12 Choose Image ➤ Adjust ➤ Contrast Enhancement. Click the Reset button, then set the Gamma to 0.20 as shown here:

Click OK. Now the image has some background sketching, and it's almost complete.

13 You'll finish the transformation by applying a slight shaded halo around the face. In the Objects palette, click the New Object button. Drag the new layer, Object 2, to a position below Object 1.

14 With Object 2 as the active layer, choose the Ellipse Mask tool. Press OPTION (Mac) or SHIFT (Windows) and click on the tip of Charlotte's nose. Drag to draw an ellipse, centered on Charlotte's nose that stretches to the top of the hair and down onto the blouse and is about as wide as the hair.

15 Double-click the Foreground color swatch in the Tools palette, set the Foreground color to black, and click OK. Choose the Fill tool and click somewhere inside the uncolored part of the mask. Choose Mask ➤ Remove to release the mask. The image should now look like Figure 10.3. Don't worry about the gray oval over Charlotte's face—it's only a mask for the blur effect, and it won't show in the final image.

16 Choose Effects ➤ Blur ➤ Gaussian Blur. Set the Radius to 100 pixels, then click OK.

17 Now choose the Eraser tool and switch to a hard-edged brush. Erase the portion of the blurred ellipse that lies within the area covered by Charlotte's head and shoulders, leaving only a "halo" behind her head.

FIGURE 10.3

Here is the image with the beginning of a shaded halo around the face.

18 To finish the job, choose Subtract from the Mode pop-up menu in the Objects palette.

The final silver point sketch is shown in Figure 10.4.

Get the Red Out . . . and the Green, and . . .

Moving on to something completely different, our next trick will be to turn a photo into a silk-screened print, or perhaps a lithograph. Henri Toulouse-Lautrec's vivid Moulin Rouge posters and other works were created as lithographs, and you've probably seen Andy Warhol's silk-screened images of famous people such as Marilyn Monroe, Mao Ze-dong, and Jacqueline Kennedy—you can check the latter out on the Web at www.warhol.dk. Both techniques result in images with large areas of fairly flat color.

To get a similar effect digitally, you'll use the Posterize command, which is the same in all five programs we're working with for this book. Posterizing an image amounts to reducing the number of levels of each color that appears within an image. If your photo is a 24-bit RGB color image—which most digital photos or scans are—then each pixel represents a combination of red, green, and blue at brightness levels between 0 and 255. When you posterize the image, you reduce the number of levels drastically, which in turn reduces the number of possible combinations.

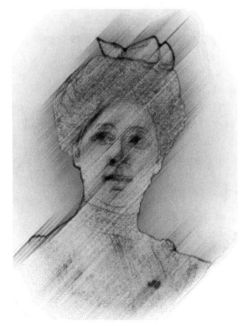

FIGURE 10.4

The finished silver point sketch of Charlotte Binder really looks as though it could have been drawn with a pencil.

Let's give it a try:

1 Open slugger.tif (see Figure 10.5). Kate took this photo in front of the Louisville Slugger Museum in Louisville, Kentucky, in June 2002. Kate's husband Don obligingly posed with his mini baseball bat, a souvenir of his factory tour.

focus ───────────────────────────

Want to see a Louisville Slugger bat made? You can get more information about the Louisville Slugger Museum on the Web at www.sluggermuseum.com. Bats are still made at this small urban factory, where you'll also find exhibits about the history of both the company and baseball in general.

2 Before you posterize the image, you'll stack the odds in favor of getting good results by playing up the image's colors. Choose Image ➤ Adjust ➤ Brightness/Contrast/Intensity and bump all three settings way up, as shown here:

3 Now choose Effects ➤ Creative ➤ Kid's Play. (PHOTO-PAINT has an actual Posterize command, but we like this version better—it yields brighter, more cheerful colors.) Here's where you get to make the only major decision involved in this technique: how many Detail levels do you want? Of course, it varies depending on the photo. In PHOTO-PAINT, you'll generally want to start at about 3 and try higher numbers until you get what you're looking for. For this image, we used a Detail setting of 4 and a Brightness setting of 25.

4 Click OK to apply the filter—and that's it! We duplicated our image three times, adjusted the hues of the three copies, and placed the four images in a grid to evoke the work of Andy Warhol. The final image is shown in Figure 10.6 (and check out Plate 10.1 in the color section to see it in all its reduced-color glory).

FIGURE 10.5

This image is a good candidate for simplifying because it's already got strong shapes—the bat, Don's head—and intense colors—the green of the hat and the red of the brick.

FIGURE 10.6

The final image reminds us of Warhol's famous portraits of Marilyn Monroe—only our model has bigger muscles.

Crayon Power:
Making Coloring Book Pictures

All right, kids, Miss Barbara says it's time to get out your color crayons and color a picture. Umm, wait a minute, we don't have a picture to color. Well, that's easy to fix! How about a nice picture of a bird? Kate took the photo shown in Figure 10.7 while she was visiting the Audubon Zoo in New Orleans.

Zoos are great places to take photos because the scenery is colorful and the subjects don't mind a bit if you photograph them. New Orleans is one of our favorite cities, and we especially like the zoo there. For more info about the Audubon Zoo, go to www.auduboninstitute.org/zoo/.

Remembering that the point of this chapter is simplicity, you'll reduce the detail in this photo to make a nice picture that a child can color easily. To do this, you have to modify the image so that you can find the most prominent edges easily and make them into lines. Open the image named bird.tif and follow these steps:

1 Choose Image ➤ Color Mode ➤ Grayscale (8-Bit).

2 Choose Image ➤ Adjust ➤ Contrast Enhancement, click the Reset button, and make the settings shown here:

![Contrast Enhancement dialog box screenshot]

FIGURE 10.7

We're not sure what kind of bird this is, but when we're done with it, a kid will be able to make it any kind that looks pretty!

3 Click OK.

4 Choose Effects ➤ Contour ➤ Find Edges. Set the Edge Type to Soft and the Levels to 50, then click OK.

5 Choose Image ➤ Transform ➤ Threshold. This is where you knock out all the gray parts, leaving only black and white. Your artistic judgment comes into play at this point because you can adjust the threshold to pick up more or less detail. Our judgment says to make the settings shown here:

Threshold

Channel: Gray Channel

Threshold
- To black
- To white
- Bi-level

Histogram Display Clipping

Percent: 5 ☑ Auto

Low-level: 0 Threshold: 192 High-level: 255

? Preview Reset Cancel OK

At this point, the image should look like Figure 10.8.

6 Choose the Eraser tool. From the Shape pop-up in the attributes bar, choose a hard-edged round brush. Erase as much complicated detail as you want. You can adjust the size as needed while you're working. At this point, we've erased the complicated detail from the image, leaving a simple picture—but it's missing a few lines that a child might need.

7 Choose the Paintbrush tool and set the Foreground color to black. Choose a very small hard-edged round brush and paint in a few of the lines that were lost in the process of finding edges. We painted the top edge of the bird's bill and finished the oddly truncated branch (actually a parking-lot railing) that he's sitting on.

8 You need to make a black border around the entire image to help kids stay inside the lines. Choose Image ➤ Paper Size. Choose Pixels from the pop-up menu. Enter 1016 in the Width field and 1272 in the Height

FIGURE 10.8

Here is the bird with all the middle tones converted to white or black.

field. Click OK. This trims 4 pixels from each edge, reducing the size of the canvas by 8 pixels in each direction.

9 Choose Image ➤ Paper Size again. Choose Pixels from the pop-up menu. Enter 1024 into the Horizontal box and 1280 into the Vertical box. Now choose black from the Background Color pop-up menu in the Paper Size dialog box. Click OK. The image is now its original size, with a neat 4-pixel border all the way around.

And that's it. Figure 10.9 shows the finished bird picture, ready to be printed and colored. Before we printed our copy, we changed its resolution so that it would fill a letter-sized page. To do that, choose Image ➤ Resample, make sure Maintain Aspect Ratio and Maintain Original Size are checked, and enter 130 in the Horizontal Resolution field. The next step is to print the image and hand it to a child with a box of crayons or some watercolors. And stand back! Check out our Web site at www.getcreativebook.com to see how our attempt at coloring the bird came out.

FIGURE 10.9

Here's our bird, ready to print and hand to a kid.

More Great Ideas

The nice thing about simplified images is that it doesn't matter how good your printer is because it doesn't matter if the color isn't quite the way it looked on-screen. With this in mind, try playing with images whose color isn't quite what it should be—old photos with color casts, shots where the lighting was decidedly off, and the like. Here are some ways you can use simplified images:

- Make a new logo for your yo-yo! Create a circular image of your cat's head, a piece of fruit, or whatever strikes your fancy. When you're done experimenting with the colors in the image, print two copies, trim, and glue to the two sides of any yo-yo for a fun stocking stuffer.

- Turn your favorite photo into a rubber stamp by using the Threshold command to make it all black and white—no colors and no gray. Size it to fit a rubber stamp, print it, and take the artwork to your local full-service copy shop, where they can send it off to be made into a stamp like no other.

- Using transparency film you can create your own suncatchers, a project that really works well with simplified images because the light shining through the film tends to obscure detail anyway. We mounted our image on an embroidery hoop using a glue gun and attached a gold cord to hang it with (see Figure 10.10, or check out the color version on our Web site).

- Go fly a kite—but not before you embellish it with your snazziest, most colorful images. You can start with a commercial kite or make your own from a pattern—there are lots available on the Web (search on "kite pattern" at www.google.com). Kits also make a great wall decoration, so yours will have a place in your life even if you can't get it to fly.

FIGURE 10.10

The colors of sunset in Florida's beautiful Everglades swamp were just what we wanted to liven up our rooms during a cold New England winter.

- You can make those trendy drink charms yourself at home—you know, the little tags party guests attach to their glasses to keep everyone's drinks straight? Shoot several different colorful drinks in different shaped glasses, simplify the images, and print them on oven shrink film. Shrink, attach to ring clips, and take along for a hostess gift the next time you go to a party.

Combining Elements

11

No Scissors, No Paste
Creating Elements for a Photomontage

REMEMBER back in Chapter 1 when we told you to "start with a photo"? Well, photomontage is what happens when you start with a whole bunch of photos. It's the art of cutting and combining multiple photos to form an entirely new image.

First used in the mid-nineteenth century to "improve" images by, for example, adding more interesting clouds to a landscape, photomontage came into its own in the early twentieth century when it was adopted by Dadaist artists. One of these was John Heartfield, a German artist who used photomontage to create striking anti-war, anti-Nazi images that portrayed the horrors of the Nazi regime during the 1920s and 1930s. (You can see some of Heartfield's work here: burn.ucsd.edu/heart.htm.)

Through the twentieth century, photomontage was used for many purposes: to create art, to make political points, and—of course—to sell products. As you might expect, photomontage has reached new heights of popularity since the advent of the digital darkroom—which is where you come in. As it happens, digital methods

We used Adobe Photoshop Elements to create the project that you'll see in this chapter and in Chapter 12. You can use any program that supports layers to complete the project. You'll also find layer effects such as drop shadows useful, in addition to the ability to control image lighting.

are ideal for creating this time-honored art form. So let's get started—time to get creative!

focus

If you want to learn more about the history and practice of photomontage, check out www.cutandpaste.info—it's a great Web site put together by artist David Palmer, an expert in the field. Be sure to visit www.pabulumpix.com, too, to see some of Palmer's work. Another fascinating site is www.collagetown.com, where you'll find discussions of the history and meaning of photomontage's cousin, collage, as well as the Collage WebRing, which will take you to enough cool sites to make you very late for dinner indeed.

Building Images Piece by Piece

As you explore the world of photomontage, you'll discover that artists take two very different approaches to their art: realistic and surrealistic. In realistic photomontages, the elements of the artwork are combined in such a way as to make the viewer believe that this image could be a true, unaltered photograph of a real-life scene. Surrealistic photomontages, on the other hand, may feature winged elephants flying across a sky studded with pink and green clouds, or flowers growing out of a trombone's bell. These images are playful and striking, and they're often used to make a pointed statement about human culture. Figure 11.1 shows a less serious—all right, extremely frivolous—photomontage that Kate created for a friend; you can see this image in the color section, too (Plate 11.1).

FIGURE 11.1

Each dog was photographed separately, with the blank sign around his or her neck, then the dogs were lined up next to each other and the text added to complete the card.

In this and the following chapter, we'll show you how to create a realistic photomontage image of a very special dog: Saint Guinefort, the Greyhound Saint. Our goal is to produce a photo-realistic icon similar to those created by the great artists of the Eastern Christian churches over the last several centuries—replete with gold leaf, finely painted details, and an ornate frame. It sounds like a tall order, but have no fear; this project is entirely within your power to create, although you will need to stick with it for two chapters instead of one.

focus

The 13th-century Dominican monk Etienne de Bourbon wrote about his discovery of the cult of St. Guinefort near Lyon, where he'd gone to preach. It seems that a local noble, the lord of Villeneuve, had left his faithful greyhound Guinefort to guard his only child while the lord rode out to hunt. On his return, he found the baby missing and the dog's mouth bloodied. Immediately, he drew his sword and killed Guinefort—only to discover that the child was alive and unharmed beneath its crib, lying next to the body of a snake killed by the faithful hound. Filled with remorse, the lord built a monument to Guinefort in a nearby grove. Soon, villagers who visited the grove began to report miraculous healings. Although the monument was torn down by church officials and the dog's body was dug up, people continued to make pilgrimages to the site into the twentieth century. Today St. Guinefort is cherished by greyhound lovers as a symbol of the breed's nobility and great capacity for love, and his feast day, August 22, is a special day for greyhounds and their owners.

The key to the digital execution of photomontage is the use of layers, although we'll use a variety of other techniques as well. Layers enable you to keep all the elements of the photomontage separate, so you can move them around, resize them, and change their color, brightness, and other aspects until you're completely satisfied. Also vital to creating a photomontage is having the right ingredients. You can download the ingredients for our icon project from our Web site at www.getcreativebook.com.

Silhouetting the Saint's Head

Let's talk about silhouetting. First, take a look at the original photo of our "saint" in Figure 11.2, which features a greyhound named Sailor and his owner, our friend Anita. Obviously, you don't want the icon to include Anita, Sailor's leash, or the shed behind the two of them. In fact, you want to get rid of the background entirely and end up with just Sailor's head and neck, which you'll combine with some appropriately posed paws and stick onto a more saintly body. So you'll need to silhouette this image—erase everything but the foreground element. Let's get started.

FIGURE 11.2

Anita—that's her T-shirted body hanging onto Sailor's leash—tells us that Sailor is anything but a saint, but we think he has a certain saintly demeanor regardless.

flash

We're creating our image at a high resolution of 300 ppi because we want to print it at the highest possible quality. You can resample the image elements we're supplying to a lower resolution if you like—it will speed up the process of applying filters and result in a smaller file—but you'll also need to change many of the filter settings, which are resolution-dependent. Whatever resolution you choose to work at, remember to save often and make use of the Undo History palette if you make a mistake.

1 First, you'll need to put Sailor on a transparent layer. Open sailor.tif and choose Window ▸ Layers to display the Layers palette. Double-click the Background layer and click OK to turn the background into a layer named Layer 0.

2 Now switch to the Crop tool and drag a cropping marquee around Sailor's head, from a little bit above his ears down to his shoulders. Be sure you don't clip off the tips of his ears on the side. When you've got the marquee adjusted to your liking, double-click in it or press ENTER to crop the image.

3 Change to the Eraser tool, with these settings:

flash

Elements' special Background Eraser tool is supposed to make silhouetting easy, but we find we get better results the old-fashioned way, so that's what we'll stick with; you can feel free to experiment with different methods.

Press CAPS LOCK so that the cursor displays the size of the brush; this makes it easier to see what you're erasing as you go.

4 Zoom in on any convenient starting point along a straight edge—we started at the tip of Sailor's right ear, in the upper-left corner of the image, and click once near the edge of the ear, but not on it. The idea is to delete all the background without leaving any telltale "fringe" pixels. Now, hold down the SHIFT key and click again a short distance away from your starting point to erase the pixels in a straight line between the two points.

5 Continue SHIFT+clicking your way around Sailor's head. Because this technique erases in a straight line, it's important to keep your SHIFT+clicks close together, especially when you're working your way along curves. Your goal is to end up with an erased line following the silhouette of Sailor's head and shoulders as shown in Figure 11.3.

FIGURE 11.3

You can see the checkered pattern that indicates transparency along the line where you erased the background pixels next to Sailor's head.

6 The remainder of this task is simply to delete the rest of the background—with the parts that abut Sailor's head already gone, you don't have to worry too much about messing up. You can use any of several tools to do this—the Eraser and the Polygonal Lasso spring to mind immediately. We chose the latter, switching to a 19-pixel hard-edged brush to clean up the erased "channel" outlining Sailor's head, and then changing to the Polygonal Lasso and SHIFT+clicking along the erased line and into the background area to select ever-larger areas of the background. Once each area of the background was selected, we pressed DELETE to get rid of it.

7 When all of the background is gone, leaving behind only Sailor's head and shoulders, you're done! Choose File ➤ Save As and save the image in Photoshop format to preserve its transparency; you'll need it again in the next chapter.

Creating the Saint's Body and Paws

Yes, paws. Remember, this is a *greyhound* saint, not just any old saint. However, the icon will have a human body in saintly robes. To make the body, you'll modify a body from an old painting. This body used to have a head and hands, but we got rid of those before we started working on the body itself, so you won't need to worry about them. What you will do is silhouette the body and then modify its shape and color so that they're more suitable for a greyhound saint. Let's get going:

1 Open saint_body.tif and double-click the Background layer in the Layers palette, then click OK to turn it into Layer 0.

2 We've done some of the heavy lifting needed to produce the saint's body by deleting the head, hands, and background from the original image. So your first step—silhouetting the body—is as easy as switching to the Magic Wand tool, clicking in the white area of the image, and pressing DELETE. Use these settings:

Don't forget to delete the white "hole" in the crook of the body's left arm. If you unchecked Contiguous on the Options bar as shown, then it should be gone by now, but if you left Contiguous checked you'll still need to click in this last little bit of white and delete it.

3 Now, as we all know, greyhounds are svelte, streamlined creatures—but this body is, quite frankly, a bit tubby. Press COMMAND+T (Mac) or CTRL+T (Windows) to enter Free Transform mode. Drag the handle in the middle of the right-hand side of the transformation marquee a bit to the left to make the body more slender, then press ENTER to apply the transformation. Don't make the body *too* skinny!

4 Now that the body's in better shape, let's change the color of those drab brown robes. You'll need to mask off the belt and buckle, so press D to change to the default painting colors of black and white, then switch to the Selection Brush tool and make these settings on the Options bar:

5 Paint carefully over the belt and buckle. If you made the right settings, you're in Mask mode, so you should see a red mask taking shape under your brush. When it's complete, choose Select ➤ Save Selection and enter an appropriate name (such as "belt and buckle") in the Save Selection dialog box. If you drop the selection or need to close the file before you're done, you can reselect this area by choosing Select ➤ Load Selection and finding the selection you saved before in the Selection pop-up menu.

6 Switch to the Rectangular Marquee tool to quickly turn the mask into a selection that encompasses everything *but* the belt and buckle, then choose Enhance ➤ Adjust Color ➤ Hue/Saturation. Make these settings:

Hue/Saturation	
Edit: Master	
Hue: −160	OK
Saturation: +7	Cancel
Lightness: −24	Help
	☐ Colorize
	☑ Preview

Click OK—now the robe is a nice purplish blue instead of that nasty brown.

7 Choose Select ➤ Inverse to select *only* the belt and buckle. Switch back to the Selection Brush and check the Options bar to make sure you're in Mask mode. Because you inverted the selection, the red mask now covers the robe, leaving the belt and buckle unmasked. Use the Selection Brush to carefully paint the red mask over the buckle, leaving only the belt unmasked. Now you'll change *its* color.

8 Choose Selection from the Mode pop-up menu on the Options bar to turn your mask back into a selection. Then choose Enhance ➤ Adjust Color ➤ Hue/Saturation so that you can change the color of the belt. This time, set the sliders as follows: Hue: −60, Saturation: 0, Lightness: −40. This yields a dark red for the belt that matches Sailor's collar.

9 Finally, save the image in Photoshop format to preserve its transparency; you'll use it in the next chapter when you assemble the icon. You can see what our version looks like in Figure 11.4.

We've silhouetted the paws for you as well; open right_paw.tif and left_paw.tif and take a look (you can also see them in Figure 11.5). Follow the above steps to turn the Background layer of each paw image into transparent layers, then delete the white that surrounds the paws. Save the files in Photoshop format to preserve their transparency.

FIGURE 11.4

A bit more colorful and a bit slimmer than the original, our saint's body is ready to have a head and paws attached.

FIGURE 11.5

We must confess, these paws don't belong to Sailor. They're the property of Freddie, a female greyhound who's the same color as Sailor.

Now that all the saint's pieces are complete, we'll move on to show you how to create a proper home for him: that fancy frame we mentioned at the beginning of the chapter. We'll put all the pieces together within the frame in the next chapter.

He's Been Framed—Creating an "Ancient" Frame in 3D

Not all icon paintings are framed, but many are, and this gives us an opportunity to set St. Guinefort up in grand style by building him a fancy frame. One of the most common kinds of medieval frame is a gold-leafed plaster frame, often with some corner decoration, so let's make our frame that way. To speed things along, we've provided a grayscale TIFF file containing the frame's design elements. It's on our Web site, and the file name is frame_element.tif (see Figure 11.6).

flash

For your own frame designs, you can find lots of great design elements in clip art design books at your local bookstore. Look for Dover's oversize paperbacks in the Art section.

FIGURE 11.6

It may be hard to believe, but this black and white design is the key to creating a three-dimensional gold frame for the icon.

Here are the steps to create the frame:

1 Open frame_element.tif and choose Image ➤ Mode ➤ RGB Color. Then create a blank layer by clicking the New Layer button in the Layers palette.

2 Choose the Rectangular Marquee. In the Options bar, choose Fixed Size from the Style pop-up menu, and set the size to 2250 × 2850 pixels. Click anywhere in the image window to create a selection marquee, then click and drag to position the marquee exactly in the upper-left corner. If Snap is turned on (choose View ➤ Snap to Grid), the marquee will snap into the right position when you get close enough.

3 Set the Foreground color to R: 220, G: 190, B: 128, then switch to the Paint Bucket and click anywhere inside your selection to fill the area. Press COMMAND+D (Mac) or CTRL+D (Windows) to drop the selection.

4 Change back to the Rectangular Marquee and set the selection size to 1650 × 2250 pixels (600 pixels less in each direction than the original selection). Click to create a selection marquee as before, and position the marquee in the upper-left corner of the image window. Then hold

down the SHIFT key and press the right arrow key 30 times to move the selection marquee exactly 300 pixels to the right. Now keep holding down SHIFT and press the down arrow key 30 times. The selection marquee should be exactly centered in the painted area.

5 Press DELETE to clear the selected area, leaving you with a gold frame, then press COMMAND+D (Mac) or CTRL+D (Windows) to drop the selection. Duplicate the frame layer by dragging it to the New Layer button at the bottom of the Layers palette, then click the Background layer (which contains the original design elements present in this file) to make it active again.

6 Choose the Magic Wand tool. In the Options bar, set the Tolerance to 50. Check the Anti-Aliased check box, uncheck the Contiguous and Use All Layers check boxes, and then click anywhere in the white area. Make the uppermost frame layer active. Press DELETE to clear the selected area. This leaves just the twisted ropy design on this layer. Choose Select ➤ Deselect to drop the selection again (or use the keyboard shortcut just given—your choice).

7 Choose Window ➤ Layer Styles. From the pop-up menu, choose Bevels, then click the Simple Inner thumbnail to apply a 3D effect to the ropy design. Choose Layer ➤ Merge Down to merge the two frame layers into one. Here's what your Layers palette should look like at this point:

8 Make the Background layer active, then make sure you're still using the Magic Wand tool. Check the Contiguous check box. Click in the black center square to select it, then hold down SHIFT to set the Magic Wand to Add mode and click five more times to select the cross and the four dots.

9 Choose Edit ➤ Copy to place the selection on the clipboard. Choose Layer ➤ Delete Layer to dispose of the Background layer, or drag it to the Trash button on the Layers palette. It's done its job—you won't need it any more.

10 Choose Edit ➤ Paste to paste the square element on the Clipboard into a new layer, then drag this new layer to the top of the list in the Layers palette. Switch to the Move tool and drag the black design element to the upper left corner of the image window.

11 Drag the corner-element layer (currently active) to the New Layer button in the Layers palette to duplicate it, then do the same thing twice more so that you end up with four layers containing copies of the corner design element. One at a time, make three of the four corner layers active and drag them to move the design elements to the other three corners of the frame. Line each corner element up carefully along the outer edges of the frame. When everything's in position, click to activate the uppermost corner layer in the Layer palette, then choose Layer ➤ Merge Down three times to merge the four corner layers into one. Now your Layers palette looks like this:

12 Switch to the Magic Wand tool. Make sure the Contiguous check box is still checked, and click anywhere in the large transparent area filling the middle of the corner layer. Choose Select ➤ Inverse. The selection should now comprise the four corner areas. Now make it smaller—choose Select ➤ Modify ➤ Contract. Enter 10, and click OK.

13 Make the frame layer active and create a new layer above it. Choose the Paint Bucket tool. In the Options bar, check the Anti-Aliased check box, and uncheck the Contiguous and Use All Layers check boxes. Click anywhere within one of the four selected areas to fill all of them with gold. Choose Select ➤ Deselect to drop the selection.

14 Make the uppermost layer, with the four black corner design elements, active. Set the Foreground color to R: 70, G: 70, B: 180 and click anywhere in a black area to fill the solid areas with blue.

15 Choose Window ➤ Layer Styles. From the pop-up menu, choose Bevels. Click the Simple Sharp Inner thumbnail. Looks cool—but it's not quite what we want. To modify the settings, choose Layer ➤ Layer Style ➤ Style Settings. Set the Bevel Size slider to 5, and click OK. Then choose Layer ➤ Merge Down to merge the blue and gold corner layers.

16 Back in the Layer Styles palette again, choose Drop Shadows from the pop-up menu and click the Noisy thumbnail. Then choose Layer ➤ Layer Style ➤ Scale Effects, enter 20 into the Scale field, and click OK. Now bring the frame together with its corners by choosing Layer ➤ Merge Down to merge the corner layer with the frame layer.

17 Choose Filter ➤ Texture ➤ Craquelure. Set Crack Spacing to 50, Crack Depth to 6, and Crack Brightness to 6, and click OK. Figure 11.7 shows what your image should look like at this point.

The frame may not look like much right now—it most certainly doesn't look much like ancient gold leaf—but give it a while. After you've assembled all the elements of the image in this chapter, in Chapter 12, you'll apply the effects you need to make St. Guinefort ready for hanging in the south transept of the nearest Canine Cathedral.

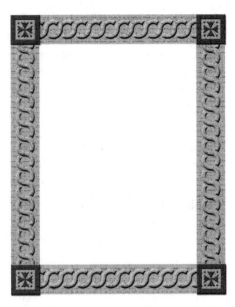

FIGURE 11.7

The frame has all its elements—the rope carving and the four corner blocks—but its surface is still pretty flat looking. Don't worry—that will change!

On Your Mettle! Let's Make Some—Metal, That Is

Creating objects that look like real metal is perhaps one of the most difficult things you can do in an image-editing program—but it's an essential technique if you want to combine created objects with real ones in a photomontage like the one we're making. To create a brass name plaque for St. Guinefort, follow these steps, working in the same image that contains the gold-leaf frame:

1 Set the Foreground color to R: 219, G: 205, B: 132. This is pretty close to the color of the frame, but it's a little greener to resemble brass.

2 Switch to the Type tool. In the Options bar, click the icon that shows centered lines of type. Enter 30 in the font size field. Choose a font from the font family pop-up menu. We chose Olde English, but you can choose any font you like.

3 Click anywhere near the center of the document to create a new type layer. Now, before you type anything, you should see that the four style buttons on the Options bar (Faux Bold, Faux Italic, Underline, and Strikethrough) have become active. Click the Faux Bold button. Now type **St. Guinefort** for the first line on the plaque.

focus ——————————————————————————————

It's a sad fact that a point is not always a point, at least where fonts are concerned. The font you pick may not be just the same size as ours, even if you have an Olde English font, too. You might need to change the point size of your text lines to make the text fit properly on the finished plaque. You'll know when you get to Step 7 whether you have to fiddle with the text. If you do, go back and choose a point size so that the marquee you create in Step 7 will allow about 130 pixels on each side of the text and about 95 top and bottom. Change the type size, not the marquee size, because making the marquee different will throw the proportions of the finished frame out of whack.

4 Enter 15 in the font size field in the Options bar and press ENTER to return to the document. Press ENTER again to start a new line of type, and type **The Greyhound Saint** for the second line.

5 Choose Window ➤ Layer Styles. From the pop-up menu, choose Bevels and click the Simple Sharp Inner thumbnail. Then choose Layer ➤ Layer Style ➤ Style Settings and click the Down radio button, then click OK. This will incise the text into the plaque. Your text should look like this:

The checkered background tells you that you're working on a transparent layer.

6 Now you need to convert the text into pixels—which you can't edit—so be sure you've spelled everything right before you continue. All set? OK, choose Layer ➤ Simplify Layer, then choose Enhance ➤ Auto Levels to incise the text more deeply.

7 Create a new layer and drag it in the Layers palette so that it's below the type layer you just worked on. Then switch to the Rectangular

Marquee tool. Still using the Fixed Size setting, set the size to 960 pixels × 360 pixels and click to create a selection marquee. Click within the marquee and drag it so that the type is centered as accurately as possible in the marquee. Don't worry about the position of the marquee within the image window—you'll move the whole plaque to its final position in the next chapter.

flash

Here's Richard's favorite way to make sure that his selection marquee is perfectly centered on the text: position the marquee so that its top and left edges are aligned with the top and left edges of the text. Hold the SHIFT key and press the left arrow, counting the steps, until the right edge of the marquee is as close as possible to the right edge of the text without going past. Multiply by 10. Release the SHIFT key and press the arrow to move the marquee until it's exactly aligned. Add the number of single steps to the number of 10-at-a-time steps and divide by 2. Move the marquee back to the right that number of pixels. Repeat this procedure for the vertical alignment.

8 Choose the Gradient tool. From the Gradients pop-up menu in the Options palette, choose Chrome (blue, white, and brown/gold) by double-clicking its thumbnail. This gradient has the shadings you want, and it's quicker and easier to apply it and then recolor it than it would be to create a custom gradient. Position the mouse on the top edge of the selection marquee. Hold down the SHIFT key and drag the mouse downward to the bottom edge. The SHIFT key constrains the gradient to an exact horizontal alignment. Here's what your image should look like at this point:

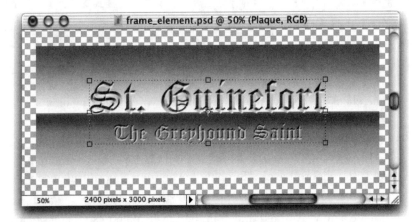

9 Choose Filter ➤ Distort ➤ Ripple. Choose Large from the Size pop-up menu, and set the Amount to 46. This step makes the plaque's flat surface look less artificially perfect.

10 Choose Select ➤ Modify ➤ Contract. Enter 90 and click OK, then choose Select ➤ Modify ➤ Expand. Enter 30 and click OK. This is a quick way to create the final shape you want; do this in two increments—otherwise you won't get the nice beveled corners you want. To finish this step up, choose Select ➤ Inverse and press the DELETE key to clear the unwanted area, then choose Select ➤ Deselect to drop the selection.

11 Choose Enhance ➤ Adjust Color ➤ Hue/Saturation. Click the Colorize check box and set the settings to Hue: 50, Saturation: 40, Lightness: 0. Click OK.

12 Choose Window ➤ Layer Styles. From the pop-up menu, choose Bevels. Click the Inner Ridge thumbnail. You'll modify this bevel later, when you assemble all the elements of the photomontage.

13 Make the type layer active and choose Layer ➤ Merge Down to merge the type with the plaque. For now, you can just leave the plaque layer where it is. In Chapter 12, you'll move it to its final position. Save the image in Photoshop format so you can come back to it in the next chapter. Figure 11.8 shows what the plaque should look like now.

Moving On

Now that you've created the pieces, it's time to put them all together. In the next chapter, we'll show you the techniques you'll use to assemble the final image so that it looks as though it was created as a whole. Lighting is a major component in this process—sloppy, amateurish photomontages are full of objects lit with different colors and intensities of light that come from different directions. Since the Saint Guinefort icon is naturally going to be a *good* photomontage, you'll adjust the image's overall lighting to make it look all of a piece. You'll also add shadows and other special effects to bring the pieces together and add dimension and detail.

FIGURE 11.8

The metallic plaque will receive some slight adjustments in the next chapter, where it will also be moved into position on the edge of the frame.

More Great Ideas

When you get into photomontage, you start looking at photos as parts of a greater, hypothetical whole. Any photo might be a piece of a completely new work of art. Of course, the individual pieces come in handy, too. Here's a list of ways you might use photomontage images—or their components.

- You find the coolest things at craft shops these days, including lots of neat unfinished wood objects. It's easy to create a treasure box with a decoupaged image montage—first, spray paint the box, then apply your photomontage with decoupage glue. You can embellish the box with fake jewels, braid, or anything else that strikes your fancy, too.

- Some big—button telephones have clear covers for the buttons so you can insert names or photographs that match the way the speed-dial numbers are arranged. You don't have to use just an ordinary photo, you know . . .

- Celebrate a holiday—or every day—by making special placemats featuring your family members. In our set (see Figure 11.9), we created a photomontage for the center mat, then embellished the placemats themselves with individual pieces of the montage. Now everyone knows exactly where to sit at meal times.

FIGURE 11.9

We used iron-on T-shirt transfers to create our custom placemats; you can see them in color on our Web site.

- If you're silhouetting kids for a photomontage, why not save the silhouetted images and print them on card stock as paper dolls? You can create clothes yourself in a drawing program, or cut out pictures from magazines, or even photograph the kids' real clothes. Don't forget to leave tabs on the shoulders and waist when you're trimming the dolls' outfits.

- Make your own gift bags quickly and easily by starting with a white bag and printing your most creative photomontage on sticker paper, then applying it to the side of the bag. This works best before you put the gift in the bag . . .

- You might think that house flags are too big for you to make them with your inkjet printer—but remember that photomontage works in real life too. In other words, you can create a banner by printing the pieces of an image on transfer paper and ironing them onto the banner fabric one part at a time.

- Make a jigsaw puzzle with your favorite wacky montage—this makes a wonderful great holiday gift because it gives everyone something to do after the gifts are opened and the big meal is eaten. This kind of picture can also be a real challenge for the inveterate puzzlers in the family!

12

Getting It Together
Assembling the Photomontage

IF you're still with us after all the hard work we laid out for you in Chapter 11, that's great! Now comes the fun part. After spending some time collecting and modifying the elements of the photomontage project—our icon of Saint Guinefort—you'll now get to put all those pieces together into a beautiful and satisfying whole.

We've used this image to help raise funds for local greyhound adoption efforts—volunteer groups that accept retired greyhounds from area racetracks and care for them until good homes can be found for them. Exercising a little creativity, we put the image on T-shirts, note cards, and other items that could be sold to raise money to support greyhound adoption. We had a lot of fun creating the icon, and we've been able to use it to help a good cause—what could be better than that?

We used Adobe Photoshop Elements to create the project that you began in Chapter 11 and will complete in this chapter. You can use any program that supports layers to complete the project. You'll also find layer effects such as drop shadows useful, in addition to the ability to control image lighting.

focus

Today, icons of the type we're creating are most commonly associated with the Russian Orthodox Church, but these icons are a very old art form. They originated during the time of the Byzantine Empire, 476 CE to 1453 CE. To see a few of the very best ancient icons, point your browser at kypros.org/Byzantine/001.htm through kypros.org/Byzantine/016.htm.

Seeing Things in the Right Light

Before you start putting the icon pieces together, you'll need to download two filter settings files that we've created for you. You'll use these two files right at the end to apply lighting effects to the whole image, but they must be installed before you launch Photoshop Elements for this final stage. If Elements is running now, quit it and install the files before starting it up again. You can download the filter settings files, along with other necessary files for this chapter, from our Web site at www.getcreativebook.com. The lighting effects files are named Frame Lighting Effects and Icon Lighting Effects, and there are two versions: Mac and Windows. Unpack the right version of the files and place them in the Plug-Ins/Filters/Lighting Styles folder that's inside the folder containing your Photoshop Elements application.

Creating an Opulent Background

While some historic icons have semirealistic background settings for their central figures, we prefer the ones featuring a lush, rich gold background. So, naturally, that's the kind of background we decided to place Saint Guinefort against. Here are the steps to follow:

1 Open the image file you created at the end of Chapter 11, which contains the gold frame and name plaque for the icon. Choose the Move tool and make sure that Auto Select Layer is checked in the Options bar, then click the plaque and drag it down so that it's centered over the bottom rail of the frame. Now the middle of the frame is clear, so you can begin creating the traditional gold background for the icon.

2 Create a new layer and drag it below the frame and plaque layers in the Layers palette. Switch to the Rectangular Marquee and click in the center of the frame's upper left corner element. Drag down to the center of the lower right corner element to create a selection that extends behind the frame rails, but not beyond them.

3 Change the Foreground color to the same gold you used to create the frame: R: 220, G: 190, B: 128. Press OPTION+DELETE (Mac) or ALT+DELETE (Windows) to fill the selected area with gold.

4 Now you'll add a texture to this flat colored background. Open background_element.tif, select all, and copy. Switch back to the frame image and paste. The black and white pattern becomes a new layer above the gold background and below the frame layer. You may need to move the pattern a little one way or the other to center it; this will make it look as if the design was created for the frame instead of being added afterward inside your computer. In the Layers palette, change this new layer's blending mode to Soft Light, then choose Layer ➤ Merge Down to combine the two background layers into one.

5 Choose Enhance ➤ Adjust Color ➤ Hue/Saturation and drag the Lightness slider to +25 to produce the final gold background.

6 Choose the Magic Wand and click in the white area, outside the frame. Choose Layer ➤ New ➤ Layer via Cut. This splits the background texture layer into two layers, one containing the textured area and one containing the white area. In the Layers palette, drag the white layer so it's at the bottom of the list, below the gold background layer.

Figure 12.1 shows the frame as it now stands, with the plaque moved into position and the gold background added. Next, you'll put Saint Guinefort into the picture.

FIGURE 12.1

Gold, gold, and more gold—that's what we love about icons.

The Head Bone Is Connected to the Neck Bone

1 Open saint_body.psd, the modified body file you created in Chapter 11. Make sure the Layers palette is visible (choose Window ► Layers if it's not) and drag Layer 0 from the Layers palette directly into the frame image window. This copies the layer into the frame document. Close saint_body.psd—you're done with it—and go back to the frame image. If necessary, move the body layer above the gold background layer in the Layers palette so you can see the saint's body.

2 Switch to the Move tool and position the saint body so that it's centered above the plaque and the hem of the robe is just hidden behind the lower frame rail. The body is all set.

3 Open sailor.psd, the head image that you created in the last chapter, and do the same with the dog's head, dragging the head layer into the frame image window. Center the head horizontally on the body and position it vertically so that Sailor's collar is just below the top edge of the robe's cowl (see Figure 12.2).

4 In the Layers palette, drag the head layer below the body layer. Activate the body layer, then switch to the Magic Wand and make these settings in the Options bar:

5 Click the inside of the robe's cowl to select the lighter purple area. You may need to SHIFT+click a time or two to select the whole area. Then choose Select ► Modify ► Smooth and enter 3 in the Smooth Selection dialog box. Click OK to smooth the selection's edges.

6 Press COMMAND+OPTION+SHIFT (Mac) or CTRL+ALT+SHIFT (Windows) and click the head layer in the Layers palette to select the intersection of the current selection and the nontransparent areas of the head layer—in other words, to select the area where Sailor's neck should show in front of the robe's cowl. Press DELETE to delete the unwanted area of the cowl. Press COMMAND+D (Mac) or CTRL+D (Windows) to drop the selection.

7 Zoom in so that you have a good close view of the area of the head and neck. Switch to the Eraser, set the Mode pop-up menu to Brush, and choose a soft-edged 13-pixel brush. Making sure the Opacity is set to

FIGURE 12.2

It's not easy to get a dog's shoulders to fit into a robe made for a man, but we think this combination works out pretty well.

100%, erase the remaining thin strip of the cowl that cuts across Sailor's neck, as well as any other bits of the cowl that shouldn't be there. That completes the head.

Things are really starting to take shape now that our saint has a head. Later on, you'll adjust the surface appearance of the head so that it looks painted, like the body. First, though, you'll add the saint's paws; they'll need the same treatment, so you need to get them in place before proceeding with the surface treatment. Follow these steps:

1 Open left_paw.psd—remember it from Chapter 11?—and drag the paw layer from the Layers palette into the frame image window, as you did with Sailor's head. Note that this paw belongs on the right side of the image—but it *is* Saint Guinefort's left paw.

2 Press COMMAND+T (Mac) or CTRL+T (Windows) to enter Free Transform mode. Press SHIFT and drag the corner handles of the transformation marquee to resize the paw, keeping an eye on the resizing percentage in the Options bar as you go. We changed our paws to 38.7 percent of their original size, and we didn't need to rotate the left paw at all. Press ENTER to apply the transformation when you're happy with the paw's size.

3 Now move the paw into position at the end of the left sleeve—it will extend too far over the sleeve, but don't worry; you're going to trim off what you don't want. Hide the paw layer and use the Polygonal Lasso to begin a selection by clicking your way along the top and outermost edge of the sleeve's cuff. Then extend the selection back along the cuff as shown here:

4 Display the paw layer again and make sure that it is the active layer, then press DELETE to remove the unneeded portion of the dog's wrist. Press COMMAND+D (Mac) or CTRL+D (Windows) to drop the selection. Now on to the second paw.

5 Open right_paw.psd and follow Steps 1 through 4 with the right paw. When we added our right paw, we resized it to the same percentage (38.7%) as shown in the Info palette and rotated it –65°, also as shown in the Info palette. Once we had the paw positioned at the end of the right sleeve, we used the same technique to delete the extra portion of wrist. Figure 12.3 shows how your image should look at this point.

6 When you're done positioning the paws, activate the upper paw layer; it's probably the right paw (on the left side of the image). Choose Layer ➤ Merge Down to combine the two paws on one layer. Then choose Enhance ➤ Adjust Color ➤ Hue/Saturation and drag the Hue slider

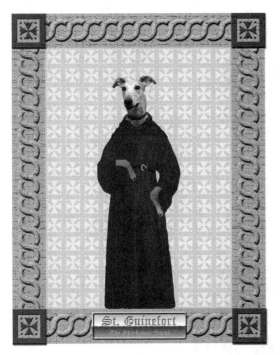

FIGURE 12.3

While the saint's paws may seem to be oddly positioned, icon images often seem stiffly posed to our modern eyes, so this position is in keeping with the artistic tradition we're mining.

to +22 to bring the color of the paws more in line with the color of the head.

Now the saint himself is complete. The next step is to turn him into a painted image instead of one cobbled together from an assortment of painted and photographed elements.

Aging Photos by Several Hundred Years

We could leave the photographed head and paws just the way they are if we were going for a surreal effect—but we're not. We want our icon to look as though it was really created hundreds of years ago, in every respect. So we're going to need to age the head and paws, as well as make them appear to be painted instead of photographed. This technique can be applied to any image, not just faux icons, so pay close attention. Here's what you need to do:

1 Continuing to work in the same image, which now contains the frame, the background, and the saint himself, duplicate the head layer and

activate the lower of the two head layers. Choose Filter ➤ Artistic ➤ Underpainting and make these settings:

Click OK. Don't be alarmed if you can't see any change in the dog's head—the unmodified head layer is blocking your view of the underpainted layer, but it won't be doing that for long. (If you really want to see what's happening, hide the unmodified head layer for a moment.)

2 Activate the upper of the two head layers and change its opacity to 50%. Create a new layer, which will appear just above this layer. Press D to return to the default colors of black and white. Press OPTION+DELETE (Mac) or ALT+DELETE (Windows) to fill the new layer with the Foreground color, black.

3 Choose Filter ➤ Render ➤ Difference Clouds. Then press SHIFT+COMMAND+L (Mac) or SHIFT+CTRL+L (Windows) to apply the Auto Levels command. Choose Filter ➤ Stylize ➤ Find Edges, and apply the Auto Levels command once more to produce a wrinkled, cracked texture.

4 Change the opacity of this texture layer to 30% and its blending mode to Hard Light, then hold down the OPTION (Mac) or ALT (Windows) key and click the thin gray line separating the texture layer from the head layer in the Layers palette, so that the effect of this texture layer is restricted to the area of the head.

flash

To change the positioning of the cracks and wrinkles on St. Guinefort's face, make sure the texture layer is active, then switch to the Move tool, click in the image window, and drag the texture around until you're happy with the positioning of the cracks and wrinkles.

5 Making sure that the texture layer is active, choose Layer ➤ Merge Down twice to combine the texture layer and both head layers into one.

6 Activate the paws layer. Press COMMAND (Mac) or CTRL (Windows) and click the layer in the Layers palette to select the paws.

7 Choose Edit ➤ Stroke and enter these settings:

Stroke	
Stroke	OK
Width: 2 px	Cancel
Color: ⬛	Help
Location	
○ Inside ○ Center ◉ Outside	
Blending	
Mode: Normal ▲▼	
Opacity: 30 %	
☐ Preserve Transparency	

Drop the selection. This narrow dark stroke around the paws will prevent a light "halo" from appearing around them when you apply the same filters to them as you did to the saint's head. You'll create a halo eventually, but you don't want it around Saint Guinefort's paws.

8 Now follow Steps 1 through 4 to apply the same underpainting and texture techniques to the paws that you used for the head. Finally, merge the two paws layers and the texture layer into one as you did with the head layers in Step 5.

The head and paws, which started out as thoroughly modern photographs, now look old, worn, and definitely painted rather than photographed (see Figure 12.4). You're almost done—go on to the next section to create that halo we were talking about.

Halo, Everybody, Halo—Creating That Saintly Glow

A saint just isn't a saint without a halo! Follow these steps to create a halo for the Greyhound Saint:

1 Create a new layer and drag it below the head layer. Make sure it's the active layer. Then choose the Eyedropper tool and click anywhere in the darker part of the icon's gold background to pick up the gold color there.

2 Switch to the Elliptical Marquee tool. Click in the middle of the dog's face. Hold down SHIFT+OPTION (Mac) or SHIFT+ALT (Windows) and drag to create a circular selection approximately as wide as the dog's ears. Press OPTION+DELETE (Mac) or ALT+DELETE (Windows) to fill the selection with the light gold.

3 In the Layer Styles palette, choose Outer Glows from the pop-up menu and click the Heavy thumbnail. Figure 12.5 shows what you'll get.

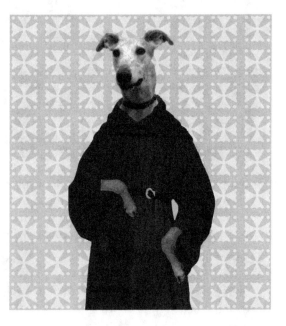

FIGURE 12.4

Sailor suddenly looks much, much older—as do Freddie's paws.

Three steps to a halo—don't you wish it were that easy to earn your own halo? Next, you'll finish up the icon by applying some light and shadow effects to it, making it seem as real as the real thing.

Let There Be Light—on St. Guinefort

To finish the photomontage of St. Guinefort the Greyhound Saint, you need to create the impression that the image is a real three-dimensional object by making it look as if lights are shining on it, highlighting some areas and shadowing or subduing others. You started this process back in Chapter 11 by applying a drop shadow to the corners of the frame before merging them with the rails; now it's time to finish the job. Follow these steps to light up the saint:

1 First, let's drop a shadow under the name plaque. Click the plaque layer in the layers palette and choose Window ➤ Layer Styles. From the pop-up menu, choose Drop Shadows and click the Noisy thumbnail, then choose Layer ➤ Layer Style ➤ Scale Effects, enter 40% in the Scale field, and click OK. Notice that this also scales the size of the bevel applied back in Chapter 11 when you created the name plaque.

2 Now you'll put a shadow under the frame. Click the frame layer in the Layers palette. Choose Window ➤ Layer Styles. From the pop-up menu, choose Drop Shadows, and click the High thumbnail. Choose Layer ➤ Layer Style ➤ Scale Effects, enter 40% in the Scale field, and click OK.

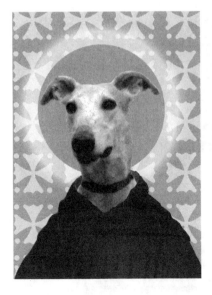

FIGURE 12.5

Every dog should have a halo. And now that you know how easy they are to create, you can make sure that all of your dogs have halos.

3 Now throw a little light on this picture! Keep the frame layer active, and choose Filter ➤ Render ➤ Lighting Effects. From the Style pop-up menu, choose Saint Frame Lighting. Make sure that the Texture Channel pop-up menu calls for Layer X Transparency, where Layer X is the name of the frame layer in the Layers palette, then click OK.

flash

Before you click OK in the preceding step, you might want to spend a few minutes playing with the various settings to see what they do to the overall lighting effect. You can always return to the Saint Frame Lighting style by choosing any other style from the Style pop-up menu and then choosing Saint Frame Lighting again.

4 In the Layers palette, hide the white layer, which is at the bottom of the list, and the frame and plaque layers, which are at the top of the list. Click any of the visible layers and choose Layer ➤ Merge Visible to combine into one layer all of the layers making up the "painted canvas" icon art.

5 Choose Filter ➤ Render ➤ Lighting Effects and choose Saint Icon Lighting from the Style pop-up menu. This setting is almost, but not quite, identical to the lighting you used to light the frame. Click OK.

6 Many medieval icons were painted on wood. To unify the whole painting, add a subtle wood grain texture by choosing Filter ➤ Texture ➤ Grain and making these settings:

7 Display the three layers you hid earlier, and *voilà St. Guinefort!* See Figure 12.6 for the final image—and check out our Web site at www.getcreativebook.com to see the icon in all its colorful glory.

Where Do We Go from Here?

These two chapters used a lot of techniques that you'll find more about elsewhere in the book. For example, if you like the idea of turning photos into paintings, turn to Chapter 5, "Roll Over, Michelangelo: Turning Photos into Art with Filters." And if you were intrigued by the processes we used to create the "three-dimensional" frame and brass name plaque, check out Chapter 14, "What Fools These Mortals Be: Creating Easy Trompe l'Oeil Images," where we teach you the theory and practice of shadows to enhance realism when you're creating 3D effects.

Traditionally, photomontage and its sister art form collage are ways to combine more than just different images—they're ways to mingle different techniques as well. That means that they're a great way to stretch your wings, try out all the things you're learning in this book and elsewhere—and get creative!

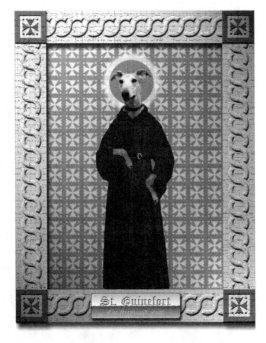

FIGURE 12.6

The final image portrays Saint Guinefort as noble and indisputably holy.

More Great Ideas

Photomontages can be serious or silly, realistic or surreal. Look for photos that build on each other to create a mood, and don't be afraid to experiment with filters and other effects to make each element of the montage look just right. Here are a few ways you can use photomontages:

- For a great wedding favor, make a mix CD of the couple's favorite songs—or romantic classics—and create a custom CD cover featuring a cuddly photo of the special couple. Your montage should include lots of hearts and flowers. Don't forget to add liner notes with more photos and a list of the tunes.

- Mirrors don't have to be bland—you can use your inkjet printer to jazz up your mirror by printing your photomontage (or other images) on stickers or transparency film and applying them to the mirror's surface. Flowers, pets, or your favorite people—any of these makes a great accent for a mirror.

- We may have gone digital, but we still have albums crammed with old photos. And the albums all look alike, too—we have to open each one to find out what's in it. Or we did—until we started making photomontage covers for our old albums, and our new ones too (Figure 12.7 is a good example).

FIGURE 12.7

The photomontage on the cover of this album gives a good feel for what you'll find on the inside. Check out the color version in Plate 12.1.

- One of our favorite craft-store finds is a snow globe kit—you print your image and attach it behind the water-filled portion of the globe so that the "snow" falls gently in front of your image. These make great vacation souvenirs for those you left behind—"My friend went to Aruba, and all I got was this snow globe!"

- You can also find chunky clear acrylic coasters at craft shops—perfect for your favorite coffee mug—with slots where you can insert a photo.

13

What I Did on My Summer Vacation
Combining Text and Images in a Postcard

IT'S usually true that a picture is worth—well, perhaps not a thousand words anymore, but certainly several hundred. Photos can convey an incredible amount of information in a single glance. But there are times when even the best photos can use a word or two to help them communicate with their viewers. Used thoughtfully, type itself can function as a design element that enhances an image and increases its impact.

Type is most often used within an image as a caption, a low-level assistant to make sure the image's viewers get the idea. If you're willing to make the image and the type equal partners, however, you can have a lot of fun integrating the two to create designs that are more than just the sum of their parts.

We created this project in Adobe Photoshop Elements. To complete this image in Elements or another program, you'll need to know how to add type, modify its shape, create gradients, and make and invert selections. You can still complete this project if your software doesn't support layers, but layers will make the project much easier.

Creating a Large-Letter Postcard

In this chapter, we'll show you a few ways to integrate type and images by creating what postcard collectors call a "large-letter" postcard. It's a tourist greeting postcard with a place name in big fat letters through which are visible photos of tourist attractions that you'd see if you went there (check out some examples in Figure 13.1). Such cards are kitschy, but they're fun to receive in the mail and even fun to design yourself. To create the card, you'll use several techniques:

- Tracing scanned shapes
- Adding type
- Warping type
- Silhouetting images within shapes

An image such as this postcard can be used in a variety of ways. Of course, you could print it on card stock, turn the card over and print its back, then cut the cards up and mail them like regular postcards. But because this image conveys such a strong sense of a particular place, it would also make a good T-shirt, memory book cover, or Web site banner. You don't have to stick to using places, either, although that's the traditional

FIGURE 13.1

Here are some of the real-life large-letter postcards in our collection. You can see them in color in Plate 13.1.

way this design concept is used. The type that forms the basis for the design could be a person's name, an organization, or an event, with appropriate photos peeking through the letters in each case (see Figure 13.2). For example, a family reunion invitation might use the family's last name as the type, with photos of each relative silhouetted within the letters.

Before starting, you need to collect the elements that you'll combine to create the card. You'll need two things:

- An image of a state, country, or city that you can trace to create an outline
- Several photos of interesting scenes or objects from that place

Our postcard uses images from a place we recently visited: East Aurora, New York. East Aurora village, founded in 1874, is home to two National Landmarks: the Roycroft Campus, a center of the Arts and Crafts movement in the early twentieth century, and the home of U.S. President Millard Fillmore. East Aurora was also famous worldwide in the late nineteenth century for the race horses that were raised and trained there. When we visited the town, we photographed a monument and a plaque at the Roycroft Campus, as well as the town's old-time movie theater and its dime store. We were also fascinated by the fire hydrants in East Aurora, all of which are painted like funny characters. Photos like these (see Figure 13.3) are pretty prosaic when placed in a photo album on their own, but when combined into a composite image, they have much more punch.

FIGURE 13.2

We created a large-letter-style postcard to use in a trip report about a recent vacation. Plate 13.2 shows the front and back of the final printed card in color.

FIGURE 13.3

Our photos are colorful, but they lack context. Combining them into a single image increases their impact tenfold.

focus

If our postcard inspires you to visit East Aurora, you can find more information about the town at the Web site of its local newspaper: www.eastaurorany.com.

We've placed the images used in this chapter on our Web site so you can download them and work along. You'll find them here: www.getcreativebook.com.

Designing a Background

To begin the postcard design, you'll create a new image the right size and add the postcard's background—in this case, a brightly colored gradient background with a silhouetted map of New York State. Follow these steps to create the background:

1 Choose File ➤ New to create a new document. We made our RGB document 5 1/2" by 3 1/2", the size of most common postcards in the

U.S., and we set the resolution to 150 pixels per inch because that's plenty good for a "throwaway" document like a postcard. If you're making a Web image, you might want to set the resolution to 72 pixels per inch instead. (You can also work at a higher resolution to preserve image quality for other uses and then just flatten the image, resample it, and output your final image at 72 pixels per inch. But don't save the flattened and resampled version over your high-resolution version!) Here's Photoshop Elements' New dialog box, with the settings we used:

New
Name: Travelogue Postcard OK
Image Size: 1.24M Cancel
Preset Sizes: Custom
Width: 5.5 inches
Height: 3.5 inches
Resolution: 150 pixels/inch
Mode: RGB Color
Contents
○ White
○ Background Color
⦿ Transparent

flash

If you're making a postcard that you really intend to mail, you should probably make it a standard postcard size. The United States Postal Service has regulations about postcard sizes on its Web site, and if your card is too large or incorrectly proportioned, you won't be able to use a postcard stamp on it. (If it's too small, the Postal Service will refuse to accept it for mailing.) A standard postcard must be between 3 1/2" and 4 1/4" along the short side and between 5" and 6" along the long side. (Of course, you can always opt to make it oversized on purpose and use a first-class letter stamp.)

2 Many of the large-letter postcards from the 1940s and 1950s have a garishly colored gradient background, so that's what we'll use. (We copied this gradient from the one used on the Asheville, North Carolina card in Figure 13.1.) Switch to the Gradient tool and click

the down arrow next to the gradient swatch on the Options bar to display a selection of gradient presets, as shown here:

Choose the Yellow, Magenta, Teal gradient (if you don't see it, choose Color Harmonies 1 from the pop-up menu). This isn't exactly the gradient you need for this card, so you'll need to click Edit so you can change it. In the Gradient Editor dialog box, drag the rightmost color stop (teal) to the 85% position. Click below the gradient strip to add a color stop at the 75% point. Now click the Color swatch and set the color for the new stop to R: 217, G: 163, B: 0, then click OK. When you added the new color stop, two diamond-shaped color midpoint markers appeared between it and the stops on either side of it; drag these markers to the positions shown here (80% between red and the new mustard-colored stop, and 50% between the mustard and teal):

Click the teal color stop, then click the Color swatch and set the color to R: 102, G: 179, B: 255. Click OK, then click OK again to finish editing the gradient.

flash

You can also download the east-aurora.grd file from our Web site. Drop it into the Presets/Gradients folder in the folder where your copy of Photoshop Elements is stored; then you can simply load it instead of going through the process of creating the gradient.

3 Drag a diagonal line in the middle of the image window to create a gradient like the background gradient in Figure 13.2. If you don't like what you get, try again—the new gradient will replace the old one.

4 Open the image you'll use to create your state outline. We used a map of New York that we found on the Web (www.gismaps.fema.gov/ 2001graphics/dr1391/dr1391dec.jpg). With the map opened, choose Select ➤ All and then choose Edit ➤ Copy to copy the selected image. Switch back to your postcard document and choose Edit ➤ Paste to paste the image in. It will make a new layer.

If you prefer to skip ahead, you can download the New York outline we created from our Web site at www.getcreativebook.com. It's a Photoshop-format document; you can use the Move tool to drag the outline right into your postcard image. Then skip to Step 6.

5 Choose Image ➤ Transform ➤ Free Transform, hold down the SHIFT key, and drag the corners of the map's bounding box until it's the size you want it to be. Then click inside the box and position the map roughly where it should go within the background; you can adjust its position later. Press ENTER to apply the transformation.

6 Choose Window ➤ Layers to display the Layers palette, then click the New Layer button at the bottom of the palette to make a new layer above the map layer. (If your new layer doesn't appear right above the original map layer, you can drag it there.) You'll use this layer as tracing paper on which you can draw an outline based on the map image. Choose the Brush tool, select the 5-pixel hard-edged round brush from the Brushes pop-up in the Options bar, and set the Foreground color to black. Carefully trace the edges of New York (see Figure 13.4). When the outline is complete, you can either delete or hide the original map layer using the Layers palette.

FIGURE 13.4

Zoom in to trace the map's outline reasonably accurately, but don't worry about getting it perfect.

flash

To create the map outline easily, click at any point on the border between New York and another state with the Brush tool. Then, while holding the SHIFT key down, move a little bit along and click to draw a line from the first point. Continue this SHIFT+clicking process all the way around; you can do straight lines like the long bottom edge of the state in one jump. Be sure your last stroke closes the outline, or you won't be able to select the inside of the state in Step 6.

7 Use the Magic Wand tool to select the inside of the traced area. Choose Select ➤ Modify ➤ Expand to expand the selection by 3 pixels. Enlarging the selection area ensures that when you fill the selected area with color in the next step, the tracing will overlap and hide the filled area's edges.

8 Make another new layer above the original map but below your tracing layer. Switch to the Paint Bucket and make the Foreground color a nice compatible blue (R: 0, G: 115, B: 229). Click in the selection to fill it with the color for the state, as shown here:

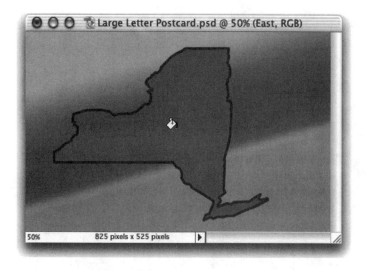

9 Our postcard is for a city, not the whole state, so you need to place a marker on the map to show where the city is. In the Layers palette, create a separate layer on which you'll place the city marker. Switch to the Brush tool, select the 29-pixel star-shaped brush, and set the Foreground color to white. Click and hold down the mouse button for a second to paint a star in the appropriate spot, making sure you let the applied color reach full intensity. Now set the color to red (R: 255, G: 0, B: 0), and with the 19-pixel hard-edged round brush, make a dot exactly centered over the star. The final background is shown in Figure 13.5.

Adding the Type

When you're using type, you have several decisions to make besides what the type will say. You'll need to size the type and choose a color for it, but most importantly you'll need to choose the right typefaces.

For this design, we wanted a decidedly retro look, so we downloaded two '40s-style freeware fonts, dekthusian for **East** and **New York**, and Swing for **Visit historic….** Because we wanted nice fat sans serif letters to show our photos through, we chose Microsoft's Arial Black for **AURORA**. If you don't have these fonts, or if you just want to use other fonts, feel free. If you're going for a vintage look, watch for typefaces that remind you of postcards, advertisements, and magazine covers of the period you're aiming for.

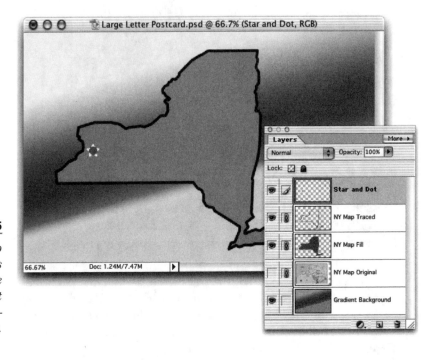

FIGURE 13.5

The map background is ready for the next set of steps— adding type.

Typeface, font—what's the difference? In general use, there's no difference between these two words, and most people use "font." Technically, however, we choose typefaces for use in each design—the font for a typeface is simply the file or files that we install in order to have access to that typeface on a computer. Now you know the difference—but don't expect to win any Trivial Pursuit games with that knowledge.

Much of the design of this postcard image comes from the letterforms it incorporates. Now you'll add the type; then in the next section you'll warp the "AURORA" text into the desired shape. Don't worry if some of the type overlaps as you follow these steps; each line of text is on its own layer, so you'll be able to move it around independently once you add all the pieces. Follow these steps to add the type to the postcard:

1 Choose the Type tool and click in the image, then choose the font, size, and color you want to use by making settings on the Options bar, and type the word **AURORA**. We set our type in black 72-point Arial Black. The color doesn't matter in this case, since you're just going to use these letters as shapes for the photos you'll add later. Choose a color that's easy for you to see against the bright-colored background

you created in the previous section. We'll use black. Here's what we have so far:

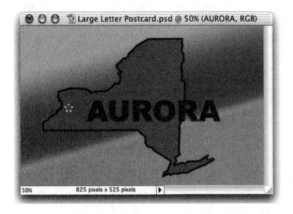

2 Press ENTER to complete the type layer you just created, then click at the top of the image window to begin a new type line. Choose black if you didn't use it in the previous step. Switch to Swing for **Visit historic...** and set the size to 18. Type **Visit historic...** and press ENTER again. If the text isn't the size you think it should be, use the mouse to select all the characters and then try a different size.

3 Change the type settings to dekthusian at 48 points. Click below "Visit historic..." and type **East**, then press ENTER.

4 Finally, click below "AURORA" and change the type size to 24, then type **New York** and press ENTER. See Figure 13.6 to check out how the type looks against the state map background.

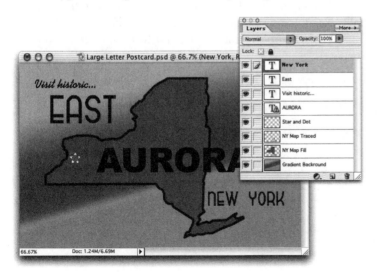

FIGURE 13.6

Almost all the pieces of the postcard design are in place now.

Warping the Type

Here's where the type starts to look like more than just letters in a row; in this section, you'll customize its shape to suit both the design of the card and the need to have photos show through the letters. To accomplish this, you'll warp the "AURORA" type to give it the proper flag-waving shape for our design. After it's shaped the way you want it, you can move each type layer to its final position so that they don't overlap each other and so that the left and right sides of the postcard image are well balanced. Follow these steps to warp the central type line:

1 Choose Window ➤ Layers to display the Layers palette, switch to the Type tool, and click the "AURORA" layer (notice that each type layer is labeled with its text contents). Although all the action here happens in a dialog box, you need to have the Type tool active so that the Options bar will display Type tool options instead of those for whatever other tool might be active at the moment.

focus

Most image-editing programs have some way to warp type, but they might use different terminology. For example, some programs use the word "envelopes" to describe the different shapes you can apply to a line of type. Check the documentation for the program you're using to find out how to warp type in that program.

2 Click the Create Warped Text button on the Options bar to open the Warp Text dialog box. You can choose from several basic shapes for the warped text using the pop-up menu at the top of the dialog box, and you can then choose whether to apply the warp shape horizontally or vertically. Finally, you can use the sliders to set the amount of Bend, Horizontal Distortion, and Vertical Distortion. Here are the settings we used:

Warp Text

Style: Rise

● Horizontal ○ Vertical

OK / Cancel

Bend: +33 %

Horizontal Distortion: +31 %

Vertical Distortion: 0 %

Click OK to apply the warp settings.

3 Next, choose Image ➤ Transform ➤ Free Transform or press COMMAND+T/CTRL+T to transform the warped text. Choose Window ➤ Info to keep track of the changes you're about to make in the type's dimensions. Drag the handles at the corners of the bounding box until the shape looks right to you—ours is 670 pixels wide and 381 pixels high. When you've got the type the way you want it, press ENTER to apply the transformation.

4 Now you'll add a really cool retro-looking stroke above the warped text to make an outline through which the images will show. COMMAND+click/CTRL+click the text layer in the Layers palette to select the text, then click the New Layer button to add a layer and drag the layer above the "AURORA" layer.

5 Make sure the Foreground color is black, then choose Edit ➤ Stroke to add a stroke around the boundaries of the selection, with these settings:

Click OK, Choose Edit ➤ Stroke again, change the color to white and the width to 6 pixels, then click OK. Once more—choose Edit ➤ Stroke a third time, change the color back to black and the width to 3 pixels, then click OK. (We used an outside stroke to provide as much area as possible within the letters for the photos to show through.)

Now you're ready to move on to the fun part: adding images to fit within the letters. Be sure to save your file after each step as you go along; the next steps require your artistic judgment and will be more difficult to reproduce if your computer should crash or the file is closed without saving for some other reason. Take a look at Figure 13.7 to see how the image looks at this point.

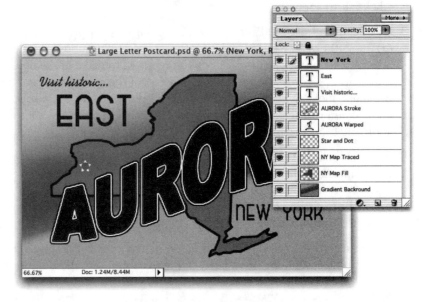

FIGURE 13.7

Keeping each image element on a separate layer enables you to move it around and hide it temporarily if you want to see what's on the layers behind it.

Silhouetting Images Within the Letters

Now it's time to add photos to the postcard. You can copy and paste each image into the postcard file, or you can drag and drop them. In Photoshop Elements, just as in its big brother Photoshop, pasting or dragging an image into a file creates a new layer. With each image on its own layer, you can move them around, resize them, and trim them to fit without interfering with the other images. After all the images are in place, you'll trim them to fit inside the warped type.

Follow these steps to add the photos to your postcard:

1 Open each photo file, choose Image ➤ Resize ➤ Image Size, and scale the image to about 300 pixels by 200 pixels so that it will fit into the postcard document.

2 For each image, select all, copy, and paste into the postcard document, or switch to the Move tool and drag each photo into the postcard document. Display the Layers palette (choose Window ➤ Layers) and drag the photo layers so that they're above the warped text layer and below the text outline layer. The Layers palette now looks like this:

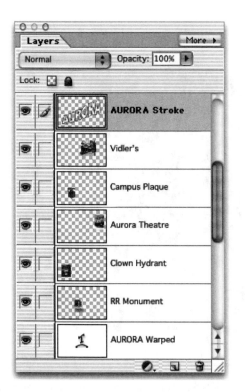

3 Arrange the pictures where you want them to be, using the Free Transform command as needed to resize them. Click each layer in the Layers palette to make it active, then choose Image ➤ Transform ➤ Free Transform or press COMMAND+T/CTRL+T and SHIFT+drag the corners of the bounding box to resize the photo. Holding down SHIFT as you drag ensures that the photos retain their original proportions. Press ENTER when you complete each transformation.

4 You don't need to worry about the parts of the photos that extend past the boundaries of their letters except where they overlap the parts of the other pictures that fall within the letters. You'll need to trim the photos in those areas. Switch to the Polygonal Lasso tool and activate the layer for the photo you want to trim. Select the overlapping area by clicking and then clicking again to place a corner. To complete the last section of the selection, double-click. When the overlapping area

is selected, press DELETE to remove it. Here's a close-up look at this technique:

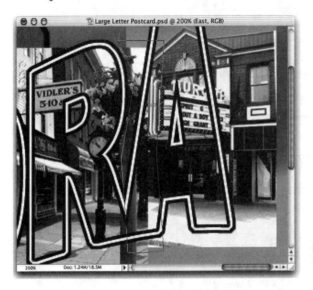

flash ——

You can also eliminate overlapping parts of the photos using masks, which will hide the overlapping areas without deleting them. Once you've trimmed a photo as described in Step 4, the overlapping areas are gone irretrievably. If you hide the overlaps by masking them, on the other hand, you can reposition the photos within their letter shapes at any point. Photoshop Elements doesn't support masks, but other programs may. To mask an image, create a selection of the warped text as described in Step 6, then use your favorite selection tool to remove all but one letter from the selection. Then make the mask for the photo that goes within that letter following the directions in the documentation for your software—the exact procedure varies according to the program.

5 When you have the pictures arranged the way you want them, merge them all onto a single layer. In the Layers palette, click the topmost photo layer, then click just to the left of each layer thumbnail on the other photo layers to link them all together. Then choose Layer ➤ Merge Linked or press COMMAND+E/CTRL+E to merge the linked layers into one layer.

6 Now you need to get rid of the parts of the photos that extend past the warped text's outline. Make a selection in the shape of the warped text by COMMAND+clicking/CTRL+clicking on the warped text layer's name

in the Layers palette. Then choose Select ➤ Modify ➤ Expand to expand the selection by 3 pixels. Choose Select ➤ Inverse to invert the selection so that the area outside the text is selected. Use the Layers palette to make the photo layer active and press DELETE to clear the photo parts that extend outside the letters.

7 Finally, hide or delete the warped text layer. Make the warped text outline layer active, link it with the Photos layer, and choose Layer ➤ Merge Linked or press COMMAND+E/CTRL+E to merge it with the photos layer. Here's what the Layers palette looks like at this point:

The postcard is almost done; all it needs is a finishing touch or two, and you'll be ready to print it, e-mail it, or display it in whatever way suits your fancy.

Applying Layer Styles to Type

With all the type in place, the postcard looks pretty good, but it's awfully flat. One easy way to jazz it up and make it snap out at the reader is to apply drop shadows to the text layers. The shadows are a little different for the solid black text than for the "AURORA" picture layer, but the technique is the same for all. Follow these steps to apply the drop shadows:

1 In the Layers palette, click the "East" layer to activate it. Choose Window ➤ Layer Styles to show the Layer Styles palette, then choose Drop Shadows from the Styles pop-up menu, and click the Low thumbnail.

focus

Drop shadows are the sort of shadow you see behind an object that stands completely away from its background. Shadows that are "attached" to their objects, like the shadow that follows you down the street, are called cast shadows. There's more about shadows in Chapter 14, "What Fools These Mortals Be: Creating Easy Trompe l'Oeil Images."

2 That was almost too easy . . . so let's add a bit more sophistication by refining the settings on that shadow. Choose Layer ➤ Layer Style ➤ Scale Effects and change the Scale setting to 70 percent.

3 Choose Layer ➤ Layer Style ➤ Copy Layer Style. In the Layers palette, click the "New York" layer to make it active, and then choose Layer ➤ Layer Style ➤ Paste Layer Style to apply the drop shadow to this layer.

4 Activate the "AURORA" picture layer and apply the Low drop shadow style to it as you did to the "East" layer in Step 1. Then, to make the "AURORA" picture layer stand farther off the background than the other type layers, choose Layer ➤ Layer Style ➤ Style Settings. Change the Shadow Distance to 15 pixels, and press ENTER to apply the change. The final image is shown in Figure 13.8.

flash

Drop shadows are a great way of giving parts of an image depth, making it look more realistic and focusing attention on the important parts. But don't overuse them—notice that we didn't apply a shadow to all the type in our postcard image, nor to the New York outline. If everything has a shadow, nothing stands out.

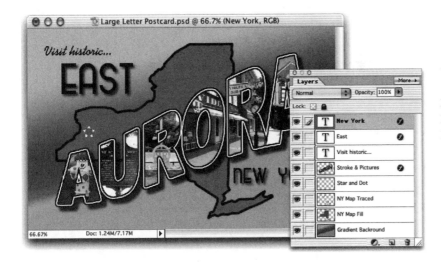

FIGURE 13.8

Finally! All the pieces of the postcard are in place to create a whole that is much more entertaining, colorful, and appealing than the original images.

To Mail It or Not to Mail It?

So now you have a postcard—but it's stuck inside your computer. You need to get it out into the real world. Maybe you'd like to mail it to someone, or you want to keep a batch of hometown postcards at your home for your guests to use. If you want to use your image as a real, mailable postcard, you'll probably want to do something about a back for it. You don't actually have to print anything on the back; all that's needed is the address, your message, and a stamp. But your cards will look much more professional if you print commercial-style backs on them. Figure 13.9 shows the old-fashioned back design we created to print on our own East Aurora card.

We make a point of saying "old-fashioned" because many modern commercial postcards have a 4 1/2" by 3/4" space marked with a border line in the lower right corner for the Postal Service's bar code. As you make your own back, you can include that space or omit it, as you prefer; just remember that if you write in the area that the Postal Service wants for the bar code, your writing might end up with a bar-coded piece of tape over it.

You can make your postcard back using Photoshop Elements, Microsoft Word, or any other program that can create the lines and text you need. A postcard back like ours has four elements: a space for the stamp, the words "Post Card," a vertical line to divide the address space from the message space, and a little caption describing what's on the front. Some programs will require you to specify the position of your postcard back on the page; others, like Photoshop Elements, will automatically print it in the center of the paper.

FIGURE 13.9

Your postcard needs a back, too. Here's the back we designed for our East Aurora card.

EAST AURORA, NEW YORK. HOME OF PRESIDENT MILLARD FILLMORE AND THE ROYCROFT CAMPUS, AND RENOWNED A CENTURY AGO FOR THE GREAT RACE HORSES FOALED HERE, EAST AURORA TODAY IS A PLEASANT RESIDENTIAL TOWN WITHIN EASY COMMUTING DISTANCE OF GREATER BUFFALO.

© 2002 RICHARD F. BINDER

PLACE
POST CARD
STAMP
HERE

MADE IN U.S.A.

POST CARD

When it comes to printing on both sides, alignment is important. The only way to align the two sides of your card is to run some tests using plain paper. If you print with trim marks on both sides, you can hold the paper up to a light to see how far off things are and make the appropriate adjustments. These marks—lines that meet at each corner of the image—also help you trim the excess paper away from the image more easily. Some programs, like Photoshop Elements, allow you to print trim marks, or crop marks, as part of the printing options; with a program that doesn't, you'll have to add trim marks as part of the card back document.

As a general rule, don't place any of the card back's elements too close to the edge; if you do, they might be cut off when you cut the cards apart after printing.

flash

A quick way to create postcards—no X-Acto knife required!—is to use prescored postcard paper made by companies like Avery. You'll still need to set up your front and back files and load the paper carefully to make sure the front and back line up, however.

More Great Ideas

Of course, a large-letter postcard image doesn't have to be used on a real postcard. It makes a great summary or introduction image for just about

any purpose, as we mentioned at the beginning of this chapter. There are lots of ways to use it—and lots of other cool ways to combine text and images. Here are a few of our favorites:

- Now's your chance to get a little creative—and a little famous! At least, you can pretend. Start with your favorite photo of yourself or a friend, then add type to turn it into a magazine cover. A fun wedding shower invitation could show the happy couple under the magazine title "TRUE LOVE," with teasers like "Planning Your Dream Hawaiian Honeymoon" and "How Joe Surprised Mary with a Diamond in Her Dessert."

- Create matching lapel buttons for a family reunion by combining a photo of the ancestral homestead, a common ancestor, or another relevant image with curved text. You can buy button blanks at craft stores—just snap them open, drop in your printed image, and snap them back together (see Figure 13.10).

- Make your kid's day by putting him or her on a sports trading card. Fronts usually have a name indicating the card collection to which the card belongs as well as the name of the player, while backs contain the fine print about a player's statistics. For best results, print the front of your card on glossy photo paper and the back on matte paper, then trim the two sides and glue them together with spray mount, available at art supply stores.

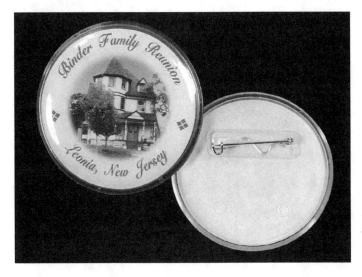

FIGURE 13.10

This house was the home of Jacob Binder, who founded the American branch of our family. We shot the photo on a rainy day and used it as the basis for these family reunion souvenirs. The color version is on our Web site.

- Create a business card for your sideline or small business featuring a large-letter image that illustrates the nature of your business—trees and flowering bushes within the name of your business for a yard service, or pets within the name for a pet-sitter, for example.

- These days you can't be too careful when donating items to a bake sale. You can play it safe by labeling your baked goods with all their ingredients—including things like peanuts that many people are allergic to—and make a visual splash at the same time by incorporating a colorful image in the label design.

- Warped text can take on many shapes, including spirals, waves, and curves of all description. Combine a photo of your friend with "Happy Birthday" repeated over and over and spiraling around the image to create an eye-catching birthday card.

Other Fun Stuff

What Fools These Mortals Be

Creating Easy Trompe l'Oeil Images

A fun thing to do with digital photographs is to create trompe l'oeil images that give the impression of real three-dimensional objects. You've already used some related techniques for producing 3D effects; in Chapters 11 and 12 you created an ornate frame for the Saint Guinefort icon, and in Chapter 13 you made text stand out from a background with a drop shadow. In Chapter 3, you learned several techniques for creating simulated 3D textures, and you saw how we used a couple of them to simulate a matted and framed photograph. In this chapter, though, the object is to produce a picture that fools the viewer into believing that the objects in the picture are real.

focus _____

Trompe l'oeil is a French phrase meaning "deceive the eye." Artists have created pictures to fool the eye since antiquity; the Roman writer Pliny the Elder wrote about a competition between the Grecian artists Parrhasios and Zeuxis, which Parrhasios won by painting a curtain so realistic that Zeuxis asked that it be drawn aside so he could see the picture behind it. Trompe l'oeil was immensely popular in the eighteenth and nineteenth centuries, and it is still widely practiced today. For a good discussion and a look at some of the world's greatest trompe l'oeil paintings, visit the Web site run by the University of Nebraska's Sheldon Memorial Art Gallery and Sculpture Garden at sheldon.unl.edu.

Once you have the idea of what will work to fool your friends, you can riff on it indefinitely!

I Can't Believe It's Not a Butterfly!

A trompe l'oeil painting can be as big as a wall or as small as the tip of your finger. In fact, many modern instances are of small objects painted on an otherwise ordinary wall or table surface. To create a good trompe l'oeil picture, you need to trick the viewer into thinking that something is real when it isn't. This works best if you employ everyday things, objects that people just naturally expect to see. Many of the great painters included postage stamps, matchbooks, or other small objects in their paintings.

We'll show you how to create a trompe l'oeil image by combining a life-size photo of a real butterfly with Richard's high-school graduation photo to produce a portrait suitable for framing. Actually, the frame (and a mat) will be part of the image, too, to heighten the impression of realism. This kind of image is a classic example of trompe l'oeil because the butterfly won't look like part of the picture. It will look like a real butterfly that has just landed there. You could create a visual joke by putting a butterfly on the end of Richard's nose and editing the image so that Richard is looking cross-eyed at the butterfly, but that image wouldn't be trompe l'oeil because no one would ever mistake a picture of Richard for the real thing unless it were life-sized and mounted in a lifelike position and setting— impractical, to say the least. The picture of a framed photo, on the other hand, *will* look like the real thing, and so will the butterfly.

The images you'll need to complete this project along with us are available on our Web site: www.getcreativebook.com.

In this chapter, we're not going to take you through the process of creating the mat and the frame. We've provided copies of these two pieces on our

Web site, and we recommend that you use them this time. When you make your own trompe l'oeil images like this one, you can make your own frames and mats using techniques like those shown in Chapter 3 (for a stucco texture that makes a good simulated mat board and an oak texture that might make a nice frame) and Chapter 11 (for a gilt frame).

Placing the Picture Elements

To get the picture elements together in a single image, follow these steps:

1 Open rfb_grad.tif. To make room for our mat and frame, choose Image ➤ Paper Size. Choose Pixels from the pop-up menu, set the Width to 2016 and the Height to 2616, and click OK. Now choose Object ➤ Create ➤ From Background. This will allow you to position the portrait to match the opening in the mat.

2 Open rfb_grad_mat.tif. Choose the Magic Wand tool. Set the tolerance to 0 and click in the white area. Choose Object ➤ Create ➤ From Background, then press DELETE to knock out the center opening, where the portrait will show through. Choose Object ➤ Select All. Choose Edit ➤ Copy. You can close rfb_grad_mat.tif now; you are done with it.

3 Return to the portrait image. Choose Edit ➤ Paste ➤ Paste as New Object to add the frame.

4 Open rfb_grad_frame.tif. Repeat Steps 2 and 3 with this image to insert the picture frame into the image you're building.

5 Now you need to position the photo in the mat's off-center opening. Choose the Zoom tool and center the view on the upper-left corner of the hole in the mat, with a magnification of 200% or larger so that you can see individual pixels. Activate the photo's layer (Object 1) in the Objects palette. Choose the Object Pick tool and drag the photo until its upper-left corner coincides exactly with the corner of the hole in the mat. (We made the mat exactly the right size!)

6 Open butterfly.tif. This is a photo that Richard took in a butterfly sanctuary. We've silhouetted the butterfly for you; now you'll need to extract it so you can include it in the image. Choose the Magic Wand tool and set its tolerance to 5. Click anywhere in the outer white area of the image to select everything but the butterfly, then choose Mask ➤ Invert. You'll see a little white fringe around the edges of the

butterfly. To defringe the edge slightly, choose Mask ➤ Mask Outline ➤ Feather, and make the settings shown here:

Click OK.

7 Choose Edit ➤ Copy. Switch to the portrait image and choose Edit ➤ Paste ➤ Paste as New Object. Choose the Object Pick tool and position the butterfly where you want it. We noticed that this poor butterfly is a little ragged, so we placed it to minimize the ragged end of the right wing. (Raggedness is a natural consequence of being a butterfly, by the way; it's just that we don't usually notice it because we're not looking that closely as butterflies flit about in the flower garden.) Here's our placement, toward the left side of the image, where the butterfly's 3D appearance can gain from overlapping the frame a little:

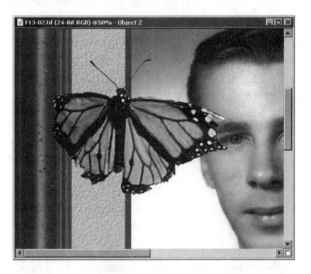

You can close the butterfly.tif window; you're done with it, too.

You now have the design elements in position, and your image should look like Figure 14.1.

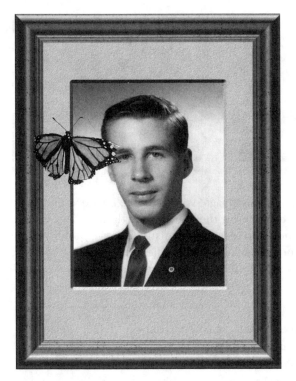

FIGURE 14.1

Here's the framed portrait with the butterfly in place, but it looks very flat and contrived. We need to add shadows to make the simulated 3D elements stand out.

Creating a Real-World Shadow

Most image-editing programs include the ability to create a drop shadow. In PHOTO-PAINT, it's the Interactive Drop Shadow tool; other programs might implement this feature as a layer style or effect.

But drop shadows aren't the only kind of shadows you see in the real world. A drop shadow appears when light falls on an object that does not touch its background—or, if it does, it touches only in areas that are completely hidden by the shadow. A cast shadow, on the other hand, is what happens when the object that makes the shadow touches the background. See Figure 14.2 for an illustration of drop and cast shadows.

flash

The general procedure for creating a cast shadow in an image-editing program is to put the object that will cast the shadow on its own layer. Duplicate the layer. Turn the lower layer (usually the original layer) into a shadow by setting its levels so that it's all black, distorting its shape so that it appears to stretch away from the light source and lie flat on the background (which is frequently the ground or a floor), blurring it with a Gaussian Blur effect, and then reducing its opacity.

FIGURE 14.2

This simulation shows the difference between a drop shadow (a) and a cast shadow (b).

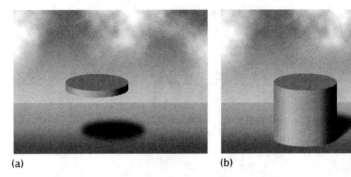

(a) (b)

For your trompe l'oeil butterfly image, you'll need to create a shadow that combines drop characteristics (for the butterfly's body and wings, which don't touch the background) with cast characteristics (for the butterfly's antennae, which don't touch the background, either, but would touch it if they were extended in a straight line through the creature's head).

focus

And just why are we making you create your shadow the hard way? Because doing it yourself teaches you how it works. Once you understand the theory and practice of creating drop shadows, you'll have a much better idea of when and how to use them. (Or it could just be because we're really drill sergeants at heart. You decide.)

There's a little bit of artistic creativity here, but it's nothing you can't handle easily. Follow these steps:

1 Drag the butterfly's layer (Object 4 in our file) to the New Object button in the Objects palette. Do this again. You now have three copies of the butterfly layer. One you'll keep as is (Object 6), and the other two will become the butterfly's shadow.

2 Click the lowest butterfly layer (Object 4) to make it active. Choose the Zoom tool and zoom in until the butterfly almost fills the window. Choose the Rectangle mask tool, click the Add mode button on the property bar, and draw a rectangle around the butterfly's antennae to create a rectangular mask. Your mask should look like this:

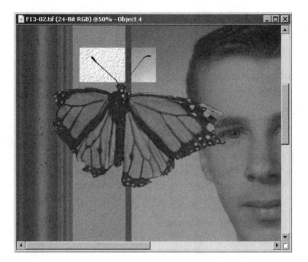

3 Press DELETE to clear the antennae from this layer. (You won't see them vanish because they're still there in layers above the active one.) Choose Mask ➤ Invert. Make the next layer up (Object 5) active, and press DELETE to clear everything except the antennae from this layer. Choose Mask ➤ Remove to drop the mask.

4 Choose the Object Pick tool. Drag handles will appear around the antennae. Click the Perspective Mode button in the Property Bar. Click the upper right handle and drag it straight downward to reduce the antennae to about half their original height. Now click the Skew Mode button on the Property Bar. Drag the top center handle (now a double-ended arrow) to the right until the left antenna is almost in line with the original antenna (which you can see on the Object 6 layer). Here's what things should look like at this point:

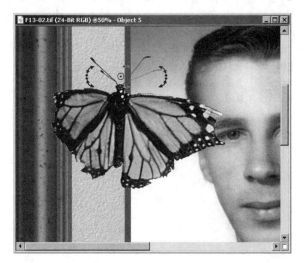

5 Drag the antenna layer to the New Object button in the Objects palette. Drag the new layer (Object 7) downward in the palette so that it is between Object 5 and Object 6. Choose the Object Pick tool. Press the down arrow once to move the new layer downward a single pixel. SHIFT+click the original antenna layer (Object 5) to select both layers at once, then right-click the same layer and choose Combine ➤ Combine Objects Together from the pop-up contextual menu. This process, which makes the distorted antennae a little more solid, will yield a better shadow.

6 Make the lowest butterfly layer, the one without antennae (Object 4), active. Choose Image ➤ Adjust ➤ Contrast Enhancement. Click the Reset button, then set the right-hand Output Range Compression value to 1. Click OK. This turns the entire butterfly image on this layer to black.

7 SHIFT+click the next layer up to select both layers (Object 4 and Object 8) at once. Choose Object ➤ Combine ➤ Combine Objects Together from the contextual menu. This gives you a "shadow" butterfly (Object 9) with its antennae changed to make a cast shadow.

8 Choose Effects ➤ Blur ➤ Gaussian Blur. Set the Radius to 5.0 pixels. Click OK. At the top of the Layers palette is a box labeled with a percent sign (%). This is the control for layer opacity. Set the shadow layer's opacity to 75% by entering the number in the box or dragging the slider that pops up when you click the plus sign. (Leaving the shadow at 100-percent opacity would obscure the details of the objects under the shadow. It would also look artificial, and that's exactly what you don't want.)

9 The last step to "real-ize" the butterfly is to displace its shadow to give the impression that the light isn't coming from the middle of your forehead. Choose the Object Pick tool. Press the right arrow 20 times and the down arrow 30 times. This moves the shadow to a position that simulates light falling from somewhere over your left shoulder. Light doesn't always fall in this direction, obviously, but this is the way we most often expect it to be because artists, photographers, and illustrators so often create images lighted in this way. (Or is that a chicken-and-egg problem? Do they do it this way because we expect it, or do we expect it because they do it? It's too deep for us!)

10 Now that the butterfly has its shadow, the frame needs one, too. Drag the frame's layer (Object 2) to the New Object button in the Object palette. Drag the new layer downward so that it is right below the frame. Set its opacity to 75%. Choose Image ➤ Adjust ➤ Contrast Enhancement. The settings should be as you made them for the butterfly's shadow. Click OK.

11 Choose Effects ➤ Blur ➤ Gaussian Blur. The blur should still be 5.0 pixels, from the step in which you blurred the butterfly's shadow. Click OK. Choose the Object Pick tool. Press the right arrow 12 times and the down arrow 16 times to move the shadow into position.

Figure 14.3 shows the finished image (and you can see it in color on our Web site). Save it in your editor's native format so you can reuse the layers for another project, and it's ready to print. For the best possible effect, print it on glossy photo paper, using the appropriate printer settings.

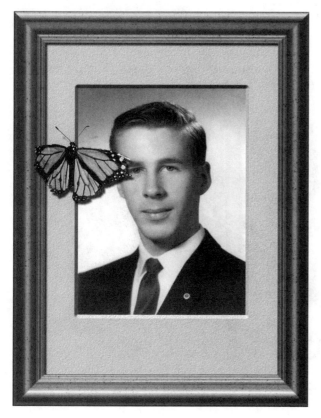

FIGURE 14.3

Here's the final masterpiece, ready to print and fool someone! Compare it to Figure 14.1 to see how much more realistic the shadows make the image look.

Leaving Other Things Lying Around

There are many other interesting ways to use a nice 3D effect. In Chapter 13 we mentioned the postcards we like to make. Figure 14.4 shows one of our favorites, a postcard that Richard made to send to friends who share his passion for fountain pens. You can see this card in the color section as Plate 14.1.

The card in Figure 14.4 started as a real 1906 holiday-greeting postcard. It actually involves two fountain pens, the obvious trompe l'oeil image of a 1934 pen and the more subtle photomontage insertion of an earlier pen (appropriate to the age of the card itself) in place of the rabbit's hiking staff. We also included a scanned copy of Richard's signature to play up our use of a real fountain pen.

We could give you an exhaustive procedure for making a postcard like this one, but we think it's time to start pushing you out of the nest. This is your chance to get creative! Here are the general steps to follow:

1 Scan a vintage photograph or postcard. If necessary, crop it to the right shape and size for a postcard (Chapter 13). You can leave white space on all sides, or you can make the image about 1/8" oversize to prevent a white stripe when you cut the card to size. Colorize the image if you like (Chapters 7 and 8).

FIGURE 14.4

Here's a trompe l'oeil postcard for Richard's pen friends.

flash ————————————————————————————————————

Sometimes you can create a better trompe l'oeil effect by exploiting the contrast between a black-and-white photo and the colored object you place on it, especially if the background photo is too old to have been taken in color. We've put an image like this, another of Richard's pen cards, on our Web site to show you how well this version of the technique can work.

2 Photograph a small object that is related to the vintage picture. Silhouette it and cut it out from its background (Chapter 11).

3 Paste the silhouetted object into the background image to combine the two images. Add a drop shadow to the small object's layer (Chapter 13), using either your image-editing program's drop shadow feature or the technique we've shown you in this chapter.

flash ————————————————————————————————————

Drop shadows frequently look more realistic if you give them a little bit of the color over which they are lying. The postcard in Figure 14.4 has a dark brown drop shadow with a saturation of 20 percent, but we recommend that you start out with a saturation of 8 to 10 percent.

4 Make a back side (turn to Chapter 13 for more details). Use a print resolution of at least 300 pixels per inch.

5 Print the card, cut it to size, write on it, stamp it, and mail it!

More Great Ideas

Remember, the idea of trompe l'oeil is to fool the viewer's eye into thinking that your image is a real object. There are lots of fun ways you can use this concept; here are a few ideas:

- Start the school year off on a fun note by turning your pictures into pencil toppers. Silhouette an image by erasing its background. Then double the canvas or paper width of your image and place a copy of the image next to the original. Flip the copy so that it's facing the opposite direction from the original version. Print, trim, and glue the two images back-to-back around the top of a pen or pencil.

- To make a pillar candle with a lovely trompe l'oeil flower or bud (with a leaf or two, of course), print your image on heavy photo paper, shape it to the curvature of the mold, dip it in melted wax, and stick it to the inside of the mold before you pour the candle. This takes practice, as the print will tend to float free in the hot wax.

- Get your online friends' attention by creating your own custom Instant Messenger icon as a GIF file up to 48 pixels square. Use a very small object, maybe a ladybug or a foreign coin. Make the image much bigger so you can work with it, save the original file for later use, then flatten the image and scale it down and apply the Unsharp Mask tool to make the final version nice and crisp.

- Dress up your home with surprising decorator touches you won't find at the Home Depot, like the light switch plate shown in Figure 14.5 (and in Plate 14.2).

- The next time you throw an evening party, startle your friends with trompe l'oeil images on a couple of your throw pillows. How about a nice little plate of canapés?

- Before you hang the decorations on next year's Christmas tree, make a close-up photo of a small area of the tree to provide a background that

FIGURE 14.5

The ribbon bow looks real, but it's actually a photo that we glued to the plate. We assembled several silhouetted ribbon photos into a tied bow, added a drop shadow, and put the bow in front of a softly marbled green and white background to simulate wrapping tissue.

will blend in with the actual tree, and add a nice 3D image of a tasty-looking holiday cookie, a foil-wrapped chocolate truffle, or...? Cut the print out irregularly along lines that will help hide the edges, color the edges with a dark marker, and hang your new ornament on the tree.

- Try making a trompe l'oeil apron for the chef in your family using pictures of cooking utensils or spice and herb jars! Scale the photos you use so they're actual size, photomontage them together, add shadows and other touches to make them pop out in 3D, and apply them as iron-on transfers.

15

Hey, They Took My Camera!
Making Good Pictures with Your Scanner

GET out your notebooks, class, it's time for today's vocabulary word. The word *photography* means "writing with light." And what *that* means is that you don't need a camera to make some pretty snazzy pictures. In this chapter, you're going to play with your scanner. And, as in any good art class, you'll go home with a few good projects that you can actually use.

Back in Chapter 2 we talked about scanners, but we haven't said much about them since. That's because most of the images we—and probably you, too—want to work with seem to come from our cameras. (Well, actually, you'd probably rather work with images that came from *your* camera....) But there are times when you can use your scanner to great effect. Take, for instance, the wine-bottle bags shown in Plate 15.1. Those bags started out life as a couple dozen grapes on our scanner's glass. Don't go away, we'll show you how we made them. (The bags, not the grapes.) And all the images you'll need to make the projects

> We used Microspot PhotoFix for the projects in this chapter. PhotoFix is a Macintosh-only program, and it does not support layers. But you can use any image-editing program that is able to adjust levels, contrast, hue, saturation, and color balance.

in this chapter are available on our Web site for downloading; you can find them at www.getcreativebook.com.

Scanner, Camera, What's the Diff?

If you bought what we said in the first paragraph of this chapter, you know that scanners and cameras both make photographs, right? Right. So how are photos made by a scanner different from photos made by a camera? (Our heads are starting to spin at this point, so from here on in we'll refer to the two kinds of images as scans and photos.)

The basic difference between scans and photos is obvious. A scan is almost always a more accurate reproduction than a photo. Suppose you're participating in the creation of an exhibition about the home front during World War II. You need to shoot a book of ration stamps so you can print a very exact copy of it for one of the exhibits. (Your great aunt lived through the war and has a ration book, but she won't let it out of the house because she's convinced you'll spill Pepsi Blue on it.) You need to produce a physical duplicate of the ration book, so if you use a camera, you'll have to shoot perfectly head-on to avoid perspective distortion that you would have to correct in your image editor. But if you shoot the book with a scanner, that's not a problem because the book will lie perfectly flat on the scanner glass.

Most digital cameras have excellent auto-focus features, but some cameras have serious problems locking onto things in low light; even with two or three lamps shining on a fountain pen, Richard's camera will occasionally refuse to lock focus on the pen. With most ordinary pictures, this kind of deficiency won't be a concern because there's lots of light and because you're far enough away that the camera's depth of field will compensate. But it can be a killer when you're trying to shoot something very small, such as that ration book. With a scanner, there's never a problem with focusing on small flat objects—the object is automatically in focus because the scanner's focus is fixed on its scanning plate.

With a scanner, there's much more uniform control of the lighting than with a camera. The scanner supplies the light, and it positions the light exactly in the proper relationship to the scanned object. A scan of the ration book will be perfectly uniform in brightness, without any of the darker areas that can result from using a light that's placed to one side of your camera. On the other hand, because the scanner controls the lighting without any help from you, what you see is what you get. So much for mood lighting. If you don't like the lighting your scanner gives you, you can't change it, so you'll end up having to edit the image—sometimes extensively—to obtain the result you want. Which can be a good thing, if you see it that way, because it gives you even more opportunities to get creative. Don't like the color?

Try posterizing the image! (See Chapter 10 for more about posterizing images.)

With their precise resolution settings, scanners make images that are a predictable size; if you scan the ration book, you can immediately print the image as an actual-size copy. With a camera, you'd need to scale the image and, as we said earlier, maybe also adjust its shape to correct for perspective distortion. On the other hand, the scanner's limited choice of resolution settings can leave you in the lurch if you want a really high-resolution image of a very small object. Say you want to make a huge blow-up of one stamp from that ration book to use as a background for the exhibition catalog's cover. The stamps are only about half an inch square, so a 600 ppi scanner will give you a scan that you could print 4 inches square at 150 pixels per inch. Not big enough. You could resample a scan upward, but the result would be blurry, not crisp. Your camera, on the other hand, might accept close-up lenses that would allow you to fill a 2000 by 1600-pixel image with that little stamp. At 150 pixels per inch, you could print that stamp more than 10" wide, and it'd be sharp and clean. (But you'd need to be careful about shooting head-on, and you'd need to watch the quality of the lighting.) To some extent, this point is moot; scanners that can scan optically at 1200 ppi are less expensive than digital cameras with sufficient resolution to tackle this job. But it's still something to consider when you're deciding which tool to use.

How to Scan an Elephant—Or Not

Elephant? What elephant? We just want to know what objects are scannable!

Not many. Or a lot, depending on how you look at it. Scanners are designed to produce very accurate images of flat things. Really flat things, like sheets of paper. (Unfortunately, elephants don't fall into this category.) Scanners frequently have minor problems even with something as almost-flat as the valley between the pages of a book. But with a little ingenuity and a good image editor, you can scan things that aren't completely flat, such as books, keys, watches, pens and pencils, grapes, the makings for a pizza, and many other small objects, especially if they have one flat side.

The objects you scan need to be either flat or relatively thin. Your scanner uses a very powerful light to illuminate the objects on the glass, but that light is very close to the glass. The farther from the glass your object is, the darker it will be, and the inverse-square law (physics mumbo-jumbo that you really should be aware of) means that things can get really dark really fast as their distance from the scanner bed increases. Figure 15.1 shows the original scan of the grapes that we will make into our bottle bags.

FIGURE 15.1

Is this the interior of a bag of charcoal briquettes? No, it's grapes laid on the scanner glass and covered with dark green velvet. It's hardly recognizable, but that can be part of the fun.

focus ───────────────────────────────────────

Don't try to scan your face, or your kids' faces, or your pets' faces. The bright light inside a scanner can seriously damage your eyesight. As for other body parts, that's up to you . . .

It turns out that you can get very good results with anything up to about 3/16" thick, and with a little extra work you might be able to go as far as 3/4" or so. You'll almost always need to adjust the image's brightness levels once you get the scan into your image editor, but it's a minor adjustment. Figure 15.2 shows a selection of pizza-ingredient slices we threw on the scanner. (We'll use them, too, later in this chapter, to make an invitation to a pizza party.)

But there's another catch. Shiny objects can give some scanners fits. When we scanned the bright rose-gold cap of a fountain pen, we ended up with some pretty psychedelic colors—go to www.getcreativebook.com to check our this image that we scanned. There are ways around problems like that, too.

There are going to be times when you want to scan transparent things, such as stained glass art. You can do this by obtaining one of those nice big sheets of Styrofoam we talked about using for reflective lighting in Chapter 1. Remove your scanner's cover, place the artwork on the glass, and prop the Styrofoam sheet up at an angle so that you can shine lots of bright lights onto it from the side and allow it to reflect the light downward toward the scanner. The more light you can apply here, the better your results are likely to be, but this—as are so many other scanning techniques—is something you'll perfect by trial and error.

FIGURE 15.2

Here are some veggie and pepperoni slices we'll use to make an invitation for a pizza party.

Brushing Up on Your Scanning Technique

Okay, let's talk about how to scan things. We'll do something flat, and then we'll do something not so flat.

The Easy Part: Scanning Flat Objects

Plate 15.2 shows a photo of Richard's house, made just after the house was demolished and rebuilt on its current site in 1901. It's blue (cyan, actually) because it's a *cyanotype,* made using the same process that was used to produce those lovely old-fashioned blueprints with white lines on a deep blue background. As you can see, it's pretty pale, and there really isn't any white in it; in other words, it has some problems. For now, let's just scan it, and we'll clean it up later so that we can use it for a vintage-style hand-tinted postcard.

This job is about as simple as scanning gets. You slap the object on the freshly cleaned scanner glass, align it as best you can, close the scanner's cover, and scan. In PhotoFix, choose File ➤ Acquire ➤ *your scanner.*

(PhotoFix comes with a TWAIN plug-in, but we're using an Apple Color OneScanner 600, so we needed to place the scanner's Photoshop plug-in into the Plug-Ins folder for PhotoFix.) Most scanner plug-ins offer you the option of cropping so that you scan only the area you want, and we've done that. Here is the scanner's dialog box after we set the desired scanning area and resolution:

focus

You may notice a slight retro quality to the shot of our scanning interface on this page. Although we normally use Mac OS X on our Macs, we had to start up in Mac OS 9 to do our scanning for this chapter, because at that time there was no OS X–compatible scanner plug-in for our scanner model.

We did say to close the scanner's cover, didn't we? Good. Do it. Religiously. Extraneous light can confuse the scanner's sensing system. It's not a pretty sight.

flash

Remember that you can often scan more than one paper at a time; this will save you time and image space as well as serve as a simplistic filing system to help you keep related scans together. Just copy and paste the pieces into separate image files when you need them.

Books are very much like flat papers except for the valley that appears between the pages when you lay an open book flat. With due respect for a book's age and condition, the easiest way to deal with the valley is simply to apply pressure to the scanner cover while the scanner is operating. When you do this, be aware that too much pressure can break the spine of the book, especially if it's an antique one. Excess pressure could also break the scanner glass, so you'll really need to exercise caution. Use your scanner's preview feature to help you decide when you have the book positioned right, and operate the scanner controls with your third hand. (This is one of those occasions when, as Tom Cuthbertson wrote in *Anybody's Bike Book*, one of the most useful tools you can have is a friend.)

Scanning 3D Objects Without Going Psycho

Many 3D objects will present little or no problem for your scanner. Look at Figure 15.2 again. There are double shadows around the various veggie bits, but the color of the image is excellent, and everything is beautifully sharp.

But then there are the problem children. Figure 15.1, at the beginning of this chapter, shows nearly a worst-case example. The subject is purple grapes, the background is dark, and the result is horrific. But we promised we'd clean this image up, and we will. As a starting point, though, we could have used a white cloth to cover the grapes instead of dark green; but then we'd have needed to deal with all the spaces between the grapes in order to produce the results we wanted for our wine-bottle bags.

Another problem child is the pen we mentioned scanning earlier, with its truly psychedelic color bloom. Many bright objects will do this; they throw the scanner's light back so strongly that its sensor elements are overloaded. But not all the elements are overloaded to the same degree. Remember that the three primary colors of light are red, green, and blue, and it should become obvious why the bloom on the pen cap has a solid red area and a solid blue area. Fortunately, there are sometimes very easy solutions for problems of this type. The easiest is often just to reorient the object on the scanner glass. When we placed the pen diagonally on the glass, we got the scan shown in Figure 15.3. There are still some slight color blooms but nothing that can't be dealt with by such techniques as using the Magic Wand tool to select the offending area and then airbrushing it to a better hue. Another possible solution might be to dull the object's gloss with artist's matte spray before you scan it.

Cleaning Up After Your Scanner

Okay, now you have some scans, what to do with them? How you treat a given image depends on how bad it is, exactly what's wrong with it, and

FIGURE 15.3

It's the same pen that turned psychedelic the first time we scanned it, but reorienting it in the scanner has banished the color bloom.

what you want to do with it. (If you're trying to represent a black cat in a coal bin at midnight, you're going to do something radically different than you'd do to show a sheep walking in the clouds.)

Adjusting Levels

The first adjusting implement in your toolbox is your image editor's Levels control. (Turn back to "On the Levels" in Chapter 6 if you need to review what levels are all about.) Let's work first with the house photo.

1 To start, choose Image ➤ Mode ➤ Grayscale to desaturate the image. (It's easier to work with images like this in grayscale. If you really want it to be cyan, you can colorize it later.)

2 Then choose Image ➤ Settings ➤ Levels and make the settings shown here:

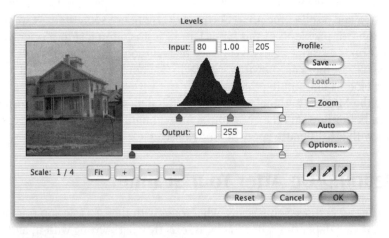

Figure 15.4 shows the photo after you make these adjustments. It's still obviously an old photo, and it still needs more work, but we'll come back to it.

Now apply the Levels control to the grapes using the settings shown here:

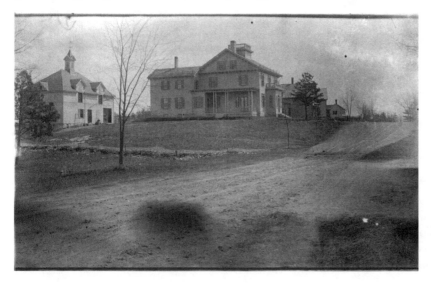

The result is shown in Figure 15.5. Now you can see the grapes. They look rather pearly and spotty, but you can do some further editing later. We'll save that for a moment because it's not actually correction.

Adjusting Image Contrast

As you saw in Figure 15.4, a simple levels adjustment isn't sufficient to produce a good picture from the old cyanotype of Richard's house. One

FIGURE 15.4

Here is the first step in improving the photo of Richard's house.

FIGURE 15.5

Here are the grapes after a hefty correction of the image's levels.

of the principal characteristics of interesting black-and-white pictures is the careful control of contrast—more important than the limits of light and dark is the degree of difference between them, and how sharply that difference is made plays a big part. Let's see what we can do about that in PhotoFix.

Choose Image ➤ Settings ➤ Bright/Cont & RGB. When you open the dialog, the Brightness and Contrast register 49. Click Auto first to normalize the settings to 50, and then apply the settings shown here:

As you can see from these settings, you didn't adjust very much—it doesn't take much. See Figure 15.6 for the result. Had you gone further, even as far as just to 60, you would have lost all the detail in the tree and the dark wall of the building to the right of the house.

FIGURE 15.6

Here is the house photo with its contrast boosted just enough to brighten it a little.

Getting Rid of Backgrounds

Frequently, probably more so than with photos, you'll want to knock out the background from a scan so that you can use the object itself without all the shadows. You're really silhouetting the object, the same as in Chapter 11, but we're going to show you a slightly different technique here. (You can always add shadows in your image editor, remember?) Figure 15.7 shows some more grapes we scanned; these are going to be part of our pizza-party invitation.

To whip this image into shape, apply two quick corrections. First, adjust the levels as shown here:

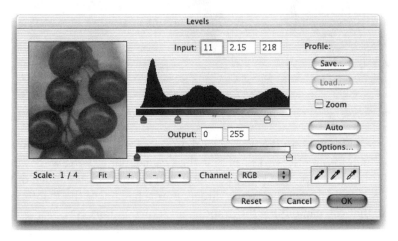

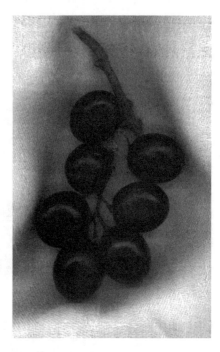

FIGURE 15.7

This is the original scan of a small bunch of grapes for our pizza invitation.

And then immediately bump up the contrast. (If this is beginning to look like a familiar procedure, good!) Here are the settings:

Now, let's knock out the background. We tried using the Magic Wand tool, which frequently works—ahem—like magic; but it didn't work well for this image. Depending on how we set it, it always took too much or too little. So we'll take another, more direct approach. Choose the Paintbrush tool so that you can outline the grapes, and set its options as shown here:

This job is much easier if you zoom the image to about x4 (400 percent) view; use the handy zoom pop-up at the bottom of the PhotoFix document window. When you need to reposition the image, hold the SPACEBAR down to switch the Paint Brush tool temporarily to the Hand tool, then drag the image around within the window. Figure 15.8 shows the image with the outline drawn.

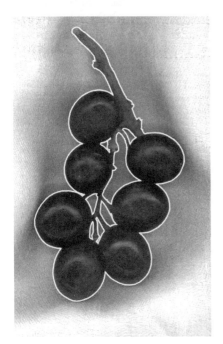

FIGURE 15.8

Here is our bunch of grapes, outlined for removal of the background.

Now you can use the Magic Wand, with the settings shown here, to select the object you've outlined.

Settings
Tolerance: 99 %
Sensitivity to: ⦿ Light / ○ Color / ○ Hue
☐ Smooth

Click the Magic Wand in the darkest part of the image; that's on the left middle grape. The tool picks up everything except two very small parts of grapes, and you can use the Rectangular Selection tool, with the SHIFT key held down, to add those areas to the selection. Then choose Selection ➤ Invert, click the Colors palette's Change Foreground to Black & Background to White button, and press the DELETE key. See Figure 15.9—we got grapes!

Many image editors offer the ability to anti-alias a selection before operating on it. This results in a soft-edged selection, rather than a hard line between the area inside the selection marquee and the area outside it. Most people's natural inclination is to anti-alias every selection because things in the real world don't have sharp edges that are defined by pixels. Well, *don't!* At least, don't *always* anti-alias. As a general rule, for anything except images that you are preparing for on-screen use, you're better off

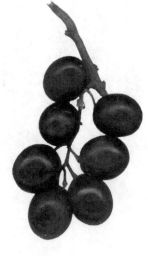

FIGURE 15.9

Here are the grapes with the background knocked out. We will use this image in our pizza party invitation, along with the veggies.

not using anti-aliased selections. You can rely on a high resolution (300 ppi or more) to produce clearly defined edges that won't appear pixelated (also known as jaggy) when people are looking at the printed picture. If you anti-alias selections in images for printing, you are likely to end up with blurred edges in the final version, and it's not nice to fool people into thinking they need their eyeglass prescriptions changed (unless you're creating a trompe l'oeil image that relies on a blur for its effect).

Let's Finish What We Started—Our Projects!

We've started a whole passel of projects, now it's time to put together all the techniques we've used and finish things up.

Pizza, Anyone?

When we set out to make our party invitation, first we scanned the random assortment of veggies that we showed you in Figure 15.2. But we decided that that wasn't really the best way to do what we wanted. So we went back and scanned several slices of each of the different varieties individually. From the individual scans, we picked the most toothsome specimens, adjusted their levels and contrast, and pulled them out of their backgrounds as we did for the bunch of grapes in Figure 15.9. We then assembled a selection of them into a mélange that we can include in our party invitation, and the result is shown in Figure 15.10.

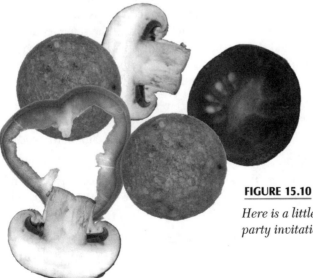

FIGURE 15.10

Here is a little gathering of edibles for our party invitation.

We created our final invitation using Adobe Illustrator, but you can also do this kind of work in your image editor. Check our Web site to see what our friends received in the mail.

Then we thought that it seemed a crying shame to do all that work and just use the results once. So, back to the drawing board, so to speak. For many years now, we've been using fabric tote bags for shopping, and we think it's fun to match the bag's design to the stuff we'll be putting in it. So, since there was a pizza party in the offing anyway, we printed some of our veggie slices on cotton fabric, cut them apart into "patches," appliquéd them to a nice canvas bag, and outlined the edges of the patches with red puffy paint to hold them securely. Then we were off to the market with the bag shown in Plate 15.3.

flash

When you're printing on fabric, use your printer's Best setting in order to make the printer use extra ink. This is necessary because fabric, unlike inkjet paper, will soak up the ink so you need more to produce a good strong image. But it's only the extra ink you need, not extra resolution, so you don't need to go all the way to photo quality—in fact, 150 pixels per inch is more than adequate for fabric printing.

A Loaf of Bread, a Jug of Wine . . .

The very first thing we scanned in this chapter was a gaggle of grapes strewn on the scanner glass (Figure 15.1). We later started to clean up that image (Figure 15.5). Now it's time to go the rest of the way and print the images for our wine bottle bags. First, we need to make an image big enough to use. In Chapter 3, we created an image to be tiled for use as a background— or for whatever else seemed appropriate. Applying the same technique to our grapes, we created the tile shown in Figure 15.11. This is a bigger tile than the ones we made in Chapter 3, but the principles are exactly the same. Here's how to re-create the image we used for our bottle bag:

1 Open the tile image (grape_tile.tif) in PhotoFix. Select all by choosing Selection ➤ Select All or pressing COMMAND+A, and choose Edit ➤ Copy Pattern. Now the grape pattern is on your clipboard, ready to fill a larger image.

2 Create a new image three times as wide as the tile and twice as tall; in this case that'll be 13.12" by 7.227". Set the resolution to 300 and the color mode to RGB.

3 Select all in the new, empty image and choose Edit ➤ Fill With ➤ Pattern.

FIGURE 15.11

Here is a tile of grapes, ready to be repeated enough times to cover a wine bottle bag.

4 Drop the selection by choosing Selection ➤ Select None or pressing COMMAND+D. Now, since wine bottles are tall and skinny, rotate the image 90 degrees counterclockwise (Image ➤ Rotate –90°).

5 Now resample the image to a much more manageable file size without changing its final printed size. Choose Image ➤ Resize to display the Resize dialog box. Before changing the resolution setting, click the Image radio button and make sure that Keep Proportions is checked and Keep File Size is unchecked. Enter a new resolution of 150 pixels per inch and click OK. Here's what your settings should look like:

Resize		
● Image		
○ Canvas	Image Position:	
Keep: ☑ Proportions	☐ File Size	
Size		
	New	Current
Memory size:	6.09 M	24.42 M
Resolution:	150 dpi	300 dpi
Width:	7.22 in	7.22 in
Height:	13.11 in	13.11 in
Unit:	Inches	
	Cancel	OK

This reduces the tiled image file, which will be about 7" wide by 13" tall.

6 Looking at these grapes, we decided that they were a little too red-brown in color. To fix this, choose Image ➤ Settings ➤ Bright/Cont & RGB to adjust the color balance, shifting the overall tint toward purple. Apply the settings shown here:

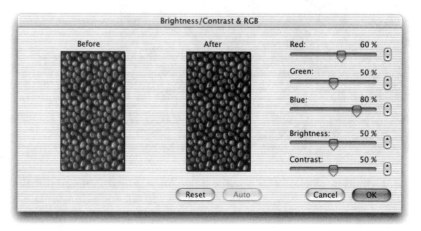

7 At this point we ran a test print on silk, and we found that the color was good but not quite saturated enough. You need to make one final adjustment to boost the saturation (choose Image ➤ Settings ➤ Hue/Saturation), using the settings shown here:

This produces an image that is technically too saturated. On the screen it looks more like cranberries than grapes, but the printed result, on silk, is darker and more subdued, and it's precisely what we're after.

We printed four copies of our final grape image, two on plain silk and two on silk organdy, and sewed up two bags. We lined one with tissue for elegance, and then we decked the bags with a nice gold ribbon and a little spray of plastic grapes (green for contrast). The completed bottle bags are shown in Plate 15.1.

More Great Ideas

Once you start scanning objects, it's amazing how many things around the house you'll end up putting on that scanner. You can scan your jewelry, your hands, food, anything at all that's flat or at least has a flat side. Let your creativity run wild, and give a few of these projects a try:

- Make place cards for your next dinner party or family gathering—scan a different fruit or vegetable for each card and coordinate the colors of your guests' names to match the images.

- Make gift tags by scanning holiday greenery, your favorite ornaments, a motif from your gift wrap, or even a simple ribbon bow. Print the images on prescored business cards from the office supply store and use a punch to make a hole that you can thread with ribbon. We used a simple sprig of holly to create our gift tags last Christmas (see Figure 15.12, or go to our Web site to see them in color).

- This summer, try scanning fruit or even cookies to make labels for homemade goodies that you're taking to friends. Just be sure to clean the cookie crumbs off the scanner bed when you're done.

- Make a tote bag like ours to carry in the car for impromptu shopping trips or give to a friend. In the spring, try scanning flowers (carefully—so as not to crush them); in the summer, perhaps seashells. Fall leaves are very easy to scan, and in the winter you can scan mittens and ski caps for a sporty look.

FIGURE 15.12

Silk ribbon, a few business cards, and a little creativity fulfilled our gift tag needs.

- Scan in your favorite book cover or an exciting magazine cover and print it on an iron-on transfer sheet so you can put it on a T-shirt. Or, for a teenager's room, make throw pillows featuring his or her favorite band's CD covers.

Better Than Perfect
Creative Retouching for Fun and Profit

"PHOTOGRAPHY is truth," said French filmmaker and author Jean-Luc Godard. "The cinema is truth 24 times per second." But anyone who's seen a Hollywood blockbuster in the last couple of decades knows that the second half of that quotation is no longer literally true. And it's equally obvious that the first half is wrong as well.

When photography was first popularized—and for decades afterward—it was thought of as a way to document reality. Even though primitive photo-editing techniques existed (mostly cutting and pasting), it was almost always possible to tell when a photo had been altered. If an object looked real in a photograph, it most likely *was* real.

As we all know—now, stop laughing—that's certainly no longer the case. With the advent of digital photo-editing techniques, the line between fantasy and reality when it comes to photographs has not just been blurred, it's been completely eradicated. In this chapter, you'll create a couple of projects that demonstrate just how easy it is to

> We created the projects in this chapter with Jasc Paint Shop Pro, but you can use your favorite program as long as it has layers and a few basic filters—such as Gaussian Blur and Add Noise—and some essential image adjustment features, including a levels command.

make a photo that looks real—but shows a reality that never existed, and in some cases never *could* exist.

With the techniques we've shown you for editing your photos, you now have the potential to do what *National Geographic Magazine* once got nailed to the wall for. In a cover photo of the pyramids at Giza, Egypt, they actually *moved one of the pyramids* to improve the composition! And they cleaned up some trash on the ground while they were at it. Now, we aren't advocating that you try to pull a fast one like moving a pyramid, but there are similar possibilities a little closer to home, like picking up that trash. We'll show you how to do just that, as well as venture a little farther afield. But this time, since you've had lots of practice with the techniques you'll be using, we'll give you less detailed step-by-step guidance than in earlier chapters. You could call this one your graduation exercises—or your final exam.

How to Sell Your House: Enhancing a Photo Realistically

When you take a picture of your house to show it off, you'd like it to look as nice as possible. But the weather doesn't always cooperate. And sometimes, the kids have left a few toys in the yard that you don't notice until after you've already taken the picture. Well, you can help things along a little, and you can end up with a much more attractive picture. If you're so inclined, you can even take the leap all the way into fraud territory. We'll show you how it works.

Take a look at Figure 16.1. (You can also see this image in the color section as Plate 16.1.) The first thing you'll notice is that it's not Richard's house. We're tired of using Richard's house. This is the home of Dennis and Maggie, friends of ours just down the street. Now, for the real estate listing, Dennis and Maggie would like to have a photo that doesn't show that ugly For Sale sign or the toys and newspaper delivery box, so we've offered to remove the offending items. So that you can work along with us, we've placed the images for this chapter on our Web site: www.getcreativebook.com.

Ready? Let's go! Open dennis_house.tif and follow these steps:

1 The first thing to fix is the perspective distortion. Just as we did with Richard's house in Chapter 8, when we took this photo we had to aim the camera upward to get the whole house into the picture, and as a result the walls all seem to be leaning together toward the roof. In the Layer Palette, right-click the Background layer and choose Promote to Layer from the pop-up menu.

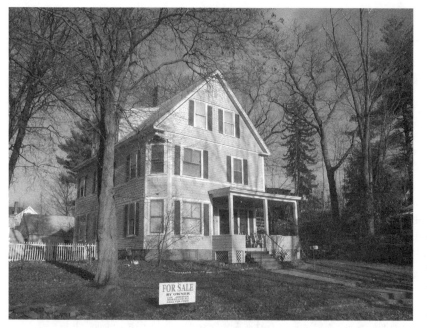

FIGURE 16.1

Here, up for sale, is a nice New England house. But it could be nicer.

2 Now choose Effects ➤ Geometric Effects ➤ Perspective—Vertical. Set the % Difference value to 15, and click OK. The image is now trapezoidal in shape, as in Figure 16.2.

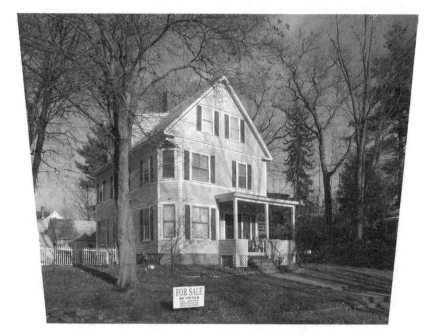

FIGURE 16.2

Eliminating perspective distortion makes the picture look better to the eye without actually making any substantive changes.

focus ————————————————————————————

Normally, you'd want to crop the image right away to make it rectangular, and that's what you did in Chapter 8; but holding off until you've finished your editing can be useful. In the case of this image, you will need some extra background material to transplant later—if you crop now, some of that background material will be gone, and you'll have less to work with.

Looking again at Plate 16.1, you'll see that there are a lot of autumn leaves on the ground. (Guess when we wrote this chapter!) We think all those leaves make the house look a little bleak and uncared for. Every autumn, we get out our leaf sucker, a big vacuum cleaner that was actually made for lawn care services, and suck up the leaves in our yards. Unfortunately, you can't use a leaf sucker on the leaves in this picture, but you can still make most of them go away by following these steps:

1 Choose the Paint Brush tool. Click and hold the Foreground Style swatch, and choose the pattern icon. Release, then double-click the pattern swatch to display the Pattern dialog box. Choose Grass, and set the Scale to 24% and the Angle to 0. Click OK. Make these settings in the Tool Options palette:

2 Paint the grass bit by bit, releasing the mouse button frequently and starting with a new click. This way, if you make a mistake, you can back up just that little bit. Don't paint until the grass is a solid version of the Paint Shop Pro Grass pattern; that would look terribly artificial. Instead, just paint enough that all the brown and gold and blackened leaves take on a nice realistic grassy hue. It should still be mottled and shadowed, and generally uneven; that's the way real grass is, unless you're grooming it for Tiger Woods (or Arnold Palmer, if you're old

enough to remember him). You can see the painted grass in Plate 16.2, but there's more for you to do before you get to that point.

With the grass so pretty, that newspaper delivery box next to the front walk sticks out like a sore thumb, followed closely by the rest of the fingers—the For Sale sign, the toys on the front porch, and the yellow toy up by the corner of the house. Those things can go away. Follow these steps:

1 To remove the newspaper delivery box, choose the Clone Brush. Make these settings:

2 Click the Clone Brush Options tab and choose Aligned from the Clone Mode pop-up menu.

3 Take a sample by right-clicking just to the right of the pole the newspaper delivery box is mounted on. Move the cursor carefully to the left until it's over the pole, and click to begin the process of erasing the delivery box and its pole. Move the mouse just a little upward or downward and click again. Repeat this process until the box and pole are gone, taking a new sample every few steps to vary the pattern in a realistic manner. If you can get a better sample for a given area, feel free to right-click to the left of the box and pole, or even farther away to the right. The idea is to choose samples that will produce as perfect and seamless a reproduction of the wall, sidewalk, and grass behind the box and pole as possible. If you're careful, it will be impossible to tell that there was ever a box and pole there.

4 Change the brush size to 5, set the Clone Mode to Non-Aligned, and turn your attention to the toys on the porch. This is ticklish, because you need to pick up the same small area right under the chair seats, between the chair legs, several times so you can transfer it farther and farther downward to fill in all of the space where the viewer should be

able to look right through the chair legs. Figure 16.3 illustrates how this area looks before and after the vanishing act.

5 Change the brush size to about 40 and obliterate the For Sale sign and the toy near the corner of the house. Don't forget to extend the tree-limb shadow across your new grass by cloning shadowed grass along where the shadow should lie.

Plate 16.2 shows the picture at this point. This is about as far as you can go without straying across the line between reality and fantasy, honesty and fraud. This will be a good image for Dennis and Maggie to use in their real estate listing. But we couldn't resist going further.

The utilities in our city are all above ground; in the trees to the right side of the image, you can see power and phone and cable TV wires leading from the street to the house. To make all those wires go away, set the Clone Brush size back down to 5 or so, and take your time. As you work, use new samples of nearby sky, foliage, or tree trunk to wipe out the wires; where necessary, grab a small branch and drop it in to fix places where the wires crossed branches. The difference between a wired house and a wireless one may be subtle, but the subliminal effect it can have on the viewer is great because it makes the house seem less "industrial age."

The picture you're working on was taken in late November. It was cold that day. Now that you've greened up the lawn and picked up the toys, wouldn't it be nice if the weather were a little warmer, maybe more like an Indian Summer day in October? A good way to make a picture seem warmer is to adjust the color balance to increase the yellow just a little. Choose Colors ➤ Adjust ➤ Red/Green/Blue, make the settings shown here, and click OK:

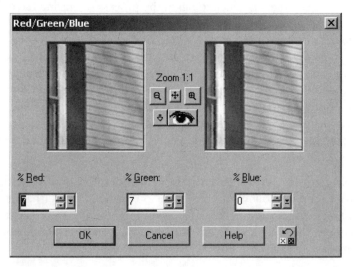

(a) (b)

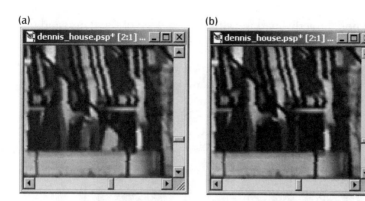

FIGURE 16.3

Here's a close-up of the front porch, before (a) and after (b) the removal of the toys that were under the chairs.

Going Too Far: Adding a Little Fantasy

Okay, now we're ready to move into serious fraud territory. Look at the left side of the picture. Notice anything about the back yard? Houses are built pretty close together around here. Let's give Dennis and Maggie some space around their house. Follow these steps:

1 Choose the Selection tool. Make a rectangular selection covering about the area shown here:

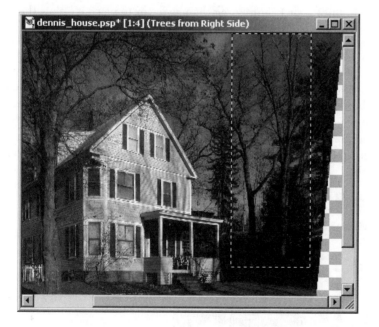

2 Choose Edit ➤ Copy, and then choose Edit ➤ Paste ➤ As New Layer. Choose the Mover tool and drag the chunk of trees to the left side of the picture, covering up those buildings there. Position the trees as

shown here, exactly lined up with the left edge of the house and the top edge of the bottom rail of the picket fence:

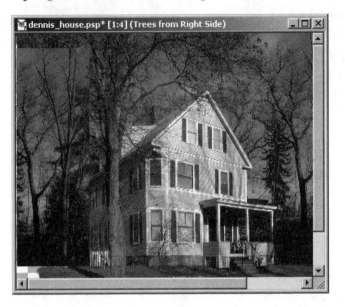

3 Now, in the Layer Palette, drag the new layer to place it below the original layer. Then click the new layer's eyeball to hide the layer.

4 Make sure the original layer, showing the entire image, is active. Choose the Eraser tool. Set the Size to 5, the Opacity to 100, the Step to 1, the Hardness to 50, and the Density to 100. Using the silhouetting technique we showed you in Chapter 11, erase the houses in the background, being careful not to take out any of the house wall or the picket fence. It's actually all right to leave "junk" along the top edge of the picket fence, because you'll need to clean that area out later. Your image should look like this:

5 Now display the layer containing the trees you moved. Set the Eraser's size to about 65 and its opacity to about 12. Gradually work through the sky covering your moved trees, erasing it partially to expose the trees behind. The idea is to blend away enough of the sky that the trees you moved appear to have been planted where they are now. Then set the eraser's size to 4 and carefully clear the areas between the pickets of the fence.

flash

An easy way to do the fence is to use the Lasso tool to select the top rail of the fence. Then invert the selection. Now you can click at the top of the fence between two pickets and then SHIFT+click at the bottom to take out the clutter between the pickets without touching the rail.

Figure 16.4 shows what this area should look like before and after this operation.

Remember, in Chapter 7, we suggested that you could use colorizing to change the color of someone's hair or of a car, or of whatever you wanted to change. Let's paint Dennis and Maggie's house! This isn't a very pretentious house, but it was built in the late nineteenth century, and it has a little Queen Anne decoration. One of the popular things to do with a Queen

(a)

(b)

FIGURE 16.4

Dennis and Maggie's back yard used to feature a crowded view of neighboring houses (a); now it holds a serene bit of forest (b).

Anne house here in New England is to stain it dark brown and paint the shutters a contrasting color. You can paint this house and finish the image enhancement in three easy steps:

1 Choose the Lasso tool and select all the shutters. Then choose Colors ➤ Adjust ➤ Hue/Saturation/Lightness. Click the Reset button to ensure that all the settings are zeroed. Then set Hue to 120, Saturation to –20, and Lightness to –30. Click OK. Isn't that a nice dignified green? (Don't like it? Then change the Hue/Saturation/Lightness settings until you get a color you do like.)

2 Now choose the Lasso tool and select all the walls of the house. Note that there are some white trim boards along the edges and around the windows; don't select these boards, just get the big wall panels where there are clapboards and shakes (shingles). Choose Colors ➤ Adjust ➤ Hue/Saturation/Lightness. Set Hue to –60, Saturation to 50, and Lightness to –75. Click OK, and the house turns dark brown.

3 Now is the time to crop the image. Choose the Crop tool and set its margins so that the bottom corners just cover the bottom edge of the trapezoidal image, with no blank space inside the crop margin, and so that the top edge goes all the way to the top of the image. Choose Image ➤ Crop.

Plate 16.3 is the final result. We like it, but we're not sure we want to show it to Dennis and Maggie—we'd like to avoid fraud charges, thank you very much.

Forget Being "Down to Earth"— Let's Fly to the Moon

Now that you've completed the "practical" project in this chapter, let's have a little fun to wind things up. Take a look at Figure 16.5; it shows a typical tourist waving for the camera. We bet you have a million photos just like this one, right? In this case, the tourist is our friend John, and he's standing in front of an unattractive gray background of a covered motorcycle and a sliding glass door. Why not move John someplace a little more, well, *interesting*? In fact, let's take him to the moon—it's just as gray, but much more exotic!

FIGURE 16.5

Our creativity was definitely not in gear when we posed John for this shot. Here we've cropped out most of the background—rest assured, it's as boring as what you see here.

You can find the files we used for this project on our Web site at www.getcreativebook.com. Now, let's send John to the moon.

The moon image came from NASA—we didn't go to the moon ourselves to take it. If you'd like to explore other areas of the moon or outer space, you can download your own NASA images at the NIX Web site—the NASA Image eXchange (nix.nasa.gov). Most of these images are not copyrighted, so they're free for you to use and redistribute as long as you give NASA credit.

Follow these steps:

1 Open the moon photo (moon.tif—see Figure 16.6) and the photo of John (john.tif). Take a minute to look over the two images so you can see how well they'll mesh and what steps you'll need to take to integrate them into a whole. These images present one major problem: The light in the photo of John shines from in front of the subject, so that

FIGURE 16.6

This image of an astronaut on the moon is just one of thousands of photos available from NASA's Web site.

his shadow is cast behind him to his left. The astronaut's shadow, conversely, falls in front of him. You'll be able to deal with this conflict, though—forge ahead and you'll learn how.

2 First, though, John must be silhouetted so that he can be placed on the moon without dragging his surroundings along. In john.tif, choose Layers ➤ Promote to Layer. This changes the image into a transparent layer, so that when you erase pixels around John they'll turn transparent instead of taking on the current Background color.

3 Next, using the technique you learned in Chapter 11, use the Eraser to silhouette John. On the Tool Options palette (choose View ➤ ToolBars if you don't see it), change to a small, medium hardness brush. Zoom in on John's head and SHIFT+click your way around his edges as shown here:

Keep going until you've erased the edge pixels all the way around John, then use a larger brush to erase the rest of the background.

flash———————————————————————————

When you're silhouetting, remember to save early and often. It's not a difficult technique, but it's time-consuming. If your cat should accidentally pull out your computer's power cord while you're working, you'll feel much better knowing you've only lost 30 seconds' worth of work instead of half an hour's worth.

4 Once you've got John floating on a layer all by himself, with no slider and motorcycle cover in the background, press CTRL+A to select the entire image, then CTRL+C to copy it. Switch to moon.tif and press CTRL+L to paste John onto the surface of the moon while keeping him on his own layer.

5 Switch to the Mover tool and drag John into position next to the astronaut. Oops—he's a bit tall; with its thick-soled boots and bulbous helmet, that space suit should make the astronaut taller than John. You can fix that quickly. Switch to the Deformation tool and right-click any of John's corners, then drag the corner handle to shrink John down to size as shown in Figure 16.7. Double-click within the deformation marquee when you're happy with John's size.

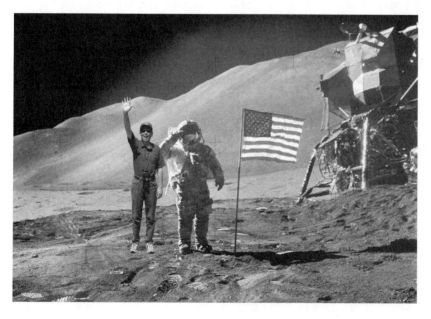

FIGURE 16.7

John's made it to the moon, but he's not quite ready for prime time yet. A few refining touches are needed to make him look as though he belongs there.

6 The image will look much more realistic if John's standing a bit behind the astronaut. Two things will make it appear that this is the case; first, John's feet should be higher than the astronaut's boots—you took care of that in Step 5. Second, the astronaut's elbow should project in front of John's shoulder. Switch to the Eraser tool and carefully erase the portion of John's shoulder that intersects the astronaut's elbow.

flash ───

The easiest way to erase John's shoulder is to make it more transparent. Confused? Don't be. Here's what you should do: Choose View ➤ ToolBars and check the Layer Palette's box to display the palette, then click OK. In the palette, right-click Layer1 and choose Properties, then enter an Opacity value of 50% or less so that you can see the space suit beneath it. Use the Eraser to remove all the area of John's shoulder that overlaps the astronaut's elbow. When you're done, change Layer1's opacity back to 100%. Easy!

7 The next step in acclimating John to his new location is to add some shadows to his face and body—right now, his upraised hand, face, and left arm are too brightly lit to fit in with the lighting in the moon image. First, make sure Layer1 is active, then press CTRL+A to select the entire layer. Follow that with CTRL+F to float the selection, then SHIFT+CTRL+F to defloat it. This procedure results in a selection that encompasses only the nontransparent pixels on Layer1—in other words, John himself.

8 Choose Layers ➤ New Raster Layer and click OK to create a new layer for the shadows you're about to create. Painting on a new layer enables you to change your mind if you decide your shadows are too dark.

9 Make the Foreground color black, then double-click the Airbrush tool in the Tool Palette to activate the tool and display the Tool Options palette. Make these settings:

Carefully paint over John's waving hand, his face, and his left arm—and anywhere other part of him that you think is too bright—so that he looks as though he's standing in shadow, with the sun behind him, as the astronaut is. If you want quicker results, you can increase the Airbrush's opacity—but be careful! A little black paint goes a long way here.

10 Before you drop the selection of John's outline, use it to create a shadow for him to cast on the moon's surface. You learned how to create a cast shadow when you worked on the butterfly in Chapter 14; but it's even easier here because you don't have to make the shadow in pieces. Choose Layers ➤ New Raster Layer and click OK to create another new layer, then switch to the Flood Fill tool, make sure the Foreground color is still black, and click within the selection to fill it with black. Press CTRL+D to drop the selection.

11 Turn this black silhouette into a shadow by blurring it. Choose Effects ➤ Blur ➤ Gaussian Blur and set the Radius to 8, then click OK. Next, switch to the Deformation tool and SHIFT+CTRL+drag the corners of the shadow so that it extends in the right direction, as shown here (we've hidden the background so that you can see the shadow clearly):

When you switch to the Deformation tool, a special marquee with eight handles appears around the object on the active layer. To resize the object, drag a corner handle; right-click and drag to resize proportionally. Press CTRL while dragging a corner to change the object's perspective; press SHIFT while dragging a side handle to skew it; and press both CTRL and SHIFT while dragging a corner to distort it. You'll need to use all of these techniques to get the shadow in the right place.

Finish off the shadow by erasing it where it passes over the astronaut's boots, then switching to the Paint Brush with black as the Foreground color and painting the shadow's legs a bit wider where they meet John's feet. Then change the shadow layer's Opacity to 75% so that the surface texture of the moon shows through it.

That's it—you're done! The final image is shown in Figure 16.8 and—in color—on our Web site. We're still debating what to do with it; we could put it on a T-shirt and send the shirt to John—what a great holiday gift!—or we might just send it back to NASA and ask them to explain how this alien life form got to the moon.

It's Been Real—or Has It?

We hope you've enjoyed these last two projects and that they've shown you that your boring images don't have to stay that way. With modern image editing software and a little imagination, you can turn your photos into a true reflection of your hopes and desires—all you have to do is get creative!

More Great Ideas

With the powerful and varied image editing techniques you now have at your disposal, you can go anywhere, and you can make the place look

FIGURE 16.8

It seems that John's vacation took a turn he never expected— fortunately he's got his camera hanging around his neck and his treasured Washington Redskins cap on his head, so he's ready for anything.

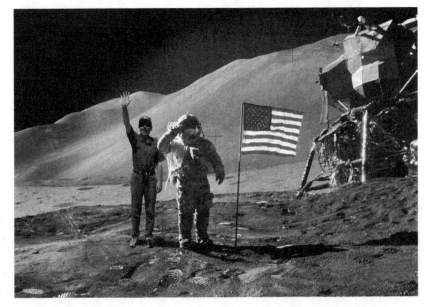

pretty good when you get there, too! You can even bring 'em back alive, as they say, to show off where you've been and what you've been doing. Just don't tell anybody you never really got up from your computer.

- Want to dazzle your tablemates at the next bridge club meeting? Make a deck of playing cards with backs that show you in an exotic locale. Scan the card faces, print faces and backs on lightweight glossy photo paper, glue together with spray mount, and trim to size. But don't try to sell your cards, because those face designs are copyrighted.

- Scrapbooking is an ideal application for edited images. You can make up a fantasy image, maybe showing you welcoming visitors to a big castle that you once visited, reduce the image's opacity, and print it as a background on acid-free paper for use as scrapbook pages. Paste in other edited images showing you dining in the great hall or pitching someone into the moat. (For these, you'll have to stage some photos...)

- If your child plays soccer or some other sport, make a "You're the Greatest" medal. Insert him or her into a photo of a pro game, add some type, scale the image to print about 3" in diameter, and decoupage the print onto a piece of gold-painted plywood. Print a complementary design on some silk, cut it into strips to make a ribbon, sew it all together, and hang the medal around the child's neck at dinner one evening.

- With winemaking and homebrewing so popular these days, why not design your own bottle label instead of choosing one of *their* designs (whoever *they* are)? Start with a photo of a vineyard (visit New York or California!) or a barley field or the Clydesdale horses' barn, and go wild!

- If you're like us, you've seen more than enough of those "My parents went to Mount Rushmore and all I got was this lousy T-shirt" shirts. As tacky as they are, those shirts can be great fun, especially if you take a little liberty with what you print on them. Figure 16.9 shows what happened when Kate's eye lit on the plastic pink yard flamingoes that we break out every other July for our Biennial Flamingo Party.

- Put yourself or a friend arm in arm with the King (Elvis) or the Boss (Bruce Springsteen) or the Material Girl (Madonna). Make it into an invitation for a costume party, and have the text read "Come as your favorite rock star!"

- Make a calendar with fun pictures of everyone in the family. January is Dad on the moon, February is Mom in front of the Eiffel Tower, March is Mom and Dad dancing with Frank Sinatra singing in the background, April is your brother hanging out with Dracula, etc.

FIGURE 16.9

A summer trip through South Dakota yielded a photo of the historic site our flamingoes are visiting on this T-shirt. The flamingoes, however, didn't actually make it out of Kate's backyard.

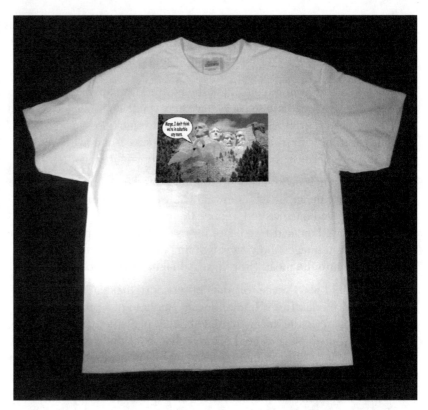

- Make a "Wish You Were Here" travel set. Use pictures of your friend (like the dorky picture of your brother-in-law waving) and put him on the moon (remember our friend John?), in front of the Eiffel Tower, in front of the Tower of London, in front of the Sphinx, and so on.

- Here's something we did that you might have fun trying: one of our older friends actually is a great traveler, and so are some of her other friends. (We wish we were better friends with those people!) As a birthday gift for our friend, we contacted some of the others, got pictures of them all at the palace of Versailles—but all at different times, as it turned out—and combined them all into a single group picture. It was a great hit!

- Did your brother or uncle miss a family reunion? Make a family portrait complete by adding somebody into the mix, so it looks like they're all there together.

Appendixes

PART IV

Appendixes

A

The Software in Review

THIS appendix gives you a brief look at each of the five image-editing programs we used for this book. All five are adequate for very sophisticated image correction and enhancement, and they all go beyond the simple mechanics of fixing images to give you a full range of painting and other creative tools. Some of them go *very* far beyond!

The most significant difference among the programs here is that PhotoFix alone of the five doesn't support layers. This is a significant weakness, but we think it's made up for by the fact that you can run this compact program on one of the ancient Macs that came over to America on the *Mayflower*.

A very valuable feature of any image-editing program is the ability to save selection masks and reload them later for reuse, either as separate disk files or as alpha channels. An alpha channel is like a grayscale image that is stored off to one side, where you can make use of it but where it is not an active part of the visible image. When you activate an alpha channel as a mask, the channel's light areas enable the image to show through or your changes to be applied, while the mask's dark areas hide the image or prevent your changes from affecting the image, depending on how the mask is being used. Alpha channels are stored within an image file, so

they're available even if you quit and restart the program. Because this feature is so useful, we paid particular attention to our five programs' masking and channel features.

All five give you the ability to save and reload selections, but none of them allows you to view and paint directly on alpha channels. (Note that the programs all refer to selections or masks instead of using the term "alpha channel.") This means that you can't view your alpha channels to see which one you want to reload, so be sure to use meaningful names when you save selections.

flash

If you're using a program that enables you to save selections to disk, you can save your selections as editable image files that you can view and modify before reloading them. Photoshop Elements doesn't allow you to save selections to disk, but you can save a selection as a new alpha channel or you can add it to, subtract it from, or intersect it with any existing alpha channel.

For each program, we list the manufacturer's name and contact information, the suggested retail price of the program, and a short tally of features. We also point up the most significant weaknesses of each program; you'll note that the weakness lists are pretty short. These are good programs, and we think any one of them will probably serve you very well (within its limitations, of course).

Paint Shop Pro 7

Manufacturer:	Jasc Software
	Phone: (800) 622-2793
	E-mail: orders@jasc.com
	Web: www.jasc.com
Price:	Boxed: $109.00
	Download: $99.00

General Features

Extensive selection of tools for correcting, enhancing, or creating pixel-based color or grayscale images, including auto-correction tools.

Dozens of built-in patterns and textures. Good features for distorting images, including horizontal and vertical perspective. 99 levels of undo/redo. Includes 75 filters. Can save and load selections to/from disk or alpha channels. Can open and save files in over 30 formats. Built-in support for TWAIN scanners and direct connection to digital cameras. Can accept plug-ins for other scanner types.

Weaknesses

Can load from or generate CMYK separations but cannot work directly in CMYK. Windows PC only.

PhotoFix 3.4

Manufacturer:	Macro Enter Corp. (formerly Microspot USA) 1756 Costa del Sol Boca Raton, FL 33432 USA
	Phone: (561) 395-9996 / (800) 622-7568
	E-mail: sales@macroenter.com
	Web: www.macroenter.com
Price:	Boxed: $59.00
	Download: $53.10

General Features

Requires only 3MB of free RAM; runs on any Macintosh made since 1987 except PowerBook 100; runs under Macintosh System 7.1+, Mac OS 8, 9, and X. Good selection of common tools for correcting, enhancing, or creating pixel-based color or grayscale images, including auto-correction tools. Good features for distorting images, including 2D and 3D perspective. Can apply effects to a floating selection before merging it with the base image. 32 levels of undo/redo. Includes 11 filters; can also use third-party Photoshop plug-in filters. Can save and load selections to/from disk. Can open files in 8 formats; can save in 6 formats. Can work directly with

CMYK images. Built-in support for TWAIN scanners. Can accept plug-ins for other scanner types.

Weaknesses

Does not support layers or alpha channels. No polygonal lasso tool. Nonrectangular selections are not anti-aliased. File format selection is very limited. Macintosh only.

PhotoImpact 8

Manufacturer:	Ulead Systems 2000 Mariner Ave Suite 200 Torrance, CA 90503 USA
	Phone: (800) 85-ULEAD / (310) 896-6396
	E-mail: sales@ulead.com
	Web: www.ulead.com
Price:	Boxed: $89.95
	Download: $79.95

General Features

Extensive selection of tools for correcting, enhancing, or creating pixel-based color or grayscale images, including auto-correction tools. Dozens of built-in "stamp" brush images; can load your images as well. Good features for distorting images, including horizontal and vertical perspective. 99 levels of undo/redo. Includes 68 filters. Can save and load selections to/from disk or as alpha channels. Can open files in over 35 formats, including Photoshop; can save in 31 formats. Built-in support for TWAIN scanners and direct connection to digital cameras. Can accept plug-ins for other scanner types.

Weaknesses

No true support for layers; editing model uses objects that behave like layers but cannot be entirely empty. Can generate CMYK separations but cannot work directly in CMYK. Windows PC only.

PHOTO-PAINT 11

Manufacturer:	Corel Corporation 1600 Carling Avenue Ottawa, Ontario K1Z 8R7 Canada
	Phone: (800) 772-6735
	E-mail: custserv@corel.com
	Web: www.corel.com
Price:	$529.00

General Features

Very extensive selection of tools for correcting, enhancing, or creating pixel-based color or grayscale images, including auto-correction tools. Image Sprayer tool paints with "stamp" brush images; can load your images as well. Acceptable features for distorting images, including horizontal but no vertical perspective. 99 levels of undo/redo. Includes 112 filters. Can save and load selections to/from disk or as alpha channels. Can open files in 37 file formats; can save in 9 formats. Can work directly with CMYK images. Can accept plug-ins for scanners and other acquisition devices.

Weaknesses

Macintosh version requires Mac OS X. Lacks gamut warning to show screen colors that will not print accurately in CMYK mode. PHOTO-PAINT is a component of the CorelDRAW Graphics Suite, not available separately (hence the high price).

Photoshop Elements 2.0

Manufacturer:	Adobe Systems Incorporated 345 Park Avenue San Jose, California 95110-2704 USA
	Phone: (800) 833-6687
	E-mail: sales@adobe.com
	Web: www.adobe.com
Price:	$99.00

General Features

Macintosh and Windows PC versions. Very extensive selection of tools for correcting, enhancing, or creating pixel-based color or grayscale images, including auto-correction tools. Can create a "brush" with any pattern or image segment you like. Excellent features for distorting images, including horizontal and vertical perspective, ripple, shear, spherize, and more. Can save and load selections as alpha channels. 1000 levels of undo. Includes 99 filters. Can open files in 21 file formats; can save in 14 formats. Can use plug-in Photoshop filters. Can accept plug-ins for scanners and other acquisition devices.

Weaknesses

No CMYK support.

How Do I Get There from Here?

ANY time you're learning from a book like this one, it's easy to follow along when you're using the same program the people who wrote the book are using. It's not so easy to follow along when you're using a different program, possibly on a different platform. Don't panic! This appendix is your Babel Fish. (In case you're not familiar with Douglas Adams' five-book "trilogy," *The Hitchhiker's Guide to the Galaxy*, a Babel Fish is a universal translator.) In the table that follows, you will find all five programs' commands for doing most of the things we do throughout the book. In order to save trees, we've omitted standard tasks such as creating, opening, closing, and saving files.

Because you can dock any palette into the window border, the Windows version of Corel PHOTO-PAINT uses the term "dockers" to refer to palettes. Wherever we mention a palette, just think "docker" and you'll be all set.

TASK	PROGRAM				
	Paint Shop Pro	PhotoFix	PhotoImpact	PHOTO-PAINT	Photoshop Elements
3D perspective	Effects ➤ Geometric Effects ➤ Perspective - Vertical	Image ➤ Distortion ➤ Perspective 3D	Choose Transform tool, set Perspective method	Rotate 90° CCW, choose Mask Transform tool, set Perspective mode, drag handles up or down, Enter, rotate 90° CW.	Image ➤ Transform ➤ Perspective
Add noise	Effects ➤ Noise ➤ Add	Filter ➤ Add ➤ Noise	Effect ➤ Noise ➤ Add Noise	Effects ➤ Noise ➤ Add Noise	Filter ➤ Noise ➤ Add Noise
Adjust brightness or contrast	Colors ➤ Adjust ➤ Brightness/ Contrast	Image ➤ Settings ➤ Bright/Cont & RGB	Format ➤ Brightness & Contrast	Image ➤ Adjust ➤ Brightness/Contrast/ Intensity	Enhance ➤ Adjust Brightness/ Contrast ➤ Brightness/ Contrast
Adjust color variations	(Manual process) Colors ➤ Adjust ➤ Color Balance	(Manual process) Image ➤ Settings ➤ Bright/Cont & RGB	Format ➤ Color Balance	Image ➤ Adjust ➤ Color Hue	Enhance ➤ Adjust Color ➤ Color Variations
Adjust hue or saturation	Colors ➤ Adjust ➤ Hue/Saturation/ Lightness	Image ➤ Settings ➤ Hue/ Saturation	Format ➤ Hue & Saturation	Image ➤ Adjust ➤ Hue/ Saturation/Lightness	Enhance ➤ Adjust Color ➤ Hue/ Saturation
Adjust levels	Colors ➤ Adjust ➤ Levels	Image ➤ Settings ➤ Levels	Format ➤ Level	Image ➤ Adjust ➤ Contrast Enhancement	Enhance ➤ Adjust Brightness/ Contrast ➤ Levels
Apply a filter or effect	Effects ➤ category ➤ filter name	Filter ➤ category ➤ filter name	Effect ➤ category ➤ filter name	Effects ➤ category ➤ filter name	Filter ➤ category ➤ filter name

TASK	PROGRAM				
	Paint Shop Pro	**PhotoFix**	**PhotoImpact**	**PHOTO-PAINT**	**Photoshop Elements**
Apply an image correction (e.g., Dust and Scratch)	Effects ➤ Enhance Photo ➤ desired correction	Filter ➤ category ➤ filter name	Format ➤ desired correction -or- Effect ➤ category ➤ filter name	Image ➤ Correction ➤ desired correction	Filter ➤ category ➤ filter name
Blur	Effects ➤ Blur ➤ Blur	Filter ➤ Effect ➤ Custom Blur	Effect ➤ Blur ➤ Blur	Effects ➤ Blur ➤ Gaussian Blur	Filter ➤ Blur ➤ Blur
Change resolution without resampling	Image ➤ Resize ➤ Actual/Print Size radio button	Image ➤ Resize, Image radio button, Keep File Size checked	Format ➤ Resolution	Image ➤ Resample (Maintain Original Size checked)	Image ➤ Resize ➤ Image Size, Resample Image unchecked
Convert grayscale to duotone	Colors ➤ Increase Color Depth ➤ 16 Million Colors (24 bit), then Colors ➤ Colorize	See instructions on our Web site: www.get creativebook .com	Effect ➤ Artistic ➤ Duotone Effect	Image ➤ Color Mode ➤ duotone	Image ➤ Mode ➤ RGB Color. Enhance ➤ Adjust Color ➤ Hue/ Saturation, check the Colorize checkbox.
Convert grayscale to RGB	Colors ➤ Grayscale	Image ➤ Mode ➤ RGB Color	Format ➤ Data Type ➤ RGB True Color (24-bit)	Image ➤ Color Mode ➤ RGB Color	Image ➤ Mode ➤ RGB Color
Convert RGB to grayscale	Colors ➤ Grayscale	Image ➤ Mode ➤ Grayscale	Format ➤ Data Type ➤ Grayscale (8-bit)	Image ➤ Color Mode ➤ Grayscale (8-bit)	Image ➤ Mode ➤ Grayscale
Convert vector text to pixels	Layers ➤ Convert to Raster Layer	Selection ➤ Defloat	Object ➤ Convert Object Type ➤ From Text/Path to Image	Object ➤ Text ➤ Render as Object	Layer ➤ Simplify Layer

TASK	PROGRAM				
	Paint Shop Pro	**PhotoFix**	**PhotoImpact**	**PHOTO-PAINT**	**Photoshop Elements**
Copy and paste a layer style	Not supported	Not supported	Not supported	With Interactive Drop Shadow tool, click Copy Shadow Properties button on Extended Property bar. In document window, click object with shadow.	Layer ➤ Layer Style ➤ Copy Layer Style, Layer ➤ Layer Style ➤ Paste Layer Style
Create a new empty layer	Layers ➤ New Raster Layer	Not supported	Not supported	Object ➤ Create New Object	Layer ➤ New ➤ Layer
Crop	Image ➤ Crop to Selection	Image ➤ Crop	Edit ➤ Crop	Image ➤ Crop ➤ Crop to Mask	Image ➤ Crop
Desaturate	Colors ➤ Adjust ➤ Hue/Saturation/ Lightness, move Saturation slider to 0	Image ➤ Hue/ Saturation, move Saturation slider all the way left	Format ➤ Hue & Saturation, move Saturation slider all the way left	Image ➤ Adjust ➤ Desaturate	Enhance ➤ Adjust Color ➤ Remove Color
Distort selected portion of image	Effects ➤ Geometric Effects ➤ desired effect	Image ➤ Distortion ➤ desired method	Effect ➤ Distort ➤ effect name	Effects ➤ Distort ➤ effect name	Image ➤ Transform ➤ desired method
Drop Shadow, edit properties	Effects ➤ 3D Effects ➤ Drop Shadow	Not supported	Format ➤ Frame & Shadow	Interactive Drop Shadow tool	Palette dock ➤ Layer Style ➤ Drop Shadows, Layer ➤ Layer Style ➤ Style Settings
Duplicate a layer	Layers ➤ Duplicate	Not supported	Object ➤ Duplicate	Object ➤ Duplicate	Layer ➤ Duplicate Layer
Duplicate the background as a layer	Select Background in Layer Palette. Layers ➤ Duplicate	Not supported	Selection ➤ All, then Selection ➤ Convert to Object (with Preserve Base Image checked)	Object ➤ Create From Background	Layer ➤ New ➤ Layer from Background

TASK	PROGRAM				
	Paint Shop Pro	PhotoFix	PhotoImpact	PHOTO-PAINT	Photoshop Elements
Expand or contract selection	Selections ➤ Modify ➤ Expand -or- Contract	Not supported	Selection ➤ Expand/Shrink	Mask ➤ Mask Outline ➤ Expand -or- Reduce	Select ➤ Expand -or- Contract
Feather a selection	Selections ➤ Modify ➤ Feather	Selection ➤ Feather/ Transparency	Selection ➤ Soften	Mask ➤ Mask Outline ➤ Feather	Select ➤ Feather
Fill an area with a pattern	Choose Flood Fill tool, choose pattern style for Foreground color swatch. Fill with pattern.	Edit ➤ Copy Pattern, then Edit ➤ Fill with ➤ Pattern	Choose Texture Fill tool, choose texture from pop-up menu in Toolbar	Choose Fill tool, choose pattern from Select Fill dialog box.	Choose Pattern Stamp tool, set brush size, choose pattern from Pattern pop-up menu in Options bar. Paint with pattern.
Flatten image (merge all layers)	Layers ➤ Merge All	Not supported	Object ➤ Merge All	Object ➤ Combine ➤ Combine All Objects with Background	Layer ➤ Flatten Image
Gaussian Blur	Effects ➤ Blur ➤ Gaussian Blur	Filter ➤ Effect ➤ Custom Blur	Effect ➤ Blur ➤ Gaussian Blur	Effects ➤ Blur ➤ Gaussian Blur	Filter ➤ Blur ➤ Gaussian Blur
Invert image (negative)	Colors ➤ Negative Image	Image ➤ Settings ➤ Negative Image	Format ➤ Invert	Image ➤ Transform ➤ Invert	Image ➤ Adjustments ➤ Invert
Load a saved selection	Selections ➤ Load from Alpha Channel	Open document containing selection, then Selection ➤ Load Mask	Selection ➤ Load Selection, choose from Selection Manager palette	Mask ➤ Load ➤ name	Select ➤ Load Selection

TASK	PROGRAM				
	Paint Shop Pro	PhotoFix	PhotoImpact	PHOTO-PAINT	Photoshop Elements
Merge layers	Layers ➤ Merge Visible	Not supported	Object ➤ Merge	Object ➤ Combine ➤ Combine Objects	Layer ➤ Merge Layer
Motion Blur	Effects ➤ Blur ➤ Motion Blur	Filter ➤ Effect ➤ Motion Blur	Effect ➤ Blur ➤ Motion Blur	Effects ➤ Blur ➤ Motion Blur	Filter ➤ Blur ➤ Motion Blur
Posterize	Colors ➤ Posterize	Filter ➤ Effect ➤ Posterize	Format ➤ Posterize	Image ➤ Transform ➤ Posterize	Image ➤ Adjustments ➤ Posterize
Resample	Image ➤ Resize ➤ Pixel Size radio button	Image ➤ Resize, Image radio button, Keep File Size unchecked	Format ➤ Image Size	Image ➤ Resample ➤ Maintain Original Size unchecked	Image ➤ Resize ➤ Image Size
Rotate canvas	Image ➤ Rotate	Image ➤ Rotate +90 -or- Rotate -90 -or- Free Rotation	Edit ➤ Rotate & Flip	Image ➤ Rotate	Image ➤ Rotate
Save a selection	Selections ➤ Save to Alpha Channel	Selection ➤ Separate Mask, save the new document the PhotoFix creates.	Selection ➤ Store Selection	Mask ➤ Save ➤ Save as Channel (name)	Select ➤ Save Selection
Select all	Selections ➤ Select All	Selection ➤ Select All	Selection ➤ All	Mask ➤ Select All	Select ➤ All
Select inverse	Selections ➤ Invert	Selection ➤ Invert	Selection ➤ Invert	Mask ➤ Invert	Select ➤ Inverse

TASK	PROGRAM				
	Paint Shop Pro	PhotoFix	PhotoImpact	PHOTO-PAINT	Photoshop Elements
Select none	Selections ➤ Select None	Selection ➤ Select None	Selection ➤ None	Mask ➤ Remove	Select ➤ Deselect
Sharpen	Effects ➤ Sharpen ➤ Sharpen -or- Unsharp Mask	Filter ➤ Unsharp Mask	Effect ➤ Sharpen ➤ Sharpen -or- Unsharp Mask	Effects ➤ Sharpen ➤ Sharpen -or- Unsharp Mask	Filter ➤ Sharpen -or- Unsharp Mask
Threshold	Colors ➤ Adjust ➤ Threshold	Image ➤ Mode ➤ Grayscale, then Image ➤ Settings ➤ Levels	Format ➤ Threshold	Image ➤ Transform ➤ Threshold	Image ➤ Adjustments ➤ Threshold
Warp text	Map text to a vector object and then deform the object.	Select area containing text, then combine Image ➤ Distortion ➤ desired method with Filter ➤ Distortion ➤ desired method*	Object ➤ Wrap	Effects ➤ Distort ➤ Mesh Warp	Text Warp button on Options bar

*Works best if you create and warp the text in a separate document, then copy and paste the warped text into the desired document.

C

Glossary

alpha channel **Channel** containing a grayscale image that can be used to **mask** parts of the main image; when the mask is activated, light areas of the channel enable the image to show through, and dark areas hide it.

anti-aliasing Blurring sharp lines or type characters within an image in order to make them appear smoother.

bicubic Highest-quality method of **interpolation**.

bilinear Moderate-quality method of **interpolation**.

bitmap mode Color mode in which an image's **pixels** are either black or white—no gray and no color.

bitmapped image Image created from colored, gray, or black **pixels**, each occupying a predetermined position on a grid.

blending mode Method of combining colors on two or more **layers** or in newly painted **pixels** and existing pixels; the default blending mode is Normal,

in which new pixels completely cover over existing ones, but other blending modes combine new and old pixels so that they create new colors.

BMP Bitmapped **file format** commonly used on Windows PCs.

burn A way to darken image details by simulating the effects of "burning" in a darkroom, where the photographer inserts an opaque object with a hole through it between the paper and the light source so that the image darkens more fully in the areas where the light passes through the hole.

channel Component of an image; each file contains a number of color channels (such as red, green, and blue channels) and can also contain **alpha channels** used for masking portions of the image.

CMYK Cyan (light blue-green), magenta (bright pinkish-red), yellow, and black—the four colors used in process printing to create full-color images.

color management Methods of ensuring that image color remains consistent from scanner to monitor to printer.

color mode A way of defining color within an image, such as **RGB**, **CMYK**, **grayscale**, or **bitmap**.

compression Method of encoding image data more efficiently to decrease file size, sometimes at the expense of image quality.

crop Delete any portion of the image that lies outside a rectangular cropping **selection**.

curve Graph that represents changes in relative brightness of **pixels** within an image.

dither A way to simulate missing colors in an image by clustering **pixels** of other colors together to "mix" a new color by fooling the viewer's eye into seeing a combination of the clustered pixels' colors.

dodge A way to lighten image details by simulating the effects of "dodging" in a darkroom, where the photographer inserts an opaque object between the paper and the light source so that the image is not permitted to darken fully in the areas where the light is blocked.

dpi (dots per inch) Measurement of printing quality in terms of the number of colored or gray dots a printer can produce per inch.

duotone An image containing shades of only two colors, most commonly black and a custom ink color.

EPS Encapsulated PostScript; a **file format** used both for bitmapped images like the ones in this book and for vector images created in drawing programs.

feather Fade out around the edges for a specified distance, usually in reference to a selection; in a feathered **selection**, the outer **pixels** are only partially selected and any change made to that selected area will be only partially applied to those pixels.

file format Method of storing image data within a file; different file formats are suitable for varying purposes—for example, **JPEG** format files are the standard for photos used on the Web.

filter Command that changes the appearance of an image by applying a mathematical formula to modify the color of each **pixel**; depending on the formula used, the modification may simulate the appearance of having moved pixels (such as rippling the shadow on the surface of a pond) or altered the image in some other way (such as blurring the image or applying a drop shadow).

gamma Brightness of an image's midtones; in a **histogram** showing an image's **levels**, moving the middle (gray) slider adjusts the image's gamma.

gamut Range of colors that can be reproduced by a particular device or process.

GIF Graphic Interchange Format, a **file format** originated by CompuServe and widely used on the Internet.

gradient A color fill that shades from one color to another; gradients can include multiple colors and even transparency.

grayscale Composed completely of shades of gray, from white to black.

guides Nonprinting lines that can be placed anywhere within an image.

highlights Brightest (closest to white) points in an image.

histogram A graph of the number of pixels within an image at each possible brightness level.

inkjet printer A printer that forms an image on paper by squirting tiny droplets of colored ink.

interpolation Method of determining the color of newly created **pixels** when an image is resized to contain more or fewer pixels.

JPEG Joint Photographic Experts Group; a **lossy compression** method and **file format** that allows for extremely high compression levels.

laser printer A printer that forms an image on paper by attracting dots of black or colored powder to the paper with an electrical charge created by a laser beam and then heat-fusing the powder to the paper.

layer Part of an image that can lie above or below other parts of the image and that can be modified without affecting the rest of the image.

levels A command that enables the user to modify an image's brightness levels as shown in a **histogram**; the exact name of the command may differ from program to program.

lossless compression **Compression** method that doesn't reduce the quality of the image compressed.

lossy **Compression** method that reduces the quality of the image compressed.

marching ants Common term for an animated **selection** marquee.

mask Method of blocking part of an image, either so that it doesn't show or so that it isn't affected by changes made to the image.

midtones Middle (between white and black) tones in an image; in a **grayscale** image the midtones are gray, and in a color image the midtones are colors of medium brightness.

nearest neighbor Lowest-quality (but quickest) method of **interpolation**.

pixel "Picture element," the smallest unit of a picture; a square area that can be only one color.

plug-in Add-on software that gives a program additional capabilities.

ppi (pixels per inch) Image resolution in terms of how many **pixels** are displayed or printed per inch.

process color One of the four ink colors used to print **CMYK** images, i.e. cyan, magenta, yellow, or black.

quadtone An image containing shades of four colors, usually *not* the standard four printing colors of cyan, magenta, yellow, and black (**CMYK**).

RAM Random access memory, the computer memory in which currently active programs and documents are stored.

rasterize Convert to **pixels**.

resample Add or delete **pixels** and rearrange existing pixels to resize or change the **resolution** of an image.

resolution An image's quality measured in terms of the number of **pixels** per measurement unit that it contains when printed or displayed at a particular size.

RGB Red, green, and blue, the colors displayed by computer monitors and combined to create the illusion of full-color images.

selection Currently active area of the image, to which any changes will be applied; often indicated by **marching ants** along the outer edges of the selected area.

shadows Darkest (closest to black) points in an image.

spot color Printed color that will be reproduced by a single ink, rather than by a combination of the four **process colors**.

spot color channel Color **channel** that contains image data to be printed with a **spot color** rather than with the **process colors**.

TIFF Tag Image File Format; bitmapped file format commonly used in prepress applications.

transform Modify an image or a portion of an image by rotating, skewing, or otherwise reshaping it.

transparency mask A **selection** that includes all nontransparent pixels on a **layer**, thus excluding, or **masking**, the layer's transparent areas.

tritone An image containing shades of only three colors, most commonly black and two custom ink colors.

Index

INTERNATIONAL CONTACT INFORMATION

AUSTRALIA
McGraw-Hill Book Company Australia Pty. Ltd.
TEL +61-2-9900-1800
FAX +61-2-9878-8881
http://www.mcgraw-hill.com.au
books-it_sydney@mcgraw-hill.com

CANADA
McGraw-Hill Ryerson Ltd.
TEL +905-430-5000
FAX +905-430-5020
http://www.mcgraw-hill.ca

**GREECE, MIDDLE EAST, & AFRICA
(Excluding South Africa)**
McGraw-Hill Hellas
TEL +30-210-6560-990
TEL +30-210-6560-993
TEL +30-210-6560-994
FAX +30-210-6545-525

MEXICO (Also serving Latin America)
McGraw-Hill Interamericana Editores S.A. de C.V.
TEL +525-117-1583
FAX +525-117-1589
http://www.mcgraw-hill.com.mx
fernando_castellanos@mcgraw-hill.com

SINGAPORE (Serving Asia)
McGraw-Hill Book Company
TEL +65-863-1580
FAX +65-862-3354
http://www.mcgraw-hill.com.sg
mghasia@mcgraw-hill.com

SOUTH AFRICA
McGraw-Hill South Africa
TEL +27-11-622-7512
FAX +27-11-622-9045
robyn_swanepoel@mcgraw-hill.com

SPAIN
McGraw-Hill/Interamericana de España, S.A.U.
TEL +34-91-180-3000
FAX +34-91-372-8513
http://www.mcgraw-hill.es
professional@mcgraw-hill.es

**UNITED KINGDOM, NORTHERN,
EASTERN, & CENTRAL EUROPE**
McGraw-Hill Education Europe
TEL +44-1-628-502500
FAX +44-1-628-770224
http://www.mcgraw-hill.co.uk
computing_europe@mcgraw-hill.com

ALL OTHER INQUIRIES Contact:
Osborne/McGraw-Hill
TEL +1-510-549-6600
FAX +1-510-883-7600
http://www.osborne.com
omg_international@mcgraw-hill.com